Caravaggio

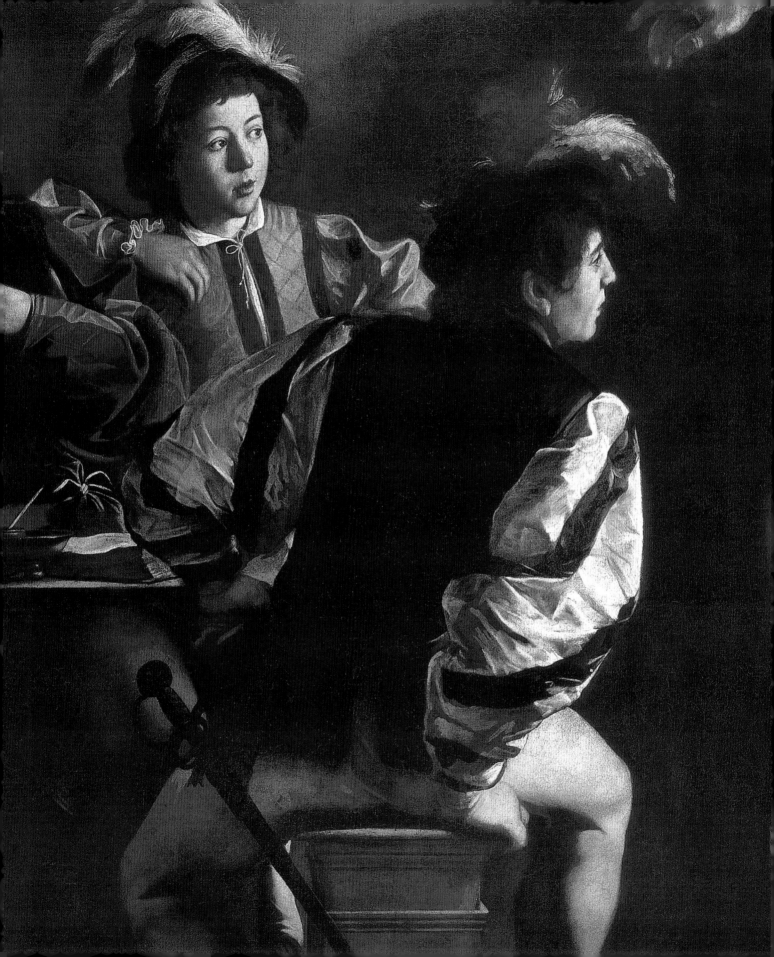

Eberhard König

Michelangelo Merisi da
Caravaggio

1571–1610

h.f.ullmann

Frontispiece
The Calling of St. Matthew
(detail ill. 84)

Front cover
Rest during the Flight into Egypt
(detail ill. 81)
© BAL

Back cover
Basket of Fruit
(ill. 23)
© Ambrosiana, Milan, Italy / The Bridgeman Art Library

Quotation (back cover)
Franz Kugler on Caravaggio and Rembrandt, 1836

© 2007 for the original edition: Tandem Verlag GmbH
h.f.ullmann is an imprint of Tandem Verlag GmbH
Special edition

Art Director: Peter Feierabend
Project Manager and Editor: Sally Bald
Assistant: Susanne Hergarden
German Editor: Ute E. Hammer
Assistant: Jeannette Fentroß
Layout: Bärbel Meßmann
Cover Design: Simone Sticker

Original title: *Meister der italienischen Kunst - Caravaggio*
ISBN 978-3-8331-3786-0

© 2007 for the English edition: Tandem Verlag GmbH
h.f.ullmann is an imprint of Tandem Verlag GmbH

Translation from the German: Anthony Vivis

Printed in China

ISBN 978-3-8331-3787-7

10 9 8 7 6 5 4 3 2 1
X IX VIII VII VI V IV III II I

Contents

In Search of the Artist

2 *David and Goliath*, ca. 1605–1610
Oil on canvas, 125 x 101 cm
Museo Galleria Borghese, Rome

David is depicted against a deep black background as a kind of ideal portrait. He is holding the head of Goliath, whom he has felled with his sling. Accordingly, he will be presented to the virgins of Jerusalem, and then to King Saul. Yet Caravaggio shows us a melancholy hero, who looks at the chopped-off head with a pained expression, without taking any notice of the viewer. His pleated white shirt has slipped down his left shoulder. His coarse trousers, which are even open a little at the front, suggest that, as a shepherd boy, David fought the duel only by accident. The sling, his most important symbol, is of no interest to the artist.

CARAVAGGIO'S SELF-PORTRAITS

Rarely have a painter's life and art contrasted so starkly as is the case with Michelangelo Merisi da Caravaggio. After an eventful life full of violence and conflicts with legal authorities, the artist died – not by another's hand, but "marked by the knife." There have been many attempts to find self-portraits of the artist in his paintings. The beheaded giant, Goliath, in a picture in the Galleria Borghese (ill. 2) is supposed to be a self-portrait. Some people have seen a second self-portrait in the face of the youthful David who is offering the blood-soaked head to the viewer, as if Caravaggio was expressing his own contradictory nature in this painting. This presupposes an extraordinary age-difference, though other speculations about Caravaggio's self-portraits also take little notice of facial changes as the artist grew older. Yet a drawing by Ottavio Leoni (1509–1590) of Goliath's head offers posterity the best available picture of how Caravaggio looked (ill. 7). At all events, as early as 1672 the biographer, Gian Pietro Bellori (1615–1696), identified the artist with this dead head, thus continuing a tradition started by Michelangelo (1475–1564). His face, distorted even more grotesquely, is depicted upon the skin which the flayed apostle, Bartholomew, is holding in his hand in the Sistine Chapel fresco of the *Last Judgment* (ill. 3). The great Florentine artist flayed, and the artist from Caravaggio in Lombardy beheaded – unless this is all mere coincidence, or the future biographer's whim, this self-portrait in Goliath's hacked-off head proves that there is no truth in the belief that Caravaggio never took anything from the great masters!

Certainly, Caravaggio's possible self-portrait as the slain Goliath goes beyond the painting with the apostle's flayed skin. Nor should we forget that Michelangelo was already getting on in years and must have felt flayed alive after his Herculean labor on the Sistine Chapel, whereas Caravaggio was still under forty, whatever the precise date of the Borghese *David*.

For many scholars this painting brings Caravaggio's life to a monumental close. This view makes the Borghese *David* one of the art-works which can be seen as a last will and testament. For Caravaggio to mark his end with a self-portrait in the features of a giant slain by a youthful assailant creates the kind of monument which art history reserves for its greatest heroes.

In the Borghese *David* Caravaggio commits himself to the noble young hero whose victory over Goliath was understood to herald Christ's triumph over Satan. As such, he became a guiding light not only for the Jewish people but also for Christian states like the Florentine Republic. At first glance Caravaggio appears to be indulging in artistic irony by depicting himself as a slain figure and incorporating a good deal of self-doubt in the self-portrait. Beyond that, however, death at the hands of a handsome youth adds an erotic overtone to the bitterness death inevitably brings. For this reason, Caravaggio's self-portrait in the hacked-off head has encouraged Freudian speculation, insofar as this pictorial subject expresses sexual dependency and surrender.

Paintings from Caravaggio's early years in Rome seem to confirm the fact that David's male beauty and Goliath's severed head also have an erotic meaning. In these early paintings some scholars claim to have detected Caravaggio's self-portrait among the semi-naked boys hiding in the shadows, or the figures of young men lustfully challenging the viewer.

The most important of these paintings, the New York *Concert* (ill. 4), highlights various problems in this fundamentally romantic search for real evidence about great artists.

It is certainly difficult to find in the New York painting the same face which Ottavio Leoni (ill. 7) later identified by the beard and the man's age. Both of the faces, which are turned towards the viewer, have powerful brows. Anyone who claims to see Caravaggio's self-portrait in the lute-player must also accept that even as a young man in Rome the artist had already established himself as a commanding figure. In this case, the enchantingly androgynous picture of a *Lute-Player* in St. Petersburg (ill. 29) would also have to qualify as a self-portrait on physiognomic grounds.

All things considered, it seems more likely that this head is a portrait of the Sicilian painter, Mario Minitti (1576–1640), of whom Caravaggio was a very close friend for many years and who probably gave him shelter

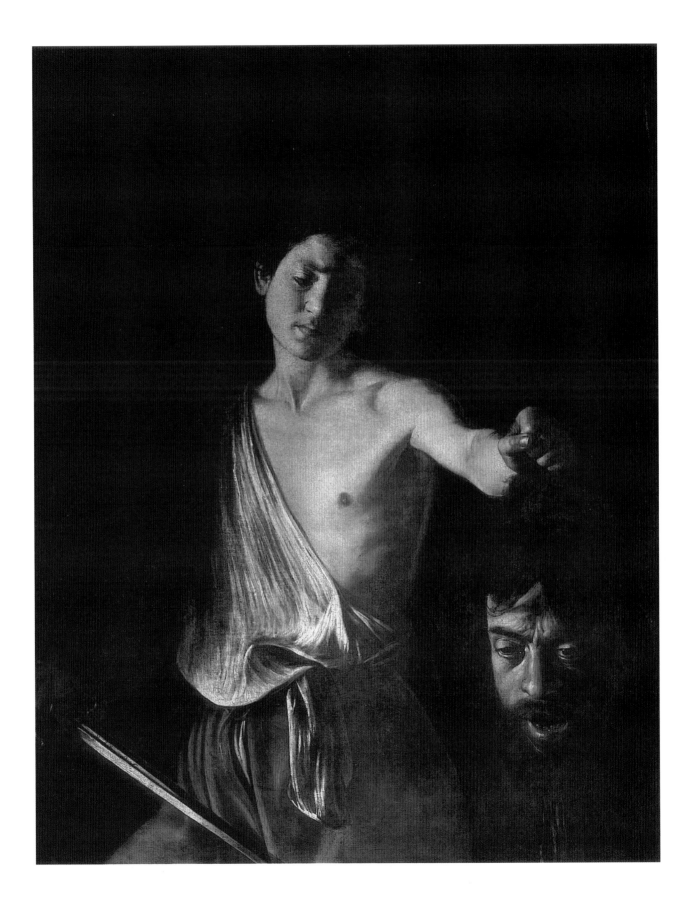

in Syracuse when he was fleeing from the Knights of Malta.

The hair, if not the complexion, argue in favor of this. In "La Pittura Trionfante", Venice, 1615, Cesare Gigli wrote that with his strange sense of humor Caravaggio had pallid features and thick hair, that he was extremely tall and sturdy, and had bright, deep-set eyes.

Caravaggio completed the painting for Cardinal del Monte, a prince of the church of his generation and an important patron of the arts. In it love and wine, the lute and singing combine into an urban Arcadia – but indoors rather than outside under the open sky.

The artist spirits his young men out of the land of Cupid and Bacchus and the temporal distance of myth, then locates them in a rather untidy-looking cultural situation. Caravaggio was the first artist to make effective paintings of violins, and one lies in the foreground. These instruments represent new music of Caravaggio's generation. Song-books tell the young man in the front of the picture what songs and melodies he has to sing. They owe their appearance to the new art of printing.

The clothing Caravaggio paints shows what a sophisticated game he was playing. All the youths are semi-naked. Yet they have not clothed themselves in timeless robes which would have made sure they looked classical. That said, the main figure, the lute-player, is wearing a modern-looking tailored shirt, with thick pleats. The shirt is worn loose, however, and thus does not match the naked knee. This means that instead of innocent nakedness we see a state of undress or a dressed state that is no longer respectable.

From the young man in the shadows near the New York *Lute-Player*, we turn next to two paintings from Caravaggio's early days in Rome. Judging by the facial features, these two paintings, the *Sick Bacchus* (ill. 5) and the *Boy with a Basket of Fruit* (ill. 22), both in the Galleria Borghese, Rome, must also be self-portraits of the artist.

These two paintings both play with the idea of classicism in different ways. One of them alludes to an anecdote about the Greek painter, Zeuxis, and it depicts an anonymous boy along with its real subject, a still life (ill. 22). However, anyone who shows Bacchus, the god of wine, as sick is ridiculing all the old gods (ill. 5). Most art experts see this paradoxical figure as a self-portrait. As seen in the mirror, the artist's painting hand would present a problem, of course – in this picture, the *Sick Bacchus*, that hand does not appear.

This painting is often compared to self-portraits in which Dürer (1471–1528) depicted himself in pain. Others see it as a manifesto of poetic painting in the Giorgione (1476/78–1510) sense against the historical painting of Rome.

Artists paint self-portraits in a mirror since although they depict everything around them the one thing they cannot look at is themselves. One's own features are linked to a secret which classical myth knows in a quite different, terrifying dimension. Only in a mirror can mortals endure to look upon the face of Medusa, because it turns to stone anyone who sees it –

as Perseus found when he managed to overcome the monster.

Art history becomes pure speculation when it claims to see the self-portrait of a young man in a head of Medusa. Yet it is still a fascinating idea. Scholars, at least, are agreed that Caravaggio used a boy, not a woman, as the model for the painting which Cardinal del Monte is supposed to have given to the Grand Duke of Tuscany, Ferdinando de' Medici (ill. 6).

If this face were a self-portrait the artist would not only have combined shield and mirror into one entity but would have also seen his own features in the mirror, instead of the head of Medusa. A stroke of genius – the genius that is *stupor mundi* (that which astonishes the world) – might have inspired Caravaggio to take this step. Seeing one's own nature as something horrifying is certainly not beyond an artist who, like Caravaggio, has led a life marked by outbursts of violence and arrogance.

A totally different kind of horror distorts the features of a head in the *Martyrdom of St. Matthew* (ill. 8). This face is generally accepted as a self-portrait by Caravaggio because the features accord best with Ottavio Leoni's drawing (ill. 7). The face's serious, agonized features express the helplessness of someone who cannot prevent the murder.

It is more problematic to follow the widely held belief that Caravaggio also executed a self-portrait in the *Kiss of Judas* (ill. 70), which turned up in Dublin only a few years ago. In this picture the head in question appears in profile, in other words from a viewpoint the artist could hardly have seen even in a mirror. Caravaggio is also supposed to have mingled with Christ's persecutors, which has led many commentators to see the artist confessing to sin and seeking redemption. If this were indeed a self-portrait the figure holding a lantern would bring the light into the picture and thus play the part most appropriate to the artist, who sees history happening before his very eyes.

A LIFE OF VIOLENCE AND GENIUS

Especially in his period in Rome when his fame was beginning to spread, our main impression of Caravaggio from old documents is that he is a veteran of many battles, constantly making himself conspicuous by virtue of insults, quarrels leading to bloody brawls, illegal carrying of weapons, etc. Modern graphologists have detected the following characteristics in a handwritten note Caravaggio made on 8 April 1606: "violence and generosity, sensuality, pride and desperation when deprived of the place he considers his due, brilliant originality and bravery, stamina and swiftness of response."

According to the two epitaphs which Caravaggio's friend Marzio Milesi wrote after Caravaggio's death on 18 July 1610, the artist was "36 years, 9 months and 20 days old". This would mean he was born on 28 September 1573. He may, however, have come into the

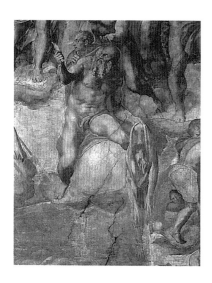

3 Michelangelo (1475–1564)
The Apostle, St. Bartholomew
Fresco
Detail from the *Last Judgment*, Sistine Chapel, the Vatican, Rome

As a sign of his martyrdom, the apostle St. Bartholomew is holding his own flayed-off skin in his hand. Instead of repeating the saint's face on his skin, Michelangelo has painted his own self-portrait there. This unique step may have inspired Caravaggio to depict himself in the hacked-off head of Goliath, the giant.

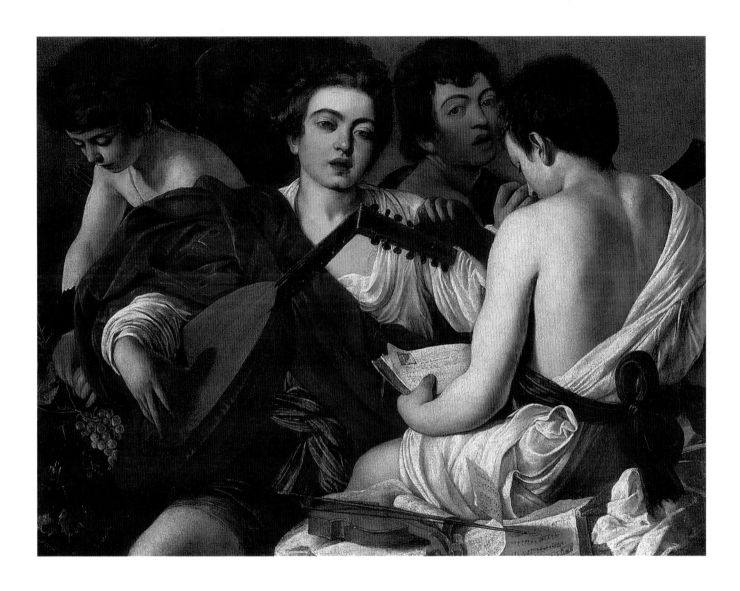

4 *The Concert*, ca. 1595
Oil on canvas, 92 x 118.5 cm
The Metropolitan Museum of Art, New York

A lute-player, shown in the light and dominating the whole
composition, along with a second youth, in his shadow, look
out from a group of young men. The boy in shadow is
holding a crumhorn in his raised right hand. Though he
might well be alluding to the visual artist who has applied his
sculptural skills to this hand. Both boys have been suggested
as possible self-portraits of the artist. They are making music
together with a singer on the right. A fourth youth on the left
symbolizing the god, Cupid, whose curved pipe he is holding
in his right hand is leaning towards a bunch of grapes. The
wings on his shoulders had been painted over for some time,
in order to make the painting look like a pure genre-picture.
Baglione mentions the picture, under the title of *Musica*,
painted for Cardinal del Monte.

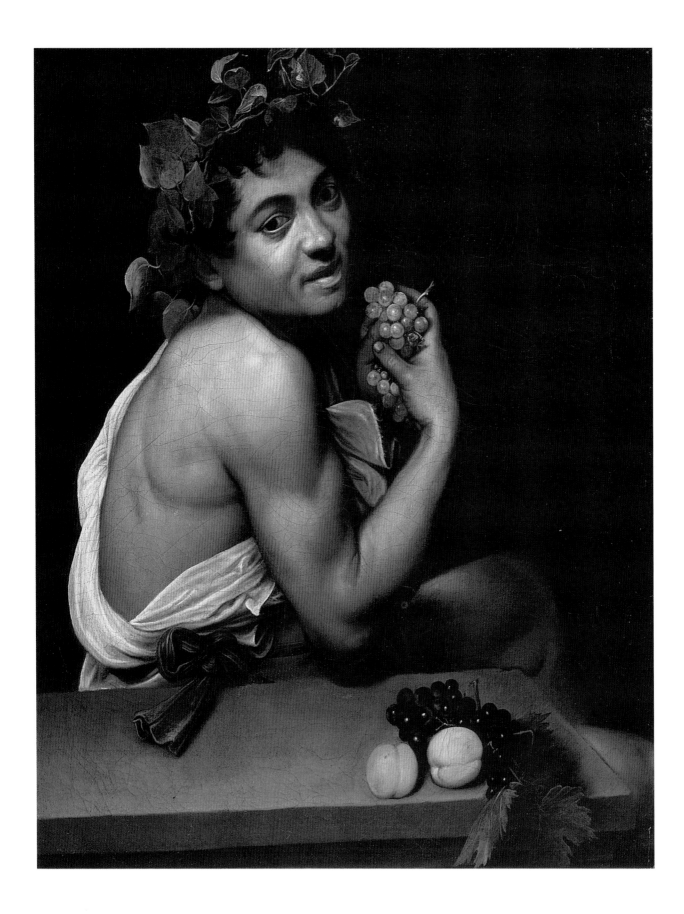

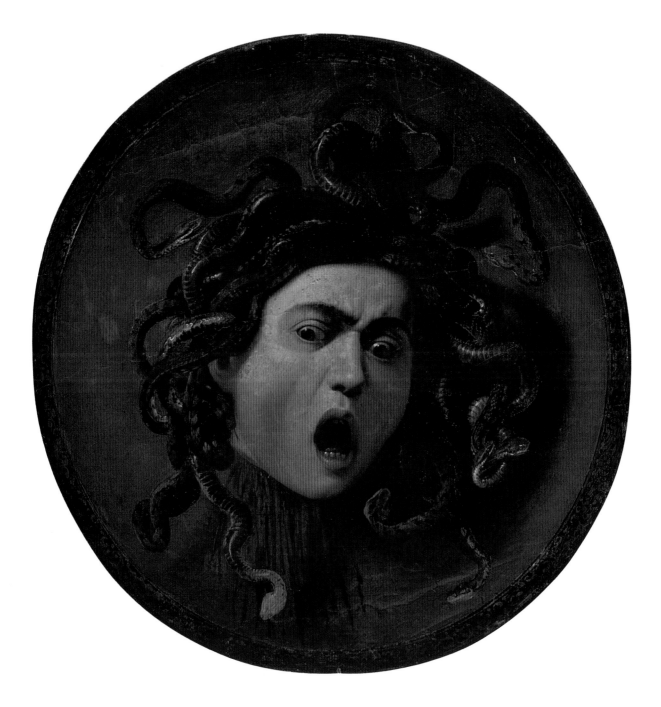

5 *Sick Bacchus*, or *Satyr with Grapes*, 1592–1593
Oil on canvas, 67 x 53 cm
Museo Galleria Borghese, Rome

Behind a dull greenish slab, on which two peaches and a
bunch of brilliantly black grapes lie, a half-naked youth is
crouching. A crown of ivy-leaves – not vine leaves – is
woven into his hair. His face, which he has turned
towards the viewer, looks greenish, as does his whole
body. This explains why – in recent times, at least – the
picture has been given the nickname of *Sick Bacchus*.
Early sources called the painting simply a portrait of a
boy, though later it was said to depict a satyr. It belonged
to the Cavaliere d'Arpino (1568–1640), at whose house
Caravaggio spent a few months from 1592/93.

6 *Head of Medusa*, 1595–1600
Oil on a specially prepared shield covered with leather, 60 x 55 cm
Galleria degli Uffizi, Florence

This time Caravaggio did not paint a standard picture-surface, but a
convex ceremonial shield. This shield from the Medici armory was a
decorative accompaniment to a suit of armor which Shah Abbas of
Persia had presented to the Grand-duke of Tuscany. The myth of
Perseus, who cuts off the head of the monster, Medusa leads to a
curious paradox. On Caravaggio's shield, the head has already been
severed from the body, and blood pours out of the neck. But life has
not yet departed. Eyes widened in horror, the monster looks at the
world one last time, whilst a scream of death is wrenched from its
gaping mouth.

world in mid to late October 1571, since he was the first child of Fermo Merisi and his wife, Lucia Aratori, both from Caravaggio. As there is no documentary record of his birth either in the baptismal registers of Caravaggio for the years 1569 to 1579 or in the appropriate Milan register, we cannot even be sure of his place of birth. After getting married, his parents lived in Milan, and so it is more likely that Michelangelo was born there than in Caravaggio. The family was *petit bourgeois* and owned several smallish estates.

From 1576 onwards the artist lived for a while with his family in the village of Caravaggio, presumably to escape the plague which was raging in Milan. In 1584, however, he returned to the big city. Here he was apprenticed to Simone Peterzano (active between 1573 and 1592) for – so the contract said – four years. Peterzano was not unknown as a painter in Milan, and called himself a "pupil of Titian" (1479–1576). How long Caravaggio stayed in Milan is not certain. Yet from 1589 onwards he was obviously back in Caravaggio. Here, he sold his entire inheritance – his father had died in 1577 – over the next three years. The documents of sale confirm that he lived in Caravaggio until 1592. He may have moved to Rome that year where, in 1593, he spent a short time in the studio of the painter, Giuseppe Cesari d'Arpino, later the Cavaliere d'Arpino (1568–1640). Pictures which dated from his early years in Rome include the *Boy with a Basket of Fruit* (ill. 22) and the *Sick Bacchus* (ill. 5), which, after the Cavaliere d'Arpino's goods were confiscated, became the property of Cardinal Scipione Borghese, the Cardinal's "nephew".

In the following years, Caravaggio earned a living from private pieces of work through which he built up a small circle of wealthy admirers. About 1595 Cardinal Francesco del Monte, a versatile, cosmopolitan man with a strong humanist interest in art and science, gave the painter accommodation in his house. For him Caravaggio painted pictures like *The Cardsharps* (ill. 59), *The Fortune-Teller* (ill. 58) and *The Lute-Player* (ill. 30). Caravaggio probably had del Monte to thank for the commission originally intended for the Cavaliere d'Arpino: the two historical paintings (ill. 84, 86) for the side-walls of the Chapel of Cardinal Matteo Contarelli in the church of San Luigi dei Francesi, Rome.

Shortly after this, in September 1600, the artist received his second public commission: Tiberio Cerasi, bursar to Pope Clement VIII (1592–1605), had acquired a family chapel in Santa Maria del Popolo, and wanted paintings from Caravaggio for both of the side walls. Caravaggio was due to deliver the *Crucifixion of St. Peter* and *The Conversion of St. Paul* (ill. 88) in late May 1601. However, after Cerasi died that same month, the new owners (presumably the Ospedale della Consolazione) rejected the pictures, so that Caravaggio reconceived and repainted them (ills. 89, 92).

Caravaggio received his third important commission in February 1602, with the altarpiece for the Contarelli Chapel. The first version of this painting, *St. Matthew and the Angel*, was also rejected, and Caravaggio had to redesign and re-execute it by September of the same

year. Whilst the first version, which was destroyed in the War in Berlin in 1945 (ill. 95), found an admirer and purchaser in Marchese Vincenzo Giustiniani, the second version, also financed by this collector, is still hanging above the altar in the Contarelli Chapel (ill. 94).

In 1603 Giovanni Baglione (1571–1644), who wrote a biography of Caravaggio and is therefore of great interest to scholars, brought an action for libel against him and two other painters as well as the architect, Onorio Longhi. Caravaggio was imprisoned for a few days, but soon released when the French Ambassador intervened.

Yet such incidents did not lessen his fame as a painter in the least. His services were much sought-after both by private collectors – such as, for example, Cardinal Federico Borromeo, Vincenzo Giustiniani, whom we have already mentioned, Marchese Ciriaco Mattei and the banker, Ottavio Costa – and by church authorities. About 1603/1604, for the Oratorian Church of Santa Maria, Vallicella, known as the Chiesa Nuova, Caravaggio painted an *Entombment of Christ* (ill. 99). In July 1605, however, he had a dispute with Mariano Pasqualino, a notary, over a woman called Lena, "donna del Caravaggio", in which he badly injured Pasqualino. Caravaggio fled to Genoa, but later apologized, whereupon the charges were dropped. He returned to Rome, where, shortly afterwards, the Confraternity of Sant' Anna dei Palafrenieri commissioned him to paint a *Madonna* for the altar of St. Peter's. This painting (ill. 103) stayed in its appointed place only a short time, however, before being given to Cardinal Scipione Borghese .

On 28 May 1606, Caravaggio and his friend, Onorio Longhi, became involved in a brawl during a ball-game. Caravaggio killed one of their opponents. The two friends fled from Rome – the injured Caravaggio probably went into hiding on nearby land owned by Prince Marzio Colonna, whilst Onorio fled to Lombardy.

A document dated 16 October 1606 shows that Caravaggio was now in Naples, where he was already carrying out further commissions. Here, in 1607, he was paid 400 ducats for the *Seven Acts of Mercy* (ill. 106), and in May of the same year, 290 ducats for the *Flagellation of Christ*, formerly in San Lorenzo (ill. 108).

A court record of July, 1607, calling the artist as a witness, shows that Caravaggio was in Malta, where, among other work, he painted the *Portrait of Grand Master Alof de Wignacourt* (ills. 11, 13), and the *Beheading of St. John the Baptist* (ill. 110) for the cathedral. On 14 July 1608 he was made a Knight of Malta "de gratia" (Knight of Obedience of the Order of St. John), and was clearly leading a respectable life. It is all the more astonishing that by December of the same year he had been expelled from the Order. He was imprisoned, but managed to escape, and set sail for Sicily. Here, a close friend from his time in Rome, the Sicilian painter, Mario Minnitti, gave him shelter in Syracuse. Through Minnitti's good offices Caravaggio was commissioned to paint *The Burial of St. Lucy* for the

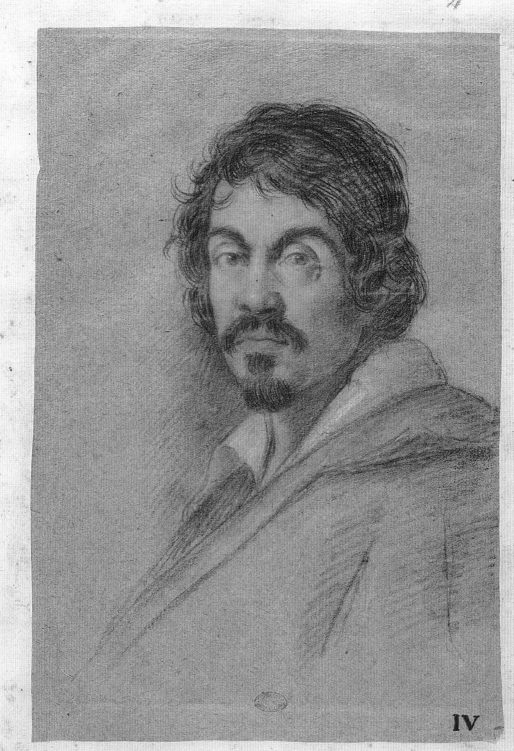

4

IV

Michel: da Caravaggio

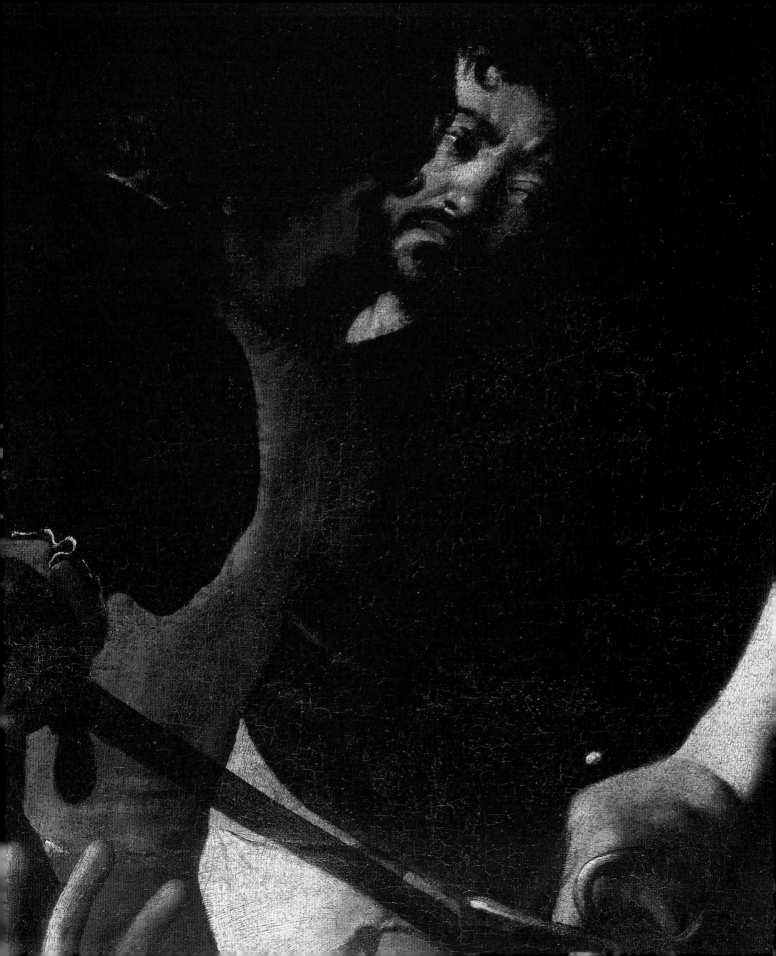

altar of Santa Lucia (ill. 111). He traveled on to Messina, where he painted the *The Raising of Lazarus* (ill. 112) and *The Adoration of the Shepherds* (ill. 113). In 1609, in Palermo, Caravaggio was commissioned to paint *The Nativity with St. Francis and St. Lawrence* (ill. 114). By October of the same year, the artist was back in Naples. Here he was attacked and badly injured in the face, or, as an old document put it: "marked by the knife."

Caravaggio left the city in which he no longer felt safe. Cardinal Gonzaga had prevailed upon Pope Paul V (1605–1621) to grant him a pardon, but this had not yet been officially confirmed. He nevertheless embarked on a ship bound for Rome. After he landed he was arrested – probably due to mistaken identity – by Spanish soldiers, though he was soon released. He continued his journey on foot and in Porto Ercole was afflicted with a fever, from which he died on 18 July 1610.

For a long time scholars thought that they knew the whole situation. Yet in recent times sensational attempts have been made to clarify the mystery of Caravaggio's death. It has been suggested that a mortally insulted Knight of Malta joined forces with the artist's papal pursuers and killed Caravaggio.

EARLY COMMENTATORS ON CARAVAGGIO'S LIFE AND WORK

There is one underlying tone to all the comments written about Caravaggio up to our own day. Anyone who regards the artist highly feels obliged to make a sharp distinction between the personality and the work. This already applies to the first detailed *vita* (biography of the artist) – contained in the Considerazioni sulla pittura by Giulio Mancini, personal physician to Urban VIII (1623–1644), dating from about 1620.

Searches made over the last few years in various archives have unearthed an extraordinary number of direct statements. Among these are commissions for several still extant major works, as well as documents recording payment for and storage of a large number of pictures. Old inventories list the paintings in the possession of the artist's major patrons. In letters and other writings contemporaries give reports about him or individual works by him. A letter from one of his patrons, the Marchese Vincenzo Giustiniani, written about 1620, even goes so far as to advance arguments for an evaluation of Caravaggio, in the context of a systematic theoretical study. Another highly placed owner of a Caravaggio, Cardinal Federico Borromeo of Milan, praised Caravaggio's Milan *Basket of Fruit* in his

"Musaeum", a text published in 1625, as a "unique work of art". This judgment was in fact predated by the fragmentary comments made by Giovan Battista Agucchi between 1607 and 1615, which explored Caravaggio's attitude to nature.

Court records give us information about incidents in which Caravaggio was involved. Evidence given by Caravaggio, Orazio Gentileschi (1563–1639) and others, in the libel action brought by Giovanni Baglione (1571–1644), give us an idea of how the artist used to speak and the competition that existed between them. We are even given a verbatim account of Caravaggio's attitude towards the characters and abilities of his most important contemporaries when he says: "I think I know almost all the painters in Rome... They are almost all my friends, but not all of them are good painters... those who are not my friends are Cesari (the Cavaliere d'Arpino), Baglione, Gentileschi, and Giorgio Tedeschi (Hoefnagel), for they do not talk to me... the following are good painters: Cesari, Zuccari, Roncalli, Annibale Carracci." It is surprising here to see that he considers certain artists whom today we would regard as Caravaggesque, in other words, like him in style, neither his friends nor good painters.

The impression of Caravaggio which later generations developed was derived from a handful of printed texts. They began during the artist's lifetime with Karel von Manders's "Schilderboeck" of 1604. Writings like this seek to establish art theory. Models and so-called *topoi* (traditional conventions) were quoted from classical antiquity – pithy situations and anecdotes which several different artists retail in much the same way. These need not be true as such but must offer the reader concrete criteria.

A writer as early as Karel von Mander described Caravaggio as an eccentric person with a highly exceptional view of art. Most other early commentators also saw him in a critical light. The most important of these is Giovanni Baglione – painter, competitor and litigant. The book he wrote in 1625 or thereabouts was published in Rome in 1642, and called: "Le vite de'pittori, scultori ed architetti. Dal pontificato di Gregorio XIII del 1572 in fino a tempi di papa Urbano Ottavo nel 1642". In his "Microcosmo della Pittura", published in Cesena in 1657, Francesco Scannelli took a detached attitude. Despite his sharp criticisms, however, Scannelli acknowledged the fascination which Caravaggio's work exercised. Another key work was the *vita* most influenced by *topoi*: in Gian Pietro Bellori's "Le vite de'pittori, scultori ed architetti moderni", published in Rome in 1672. At the other end of the spectrum, Joachim von Sandrart's "Teutsche Academie" of 1675 took a thoroughly positive view of Caravaggio's work.

8 *Martyrdom of St. Matthew* (detail ill. 86), 1599–1600

In the panic which breaks out in what first looks like total confusion at the altar, where the apostle and evangelist, St. Matthew, is thrown to the ground and slain, the victim's followers flee in horror. Only one head among several has the features which correspond to a portrait. Almost every authority agrees that this is Caravaggio's self-portrait.

Essential Features of
Caravaggio's Art

9 *St. Catherine of Alexandria* (detail ill. 15), ca. 1600
(1598?)

The young woman who was in the destroyed Berlin
portrait posed for St. Catherine. Since Caravaggio
probably only worked for a short period with the same
models, scholars are able to get clues from them to help
date the artist's works.

10 *Phyllis*, or *Portrait of a Courtesan*, ca. 1600 (1598?)
Oil on canvas, 66 x 53 cm
Formerly Kaiser-Friedrich-Museum, Berlin, destroyed in
the War

A young woman, holding a bunch of flowers in front of
her breast, appears against a dark neutral background.
Her intense eyes are looking almost straight at the viewer,
in dramatic lighting. Although the woman depicted is
more likely to have been one of the artist's models than a
lady from an upper-class house, and was, for a while,
known as Phyllis the courtesan, the painting soon found a
place alongside the Berlin *Cupid* (ill. 31), and the first
version of St. Matthew in the magnificent Giustiniani
Collection in Rome (ill. 94).

THE PRINCIPLE OF PORTRAITURE

The portrait, which developed into a major art form in
both Italy and in northern Europe in the fifteenth and
sixteenth centuries, was not a genre for leading artists in
the two decades around 1600.

The handful of portraits attributed to Caravaggio
are all disputed by scholars except for one. This
exception is a woman's portrait from the collection of
Caravaggio's patron, Giustiniani, whose provenance has
always kept it beyond suspicion. Furthermore, at the
end of the War it was destroyed in Berlin, and that
may be why it is virtually never mentioned nowadays
(ill. 10). The painting did not depict the figure who had
commissioned the picture, but rather a woman who

modeled for other paintings by Caravaggio in historical
costume (ill. 9). She is remembered as the Roman
courtesan, Phyllis. Yet this name has no historical value
because it merely recalls the woman who made a fool
even of the wise Aristoteles.

The idea of simply painting an impressive face as an
end in itself and considering the result a work of art, is
relatively new. Only later generations came to regard
full-length portraits of such people close to artists as
common – to such an extent that Dutch even has a word
for it: "tronye", slang for "face".

Official portraits do not constitute any high spots
in Caravaggio's work. According to Bellori he painted
a portrait of Pope Paul V (1605–1621) which has
been linked with a painting in the Borghese Gallery,
Rome. Two different versions of a portrait of Cardinal
Maffeo Barberini have been attributed to him
with greater confidence. The version in the Galleria
Corsini, Florence, shows the future Pope Urban VIII
(1623–1644) sitting beside a small table with a vase of
flowers, similar to those Caravaggio painted near his
anonymous young men (ills. 26, 27). No such accessory
belongs in an official portrait, which may explain why
this motif is absent from the more impressive version in
a private collection, Florence (ill. 12). *Chiaroscuro* alone,
as well as a limpid palette of earth-colors, combined
with smoothly executed highlights, are hardly enough
to reveal Caravaggio's fiery personality in these
paintings.

Two paintings, considered authentic, which depict
the Grand Master of the Order of the Knights of St. John
on Malta, Alof de Wignacourt (ills. 11, 13), are a quite
different matter. Whilst the half-figure picture in
Florence achieved the high standards of early Baroque
portrait-painting, the monumental portrait in the
Louvre, on whose earth-coloured background the
Knight of Malta's powerful shadow falls, strikes me as
being Caravaggio's most characteristic contribution to
the genre. In one respect the painting demands
comparison with other full-length official portraits like
Titian's *Philip II*. Yet it does not fit comfortably into that
tradition. In other words, wearing that armor, the man
looks like a jointed doll. Caravaggio depicted Alof de
Wignacourt as an arrangement of figure and accessories.

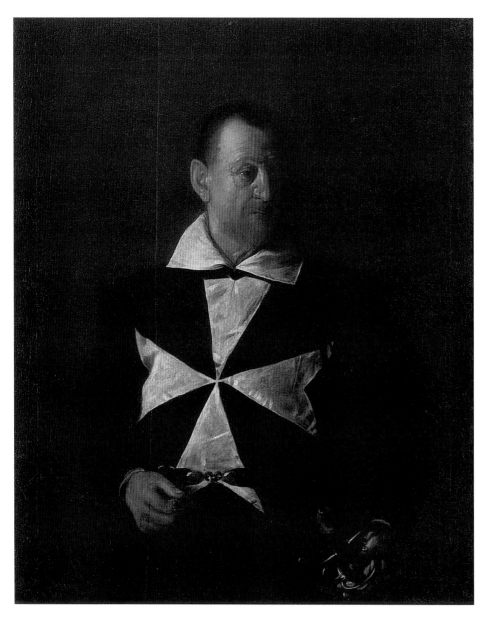

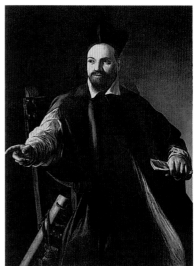

12 *Portrait of Maffeo Barberini*, the future Pope Urban VIII, 1598/99
Oil on canvas, 124 x 90 cm
Private collection, Florence

The still undeveloped features of this young cleric, who later became Pope Urban VIII (1623 – 1644) were portrayed as a much more distinguished figure by the skills of Gianlorenzo Bernini (1598 – 1680). Here, the face appears in *chiaroscuro* against a neutral background in such a way that a wall appears to be screening off the figure from the left. In order to give the figure more *rilievo*, or more three-dimensionality, the lit sections are painted against a dark, and the sections in shadow against a light, background.

13 *Portrait of Alof de Wignacourt with a Page-boy*, 1608
Oil on canvas, 195 x 134 cm
Musée du Louvre, Paris

The Grand Master of the Knights of Malta, wearing armor and wielding a heavy staff of office, has come in from the left, gently illuminated, and standing against a neutral background which marks no division between wall and floor, but which suggests a wall on the right. His standing leg forms the midline of this unusual composition. The right-hand side of the picture is dominated by a pallid boy, who is bringing in the helmet with a ceremonial plume. Many present-day experts doubt that this is an authentic Caravaggio. This is partly because it is historically inaccurate – Alof de Wignacourt's armor, which is preserved in Malta, looks different. And it is partly because the spatial layout is inconsistent. However, since the Knight of Malta looks younger here than in the Florence portrait, a Caravaggesque painter must have strayed on to the island before his master.

11 *Portrait of Alof de Wignacourt*, 1608
Oil on canvas, 118.5 x 95.5 cm
Palazzo Pitti e Giardino di Boboli, Florence

Caravaggio's flight from Rome drove him first to Malta, where he quickly got to know the Grand Master of the Knights of Malta. The Grand Master playfully rests his left hand on his sword in its sheath, whilst in his right hand he is holding a rosary. The artist subtly dramatizes the contradiction between piety and brutality by the lighting and the fact that his subject is averting his eyes from the viewer. Only very recently was this painting identified in the gallery's storeroom, and related to a reference in Bellori's book of 1672.

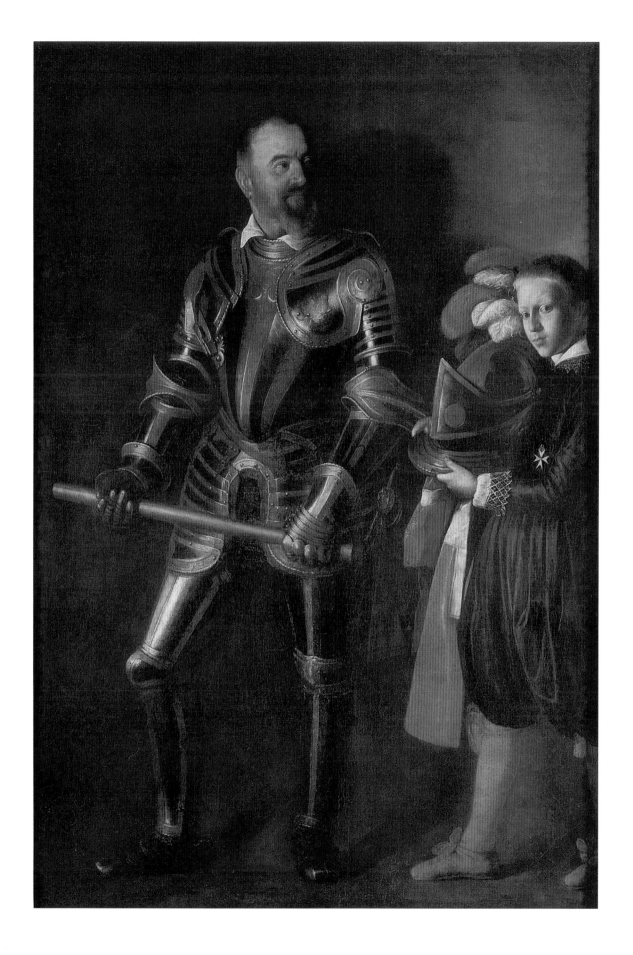

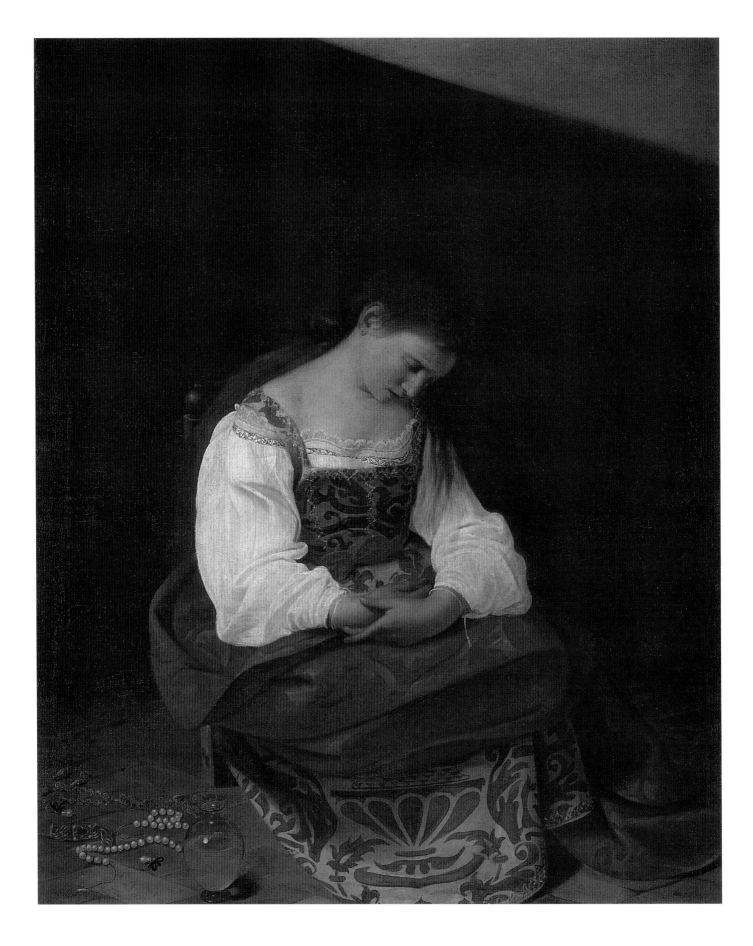

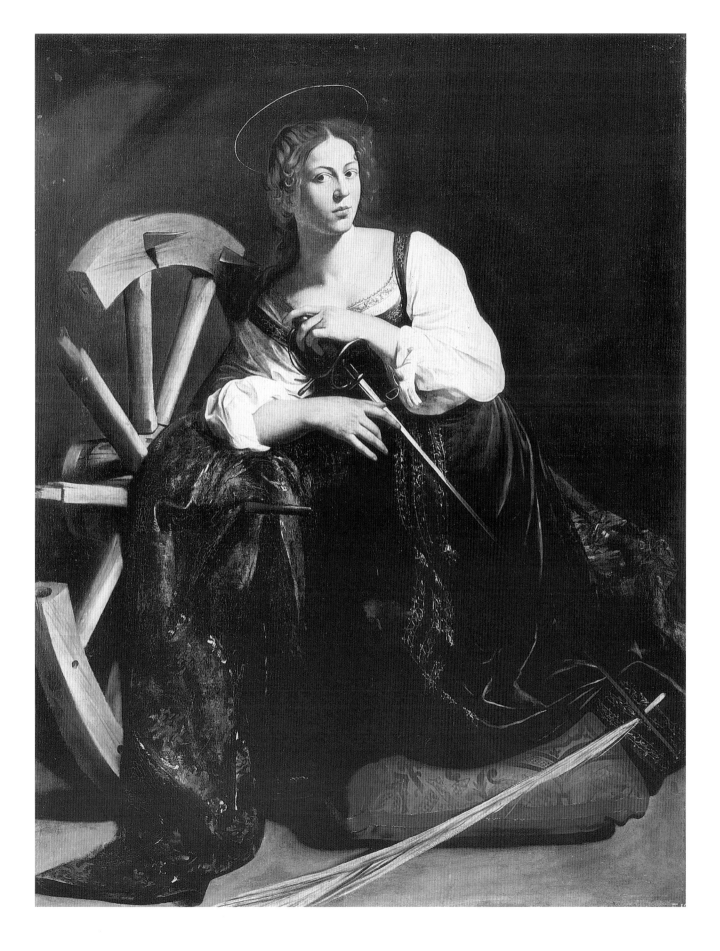

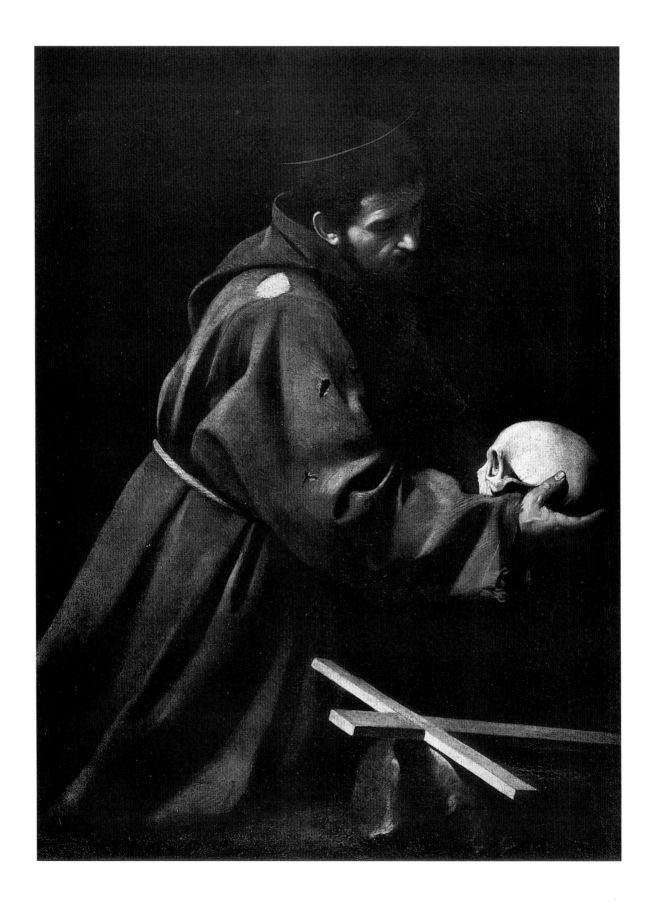

14 (previous double page, left)
The Penitent Mary Magdalene, ca. 1595
Oil on canvas, 122.5 x 98.5 cm
Galleria Doria Pamphilj, Rome

The Mary Magdalene who is mentioned in the Bible only
became a person in her own right in later legends.
According to these, she anointed Christ's feet with
ointment in Bethany, asked him to raise her brother,
Lazarus, from the dead (ill.112), and was the first person
to meet him after his resurrection. Even so, because of her
dissolute former life (cf. ill. 62), she was redeemed only
after a hard process of atonement. In this picture, portrait
in the usual sense and in the sense of a saint's portrait,
come to the same thing. From the young woman's
dejected self-absorption Caravaggio is able to achieve an
expression of human tragedy.

15 (previous double page, right)
St. Catherine of Alexandria, ca. 1600 (1598?)
Oil on canvas, 173 x 133 cm
Museo Thyssen-Bornemisza, Madrid

St. Catherine of Alexandria cannot be depicted as casually
as Mary Magdalene. This princess from Alexandria was a
proud woman of great learning. She defied martyrdom on
the wheel several times by breaking it, and finally had to
be put to death by a sword. A young woman does not
normally go around with a broken wheel and
executioner's sword – nor with a palm–frond, which lies
in the foreground between the viewer and the saint.
Caravaggio's vision is more artificial here. He has no
qualms about adding a halo to emphasize the rapturous
expression of this majestic head.

16 (opposite) *St. Francis*, ca. 1605
Oil on canvas, 128 x 94 cm
Chiesa dei Cappuccini, stored in the Galleria
Nazionale d' Arte Antica – Palazzo Barberini, Rome

The founder of the Franciscan Order was the first person
to experience the miracle of stigmatization on his own
body. In other words, he was marked out by Christ's
wounds. Here, he is reduced to the ideal state of penance
in the wilderness – a state equally valid for saints and
pious people. Caravaggio shows no sign of reinterpreting
the story unconventionally. His rather traditional
approach may derive from the fact that the composition is
probably a commission from the papal family. They
owned the township known as Carpineto, from where an
almost identical second copy, stored at present in the
Palazzo Venezia, Rome, originated. Stylistically, the
painting is very closely related to the Brera *Supper in
Emmaus* (ill. 64), which was probably painted in Latium.

17 (right) *St. Francis*, 1606 (?)
Oil on canvas, 130 x 90 cm
Pinacoteca, Cremona

This seems to be an unconventional composition, and
depicts the saint front-on, near a tree trunk, bending over
a book. Even so, the artist decides not to depict the joyous
devotion to nature expressed in St. Francis's hymn to the
sun. Once again, the artist has reduced the founder of the
Franciscan Order to a simple, ritual model, latterly in the
traditon of St. Jerome (cf. ills. 45 – 48). The sole surviving
example is in bad condition, but it is probably an
authentic work by Caravaggio.

According to Bellori, Caravaggio is supposed to have
set out a painting, which is now in the Galleria Doria
Pamphilj, Rome, as if it were a portrait (ill. 14):
"He painted a girl, sitting on a chair, with her hands in
her lap, drying her hair. He portrayed her (*ritrasse*) in
a room, and by adding a jar of ointment on the floor,
as well as jewelry and gemstones, he made a Mary
Magdalene of her." The author provided this explan-
ation at the start of his *vita*, in order to characterize
Caravaggio's natural *modi* (manner of operation) and his
art of imitation.

As with *Mary Magdalene*, Caravaggio arranged a
figure and still life-like accessories into a picture of *St.
Catherine of Alexandria* (ill. 15). His model for the face
of this full-length painting was the woman Phyllis from
the lost Berlin portrait of that name (ill. 10).

In the history of sacred paintings both these canvases have played an exceptional role. In terms of subject, both the pictures are in fact devotional paintings. Whilst they were not meant to be worshipped as such, they were supposed to give an impression of those figures to whom the pious wished to turn. That said, Mary Magdalene avoids eye-contact with anyone at prayer. Equally, it is difficult to imagine anyone praying fervently before St. Catherine because she regards the viewer in too direct, too earthly a way.

Paintings like these two works by Caravaggio stood at a crossroads in time when both the Church and the art-world became aware of the difference between sacred and gallery pictures. The fact that the Church also distinguished between secular and devotional art can be seen from a statement by the Jesuit, Pedro de Ribadeneira. As early as 1595, he considered that the highest praise for the pious series of pictures in which Juan de Mesa depicted the *Life of St. Ignatius* lay in the fact that this cycle would not be out of place in a collection of other paintings.

But even sacred pictures for pious worshippers were painted within Caravaggio's circle. Among these were several versions of St. Francis meditating, though the authorship is disputed (ills. 16, 17). His meditation on the death's head, with a crucifix on the floor, is executed with a simplicity and anonymity which explain why such pictures were never mentioned in older art literature.

Both versions probably date from the time when Caravaggio first fled Rome. Three related sacred paintings, two of *St. John the Baptist* and one *Penitent Mary Magdalene* were found in the artist's luggage after his death.

THE STUDIO POSE

At about 1600 it was by no means self evident that an artist would simply paint reality in the form of an arranged scene with appropriate objects, then pass off the result as a figure from mythology or religion. Whilst it might cultivate noble religious thoughts to show an ordinary working-class girl as Mary Magdalene, Caravaggio had opened his art to new tendencies in the Roman Catholic Church, which, like the Oratorians around Filippo Neri (1515–1595), did not wish to see saints remotely tucked away in heaven. Instead, they believed that their precursors among ordinary people had their feet firmly on the ground. In mentioning the episode of drying hair, Caravaggio's biographer, Bellori, emphasizes the artist's irreverence. But while doing so, he may be missing a deeper level of meaning which might make this into a very worthy Magdalenic gesture – for, after all, the saint did dry Christ's feet with her own hair.

How consciously Caravaggio sometimes arranged the reality of the studio as opposed to the world of the gods emerges very strongly from the earliest picture about

whose authenticity scholars all agree, the Uffizi *Bacchus* (ill. 18).

To paint this picture, Caravaggio approached his task in an almost brazenly literal way. The boy who modeled Bacchus for him shows he is a child of the city, normally wears clothes and only exposes his hands and his head to the light. He belongs to the same circle of young men who are playing the New York *Concert* (ill. 4). Since upper-class people of Caravaggio's day were conspicuous for the whiteness of their skin, under which veins full of blue blood stood out, the coarse sun-burn on hands and face marks the boy out as lower-class.

The Uffizi *Bacchus* shows even contemporary viewers why older theories of art rejected Caravaggio's work. The canvas reveals the whole process of artistic method. Caravaggio has the classical god represented so crudely by his model that he breaks entirely with his colleagues' game of disguises as he apparently follows it through with a naive disregard for verisimilitude.

The real subject of the painting is neither the world of a Bacchus nor the hardships suffered by a genius who has just arrived in Rome from the provinces and is forced to use local boys as second-rate models. Caravaggio was more concerned to cast off the camouflage of historical painting. He turns ridicule about working in an untruthful way into a manifesto of his own style of painting.

Concentrating on accurate reproduction, this art makes precise imitation of nature decisively important. Even critics like Scannelli, writing in 1657, who think nothing of painting as reproduction, *copia*, are forced to acknowledge that Caravaggio and his school depict the elements of historical painting with such truth, power and vitality that although they are not unequalled, they make the viewers' heads spin with tremendous astonishment.

If Caravaggio's starting-point really was observation of everyday reality, he treated it in a way which pointed to the future. Yet he would have transformed the motif in the process. As the light on the back wall indicates, he has placed the woman in darkness, thus making her linger in the shadows rather than drying her hair in the sun. By depriving the normally well-coiffured woman of her artificial finery, he depicts her in distraught remorse, thrown back on to her own resources. Giving her tears of penitence in her averted eyes, which take no further notice of her discarded finery on the floor, Caravaggio shows her mourning her previous life.

But in art does the kind of everyday reality one can reproduce in paint really touch the world of ideas so closely? Between the historical conditions which a work of art brings about and the fixed projections contained within it, there is surely also an intermediary world of the studio, revealed only to the artist, where the artist's work is what really counts? Let us, for example, consider Caravaggio's Mary Magdalene in the studio.

What concerns the artist first and foremost is neither an anecdote about drying feet with hair nor a meditation on the world of the saints, but the scene's arrangement and how to reflect it in paint.

18 *Bacchus*, ca. 1595
Oil on canvas, 95 x 85 cm
Galleria degli Uffizi, Florence

We hardly imagine the gods of classical antiquity looking like this young man. He is sitting on a bed, at the edge of a table, which, like a bar, offers him a half-empty glass carafe of wine and an earthenware dish full of fruit. The white fabric he has wrapped around himself is draped so awkwardly that we can see the contemporary material of the mattress beneath it. Suntanned on his face and his hands, but otherwise pale, this would-be god reveals himself as a model from the city, affectedly holding an expensive wine-glass.

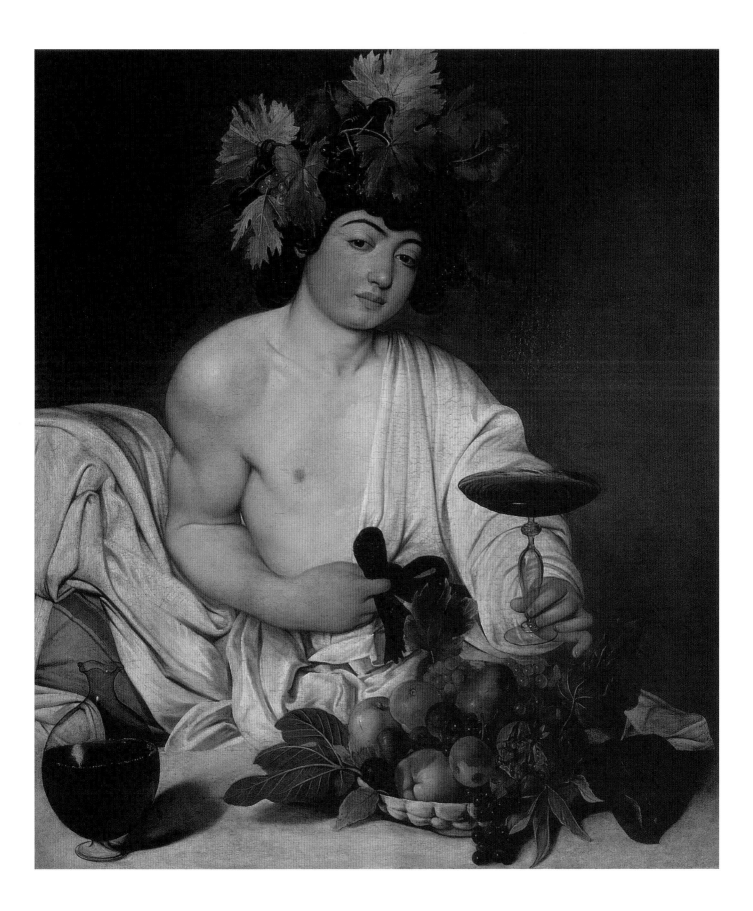

According to André Félibien, Nicolas Poussin (1593/4–1665) held the view that Caravaggio had come into the world solely to ruin painting. As early as 1642 Baglione had expressed the same opinion in his *vita*. Art theorists, particularly, complained about Caravaggio's influence on younger painters, whom he allegedly taught to be satisfied with unadulterated nature as a subject for painting.

As an artist who restricts his painting to confined spaces, Caravaggio certainly strikes contemporary viewers as being very far removed from painting nature in the raw. But for his own day, the concept of being true to nature was still too revolutionary. From the fifteenth century onwards artists had tended to study models in order to paint bodies and motion as well as accessories – but only on paper, not in oil.

In general, artists oriented themselves on the classical painter, Zeuxis (first half of the fourth century BC), of whom Cicero, Pliny and others reported that five of the noblest virgins in Athens were put at his disposal so that he could study their naked bodies and put together an ideal image out of the best features of each – a Venus or a Helen. Such an undertaking demands from the artist not so much humility in the face of accidents of nature as an organizational sense which he must put at the service of visible phenomena.

The example of Caravaggio, on the other hand, was considered a warning against studying nature without preparatory training. A characteristic voice here was that of Charles-Alphonse Dufresnoy's didactic poem of 1668, which, from line 427, runs: "That anyone who begins should not be in too great haste to study everything he wants to do from nature, before he knows the proportions, the arrangement of the parts and their contours, before he has studied excellent originals thoroughly and before he is well versed in the sweet deceptions."

The notion of nature as the real mistress of art also has classical roots. The fact that this was well known is obvious from the comparison between Caravaggio and the Greek sculptor, Demetrios, who thought only nature was valid. This was how Bellori opened his *vita* as early as 1672. Yet Bellori was horrified that, far from selecting only what is worthwhile for art, both artists also borrow nature's vulgar aspects.

Caravaggio derived his energy from portraiture. By a unique form of paradox, an artist who could scarcely have achieved greater fame as a portrait-painter, proved himself by relentlessly reproducing what he saw in front of him. Caravaggio subjugated his entire art to this talent, which Scannelli calls his "instinct for nature", so that he built up something, which art theorists would dismiss as a wrong direction, into a whole system. The very first published book on Caravaggio, Karel von Manders's "Schilderboeck" of 1604, spread the story that the artist never put brush to canvas without having a model in front of him. The most outrageous point here is that he ventured to paint direct from nature in the studio. It was in what he saw in front of him there that he found truth – not in anything ideal or classically correct.

The whole issue of working from a model is more a *topos* than a verifiable fact, because it is clearly impossible to arrange and study everything which could be painted. All the same, Caravaggio's guiding principle: to paint direct from nature explains a special characteristic of his art. Unlike almost all his contemporaries he declined to paint frescoes – thus turning his back on the noblest artistic activity of his age. In a small-scale picture in Berlin, Adolph von Menzel (1815–1905) once painted the crowd that gathered when Antoine Pesne (1683–1757) took a model on to the scaffold with him for an illusionistic ceiling-painting in Rheinsberg. We can see the absurdity of painting direct from nature while engaged on fresco work when we look at the only ceiling-painting that can be attributed to Caravaggio with any certainty (ill. 19). He would have had to dangle between two sets of scaffolding. One to allow him to observe the model from below, and from the other he painted the ceiling. If the picture really is by him, this experience would have taught Caravaggio that this kind of painting was not his métier.

Inventio, that is, invention, was regarded as the supreme quality. *Imitatio*, imitation, was subordinate to it and all that was required of it was to depict the product of some thought in a more plausible way. *Imitatio* was accorded no value in itself. But since objects themselves determined the hierarchy within art, a scale of values developed which judged painting according to its methods and subject-matter.

All forms of imitation were seen as the lowest level of artistic creation. A human being in the image of God was seen as the very highest. Images of humans and the godhead supplied from the sphere of *inventio* crowned the hierarchy, whilst painting the likenesses of inanimate objects was frowned upon as the lowest form of art. In terms of hierarchy, everything else rose higher up the scale according to how animated it was or how far it was removed from pure imitation. The spectrum ranged from still life to historical painting. Even before such hierarchies were established, so wrote Caravaggio's patron, Vincenzo Giustiniani, the artist denied that art was another ascending ladder of difficulty: "Human beings," he said, "were not one jot harder to paint than flowers and fruit."

19 *Jupiter, Neptune and Pluto*, after 1596
Ceiling painting in oil, ca. 300 x 180 cm
Archivio Boncompagni Ludovisi, Rome

This technically unusual picture, which was mentioned by as early an authority as Bellori, is nowadays considered a work by Caravaggio for del Monte, who purchased the building in 1596. It decorates the ceiling of a small room where the Cardinal apparently carried out experiments in alchemy. On his eagle, Jupiter swoops down towards Neptune and Pluto, who are standing at the opposite edge of the ceiling, as if he were making the sky light up with a crystal ball. Any interpretation of the gathering of the gods, seen – unusually – from below, must shift between mythology, astrology, alchemy and even the Christian doctrine of salvation. An oddity in the artist's work, this ceiling painting does not fit into any stylistic category.

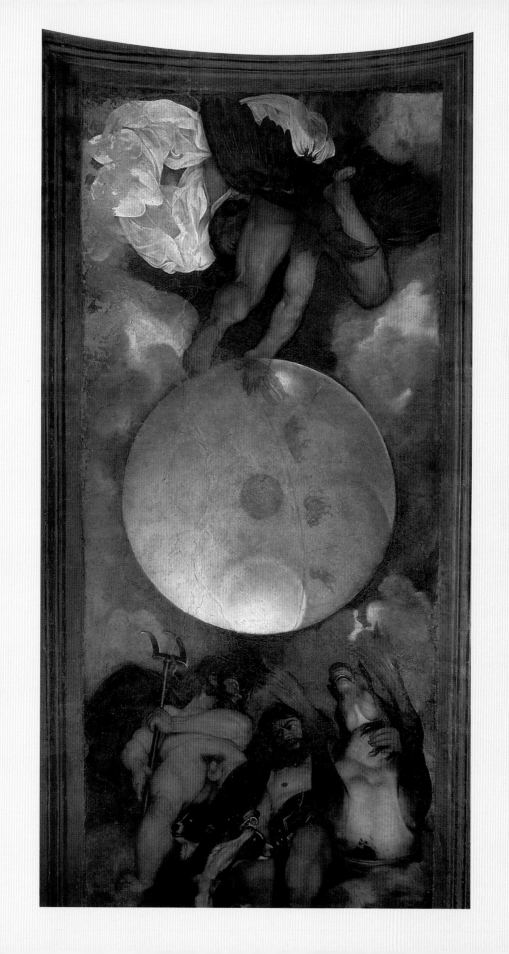

ARRANGEMENTS OF OBJECTS AND FIGURES

The way that Bellori describes the process – naturally not observed by him – whereby Caravaggio made an ordinary girl into a *Penitent Mary Magdalene*, relates to still lifes, not figure-pictures. Here, we need to remember that such pictures of inanimate objects were not automatically a fit subject for art anywhere in Europe at the turn of the sixteenth century. According to Charles Sterling, an authentic still life is born on the day a painter makes the fundamental decision to take a group of objects as a theme and to organize them into a pictorial entity.

Like the French form, *nature morte,* the phrase "still life" principally reflects an artistic process. This combination of words originating from the milieu of art does not mean life that stands still or dead nature, but the reproduction in paint of immobile or dead objects direct from life or direct from nature. Accordingly, like

the portrait, the still life aims at *imitatio.* In other words, Caravaggio's principle of portraiture could just as well be understood as his principle of still life.

Part of Caravaggio's radical break with the artistic practice of *inventio* lies in the fact that he does not base his work on prototypes. According to his biographers, he thought very little of classical artists and even of Raphael (1483–1520). With only a few exceptions, modern art historians also regard his work as being independent of older tradition.

And yet early in his career Caravaggio was in conflict with classical artists. The painter from the small town in Lombardy known as Caravaggio, who so liked to present himself as inexperienced, provincial and uncouth, clearly intervened personally in the dispute between Parrhasios and Zeuxis.

In conflict with this episode from classical antiquity,

Pliny the Elder (before AD 79) gives the following account: "Parrhasios is said to have got into an argument with Zeuxis; the latter exhibited some grapes he had painted so convincingly that birds flew down to the exhibition site. Parrhasios, however, had exhibited a linen curtain he had painted so realistically that Zeuxis, who was most anxious to win the prize, demanded that the curtain finally be removed and the picture revealed; once he saw his error, he awarded the prize to his rival, deeply ashamed, because, although he had been able to deceive the birds, Parrhasios had deceived him as an artist. Later, Zeuxis was said to have painted a boy who was carrying some grapes. When some birds flew down, he angrily said of his work, with the same honesty: 'I painted the grapes better than the boy, for if I had achieved perfection with him as well, the birds would have been too frightened.'"

Even though this classical anecdote makes no mention whatever of still life in the modern sense, from the very beginning, ideas about this genre of painting have kept returning to this episode. That said, Caravaggio was the only first-rate artist to paint the grapes of Zeuxis as well as the boy of Zeuxis.

Whilst the Ambrosiana *Basket of Fruit* (ill. 23) can be regarded as the first unchallenged masterpiece of the still life genre, the *Boy with a Basket of Fruit* (ill. 22) falls between genres. In competition with Zeuxis one could see how the birds responded to the painted grapes in the unprotected basket. If they had flown down to the pure still life, but been scared off by the painted boy in the other picture, then Caravaggio would have triumphed over Zeuxis.

In the case of the *Boy with a Basket of Fruit* on its own, however, it would not have been possible to see whether the human figure indeed scared the birds off or whether the painter failed to achieve the necessary realism.

If Caravaggio really has immortalized himself in the features of the *Boy with a Basket of Fruit*, then he has gone far beyond his Athenian precursor in his competition with Zeuxis.

If, instead of just any boy, he has used his own self-portrait to protect the grapes from the birds, then his own ego must have had a frightening effect.

Both works might be included among those reconstructions of lost classical pictures which have repeatedly been demanded of painters since the days of the humanists – even if Pliny was talking about convincingly painted fruit. Caravaggio's Milan still life was meant to promote its creator as a new Zeuxis, whose imitation of nature surpasses the achievements of an artist very long ago, whom scholars only remember because of Pliny. In his own competition against painters from classical antiquity, Caravaggio is asserting that he could paint human beings with enough truth, energy and vitality to scare off at least birds.

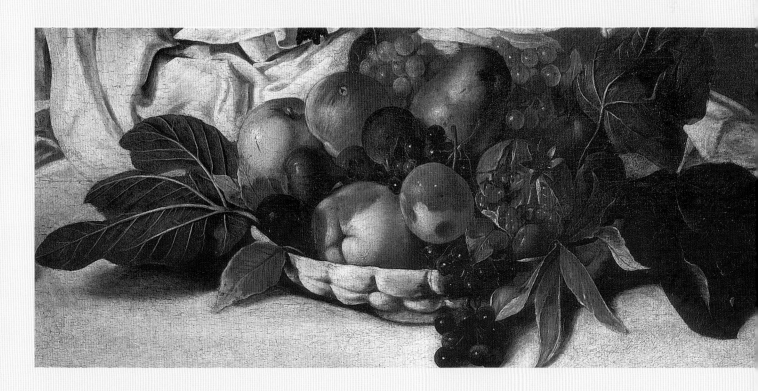

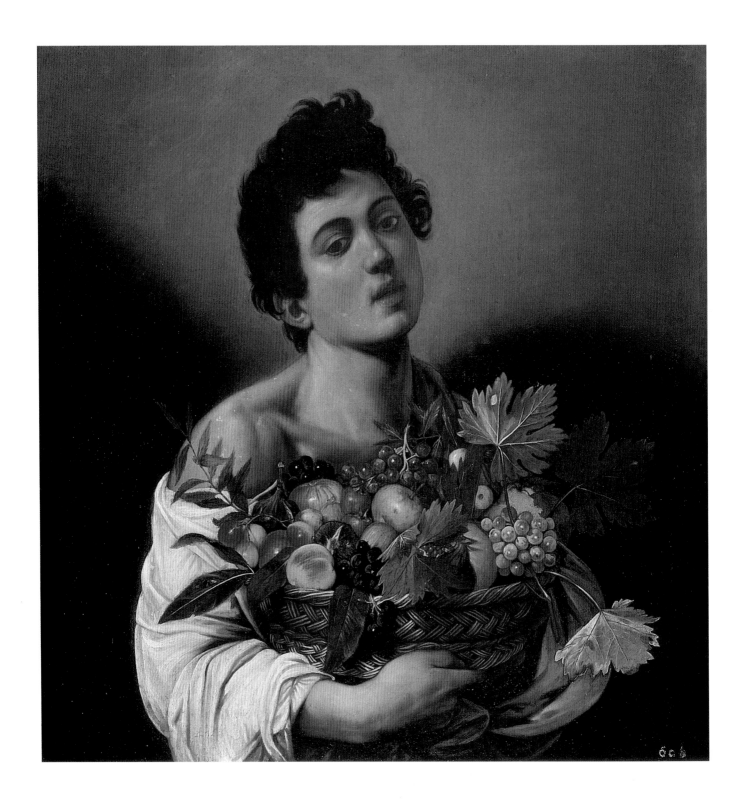

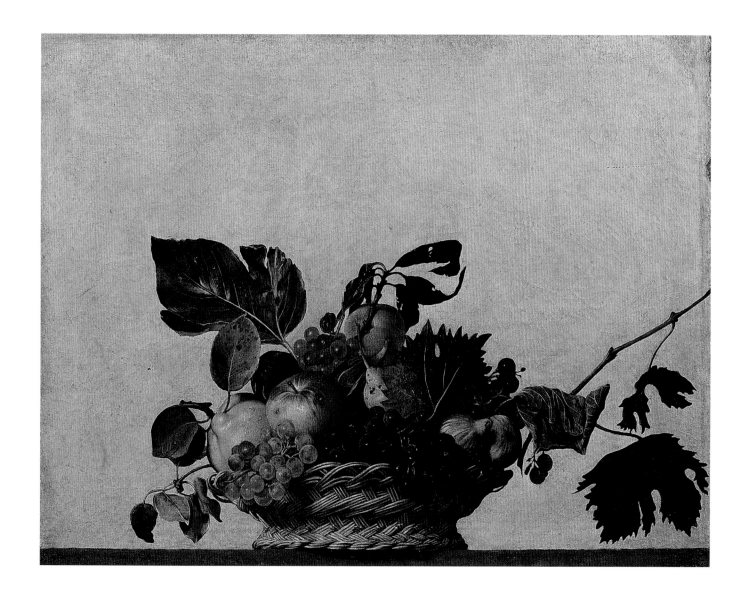

22 Boy with a Basket of Fruit
Oil on canvas, 70 x 67 cm
Museo Galleria Borghese, Rome

Grapes and vine-leaves also dominate this even more
generously filled basket of fruit, which includes not only
apples, peaches and pears, but cherries too. The basket is
the main motif in an arrangement made up of a still life
and a figure. The basket is held by a boy whose white
shirt is falling off his shoulders, thus showing Caravaggio's
sure instinct for skin – even if the musculature is not
nearly as effective as in later paintings. The expression on
the boy's face, which many scholars see as a self-portrait, is
irritating. His lips enticingly parted, and his head thrown
slightly back, the boy's eyes are half-mocking, half-
longing. Two shadows, not cast by any object in the
picture, intensify the bright light around his neck and
head.

23 Basket of Fruit
Oil on canvas, 31 x 47 cm
Pinacoteca Ambrosiana, Milan

A woven fruit-basket, placed on a simple brown line rather than a
badly painted table-top, rises towards the viewer. As well as grapes
and figs, we can see a lemon, a pear, an apple and a peach. Against
the yellow background, which is reminiscent of a distempered wall,
the arrangement stands out principally because the leaves have been
artfully spread out into the empty space. This makes me doubt the
view that the yellow paint is covering a deeper background,
modeled out of light and shadow. What looks at first sight like an
accidental ensemble, arranged merely to create a *trompe l'oeil* effect,
actually follows a careful geometric pattern. In accordance with the
golden section, the basket has been moved to the left. The leaf
projecting on the left follows the same geometric pattern. Even if
the worm-eaten apple reminds us of Eve in Paradise, and a
shriveled-up leaf on the right evokes the transience of all earthly
things, the work's almost abstract character is still most impressive.

Caravaggio achieved a great deal for the genre of still life – with just one picture and accessories in figure painting (ill. 20, 21, 28). Considering the impressive power the painting exercises, all the other still lifes attributed to the artist have until now had no chance of being accepted as genuine Caravaggios (ill. 24).

The Milan *Basket of Fruit* (ill. 23) was a success from the start. Cardinal Federico Borromeo purchased the painting before 1607. Ever since then, it has been a showpiece of the gallery he founded, the Ambrosiana, in Milan. As if he wanted to join battle over the relative merits of different genres, Caravaggio – and we know this from X-ray photographs – brazenly painted his still life over a figure which an inferior contemporary artist had already completed. The brown brush-stroke creating the consummate optical illusion of the Milan basket of fruit makes it abundantly clear that an artist painted this picture, not a mathematician. It gives the basket the rhetorical quality which Jan Bialostocki tried to define as the main distinguishing feature of the Baroque.

Along with Scannelli and other early authors, more recent art historians have seen Caravaggio's development in the following terms: "Caravaggio's formal development takes a remarkably unified, consistent line. Unlike so many of his contemporaries, he did not concern himself with conventional types of picture, but began by concentrating on one type – close-up half-

length figures, which particularly suited his talent for tactile sensuality and intimacy. He learnt not from imitating acknowledged masterpieces but by setting his ends as far away as his means would reach. Step by step he developed from single-figure to multi-figure half-length pictures, and from half-length to full-length pictures. He also moved from appropriate calm through theatrical mobility to dynamic drama. His painting style developed from the soft tones of muted light to spectacular *chiaroscuro* contrasts, and from strongly modeled surface relief to stereometric fullness by way of broader modeling. His formal technique moved on from layered parallel surfaces to geometric spatial structures, and from a dismembered, almost disconnected form of anatomy through an abstract, not always successful, physicality to sensual bodies of flesh and blood, and from simple drapery and still lifes to magnificent costumes, fragrant flowers and fruits, as well as sparkling vessels and jewelry. This development was all the more extraordinary in that it can be only partially explained by the general development taking place in art." (Christoph Luitpold Frommel, *Storia dell'arte*, 1971)

For his early pictures, Caravaggio chose subjects which diverge so sharply from convention that the handful of paintings with traditional subjects hardly fit into his work, despite being related stylistically (ill. 25). It is certainly true that portraits of an artist's

24 *Still Life in the Style of Caravaggio*, ca. 1600
Oil on canvas, 105 x 184 cm
Museo Galleria Borghese, Rome

From a thematic point of view, large-scale still lifes in the Galleria Borghese are similar to outstanding early works by Caravaggio, but they lack the brilliance and the concentration on individual objects. Because it is unconvincing to attribute such work to Caravaggio, scholars distinguish this Caravaggesque painter of still lifes from the master by naming him – after a splendid example of the genre – the Painter of the Still Life in the Wadsworth Atheneum, Hartford.

25 *Narcissus*, ca. 1600 (?)
Oil on canvas, 112 x 92 cm
Galleria Nazionale d'Arte Antica – Palazzo Barberini, Rome

This splendid work simply does not fit in with the idea of Caravaggio's gradual development from still life to historical painting. It depicts Narcissus in contemporary dress but without any accessories. According to Ovid, Narcissus saw his own reflection in a stream and fell so love with it that he never moved from the spot, and thus died, metamorphosed into the narcissus. After restoration in 1995, a fierce dispute about this Roman painting's authenticity arose, as a result of which more people favored its being attributed to Caravaggio. Despite convincing similarities with one of the artist's major works, the *Conversion of St. Paul* (ill. 89), I am not certain that Caravaggio painted this very smooth picture without accessories.

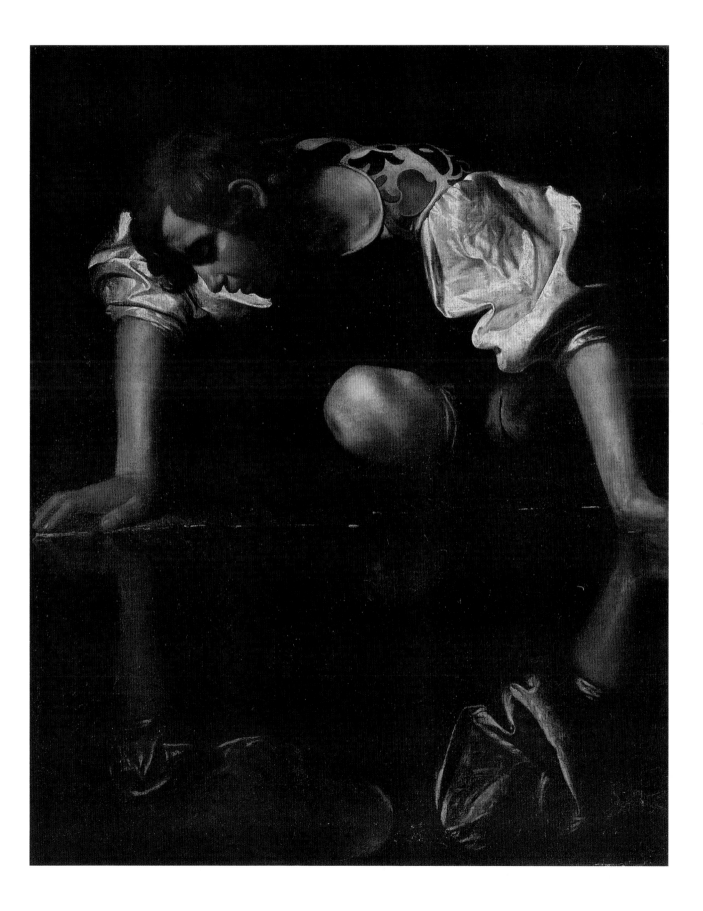

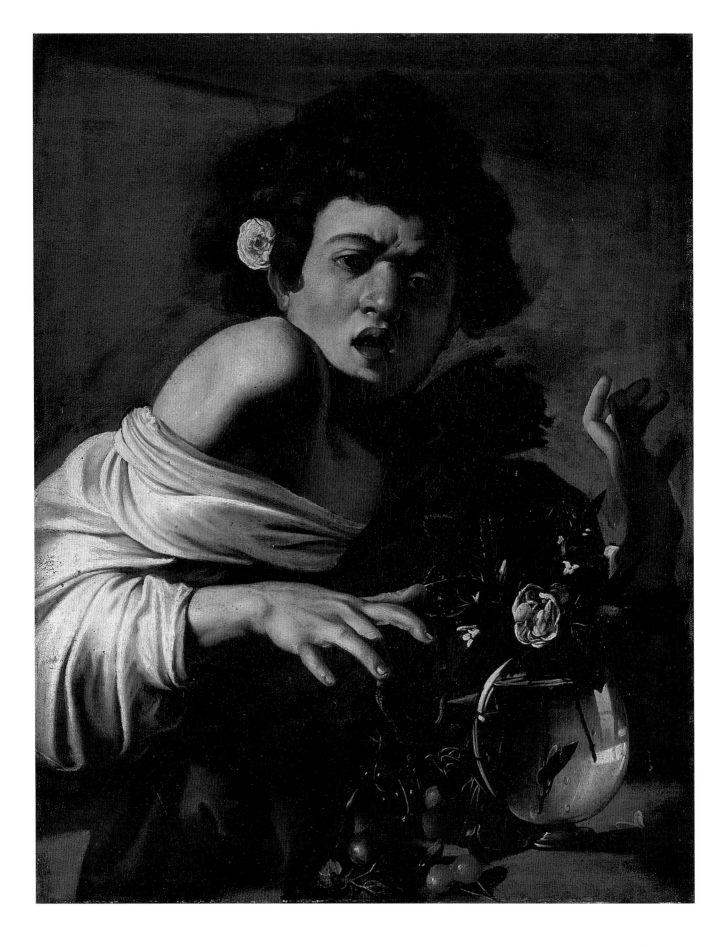

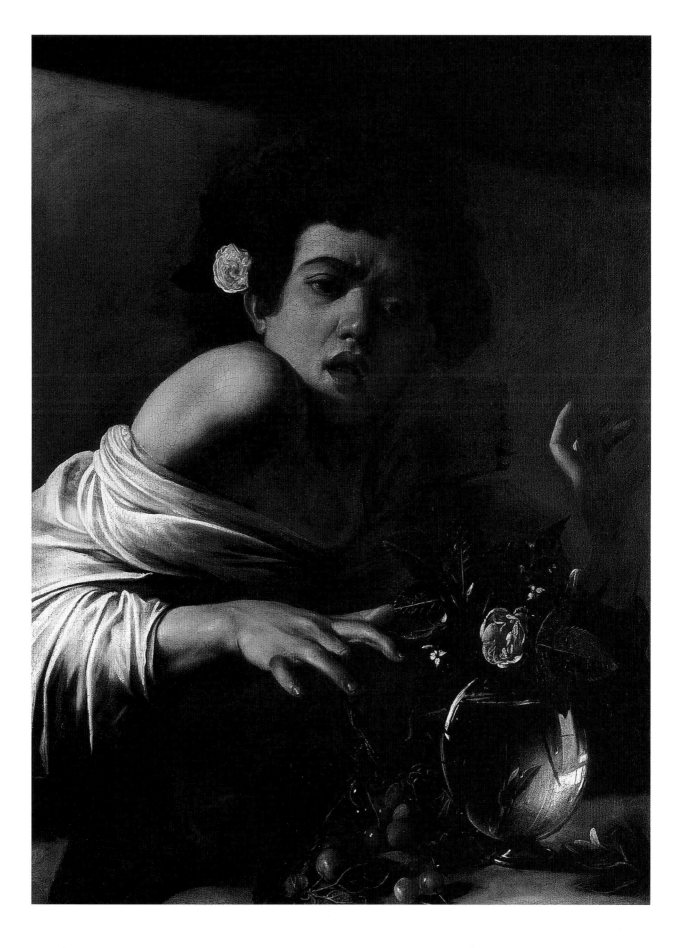

contemporaries, as well as imaginary portraits, had been
part of European culture for a very long time. But in his
half-length figures with accessories, Caravaggio does not
depict any authors, or prophets and sibyls, or even any
embodiments of the Five Senses, the Four Seasons or
other scholarly subjects. Instead, they are groupings of
anonymous figures painted like portraits but arranged
like still lifes with accessories that have no especially
expressive character. Most of them share one essential
feature with the still life: they depict not only flowers
and fruit but also the half-length figures shown life-size.

Looking first at the *Sick Bacchus* in the Galleria
Borghese, Rome (ill. 5), we start with an artist's own
reflection on art, since gods – unlike models – cannot
get sick. We can also find pure genre-painting among
the pictures attributed to Caravaggio. He considered a
Boy Peeling a Peach worthy of painting, even though it
is available only in copies. In a not very good example
whose whereabouts are unknown, a model from the
same circle of boys who posed for paintings like the New
York *Concert* (ill. 4), plays an inattentive market-lad. He
is bitten by a small crab in a wooden tub, in which the
lad has put the crabs ready for sale. Before Caravaggio,
Dutch painters handled such subjects – and virtually at
the same time as him, so did Spanish artists. Nor should
we forget that Bartolomeo Passarotti (1529–1592), as
well as the Carracci brothers, indulged in this Dutch
fashion in their own way in Rome.

We can see how sensitively Caravaggio differentiated
between social levels if we compare the market lad's
coarse expression of horror with the reaction of an
upper-class boy who is bitten by a lizard. He exists
in two good quality examples of the same size (ills. 26,
27). Unlike the *Market Lad with the Crab* but like the
Boy with a Vase of Flowers, owned by the Atlanta Art
Association, Georgia – a version which is probably not
an original Caravaggio – these two paintings are not
representative of any genuine social genre. Rather, they

are artistic products or studies of a particular expression.
Yet they were clearly so successful that, as with the *Boy
Bitten by a Lizard*, the artist reproduced them himself.
The numerous non-authentic versions prove even more
unequivocally that the more personal the subject-matter
of these pictures appeared to be, the more successful they
were with the art-buying public of the day.

At the same time, both pictures show that the artist
studied how to convey instantaneous effects, in order to
astonish a viewer by arrestingly reproducing painful
astonishment. That said, Caravaggio's art achieved its
supreme expression when challenged by music – as the
various versions of a lute-player prove. These copies,
executed by the artist, were meant for two important
patrons of Caravaggio. After the Marchese Giustiniani
had received the St. Petersburg version, Cardinal del
Monte must have ordered a second version, which later
found its way to the Barberini. Caravaggio used the same
figure-study for both versions, so that the artist can have
made only one version from the live model, the second
having been traced from the first.

Caravaggio's meticulous reproduction of musical
notes suggests that he was painting for well-informed
viewers, who would decipher the pictures by way of the
melodies. Certainly, pictures showing half-length
musicians had been traditional since Giorgione. Yet in
Caravaggio's work there is a spectacular degree of
concrete communication.

Thanks to art's astonishing affinity with music, for
Caravaggio we can adapt Horace's formula that poetry
is like painting. Instead of *ut pictura poesis*, we should
say *ut musica pictura*. Together with the human figure,
flowers, notes and instruments are the raw material out
of which he created paintings like pieces of music – as
well as varying them in copies. If two versions of a
picture were original to him, he would vary a once-
observed arrangement in the same way that composers
of his day used variations in sonatas.

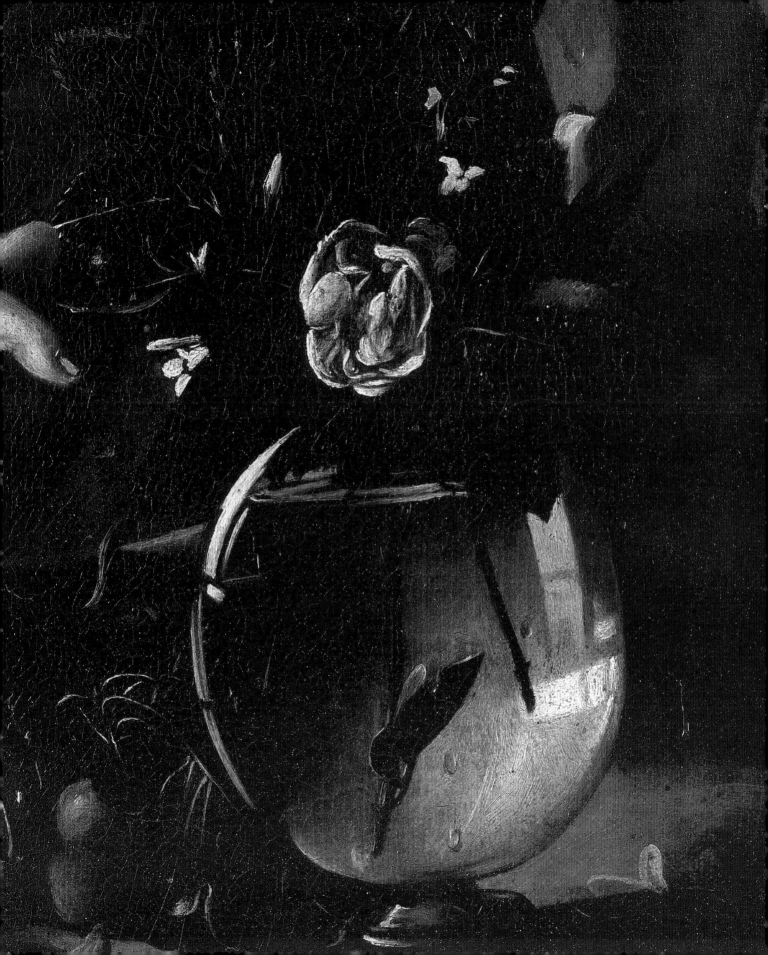

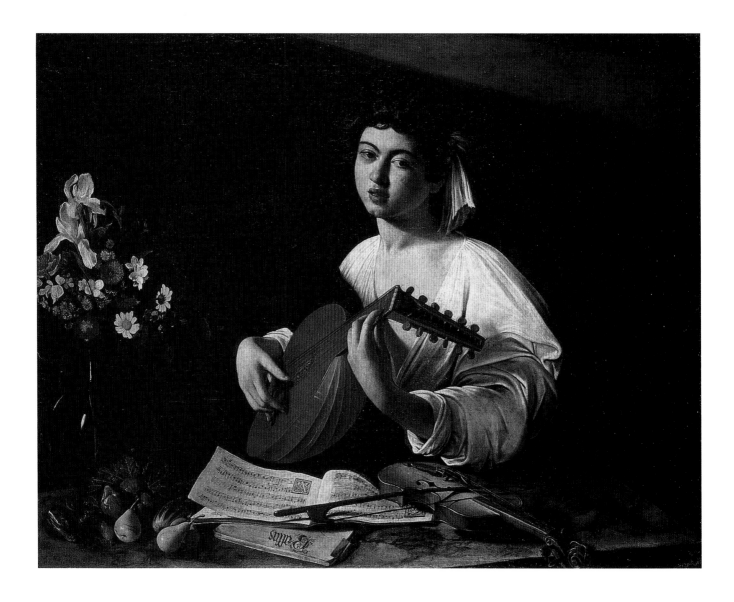

29 *The Lute-Player*, the version for Vincenzo Giustiniani, 1595
Oil on canvas, 94 x 119 cm
Hermitage, St. Petersburg

30 *The Lute-Player*, the version for Cardinal del Monte, ca. 1600
Oil on canvas, 100 x 126.5 cm
Private Collection. Photograph courtesy of the Metropolitan Museum of Art, New York

Two oblong pictures of almost the same dimensions depict a boy with soft facial features and unusually thick dark brown hair, pouting lips, a half-open mouth and a pensive expression beneath sharply-drawn broad eyebrows. His white shirt is wide open at the front, again revealing the artist's intention to paint a nude. This figure has the same dimensions in both pictures, which suggests that Caravaggio traced one on to oil-paper. In this case, only one picture was completed from a fresh study of a model.

A sort of ribbon woven into the figure's hair emphasizes its almost androgynous features. The same applies – in the version in a private collection – to a broad yoke which divides his shirt under his chest like a woman's dress. This is undoubtedly why Bellori saw this as a female lute-player, though recently it has been suggested that the model was a castrato. Light falls from a high window above left, creating a narrow triangle of brightness in the upper right-hand corner. That said, the brightly illuminated figure stands out boldly against the shadowy background.

The strongly foreshortened lute with its bent key-board demonstrates Caravaggio's virtuoso handling of perspective. Tactile elements project towards the viewer more successfully than in the New York *Concert* (ill. 4). As in the Uffizi *Bacchus* (ill. 18), the artist places a broad table-top in front of the figure – in the St. Petersburg

version it is made of marble, and in the other version, covered with an oriental carpet.

The objects in the picture include an open book of music lying on another which bears the inscription: "Bassus" in Gothic script, whilst the body of a violin serves to hold the book open at the right page. In both versions Caravaggio has painted the scores of older compositions clearly enough for us to read them. The music in question is the base voice-part of a popular collection, the "libro primo" of Jacques Arcadelt, which contains other compositions as well as works by this composer. Although the artist has cut off one row of notes, he has reproduced the initial notes so exactly that in the St. Petersburg example we can recognize the Roman printer, Valerio Dorico, whereas in the second version we can see that the book was published in Venice by Antonio Gardane.

In the St. Petersburg version, the message of this music is underlined by our being able to read the opening words of a madrigal. "Voi sapete ch'" continues "io v'amo", so that *cognoscenti* could extend "you know that" with "I love you". The second madrigal is less easy to decipher, because Caravaggio has not shown the book open at connecting pages. The question, "Chi potrà dir quanta dolcezza prova?" is also to do with love, and it continues: "Who can express what sweetness I feel?"

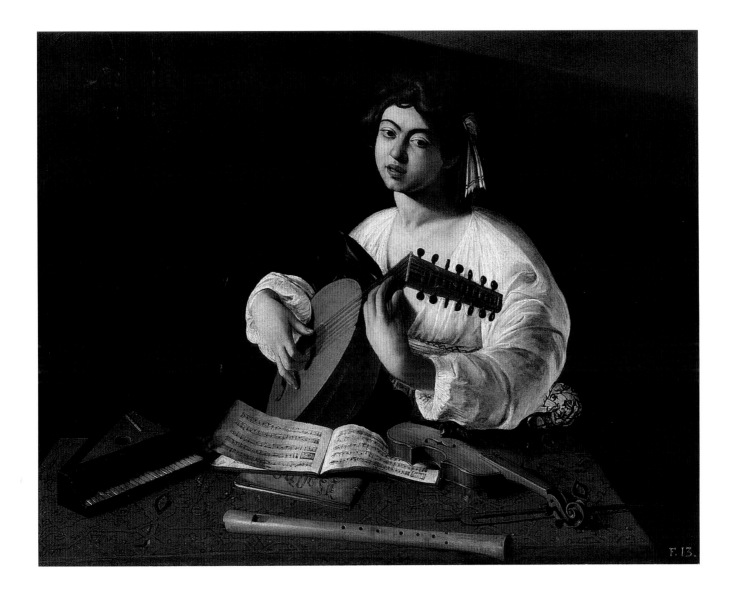

In his version for Cardinal del Monte, Caravaggio combined two other pages. Francesco de Layolle, from Florence, set to music Petrach's sonnet 11: "Lassare il velo", in which the lady is asked "to remove her veil". In the second madrigal, the Fleming, Jacques de Berchem, has adapted an anonymous poem: "Perchè on date voi?", in other words, "Why do you not give yourself?" All these verses are addressed to a woman. Anyone looking for a homoerotic context should also remember that Shakespeare wrote his "150 sonnets" for a young man, of whom he said: "Shall I compare thee to a summer's day?"

In the St. Petersburg picture, the violin bow lies across the strings and the open book of music – a prominent object for the observation of light and shade. In the second version, it is handled in a much less interesting way. Placed underneath the violin-scroll, the bow can scarcely be distinguished from the brownish pattern of the carpet. In this version, a stout recorder and a triangular keyboard instrument are the other objects we see. The x-ray picture shows that they were painted over a still life. The birdcage motif in the left-hand corner shows what unusual motifs Caravaggio liked to select – motifs similar to those preferred by Caravaggesque painters in the Netherlands.

The St. Petersburg version, on the other hand, plays with the motifs of Caravaggio's other early arrangements of still life and individual figures. Pieces of fruit lie on the marble slab, extremely brightly colored and brilliantly painted. A crystal vase contains a bunch of flowers, which would have made even Jan Brueghel the Elder (1568 –1625) jealous. The colors are applied uninhibitedly with a loaded brush – with a richness and precision we do not see elsewhere in Caravaggio's work.

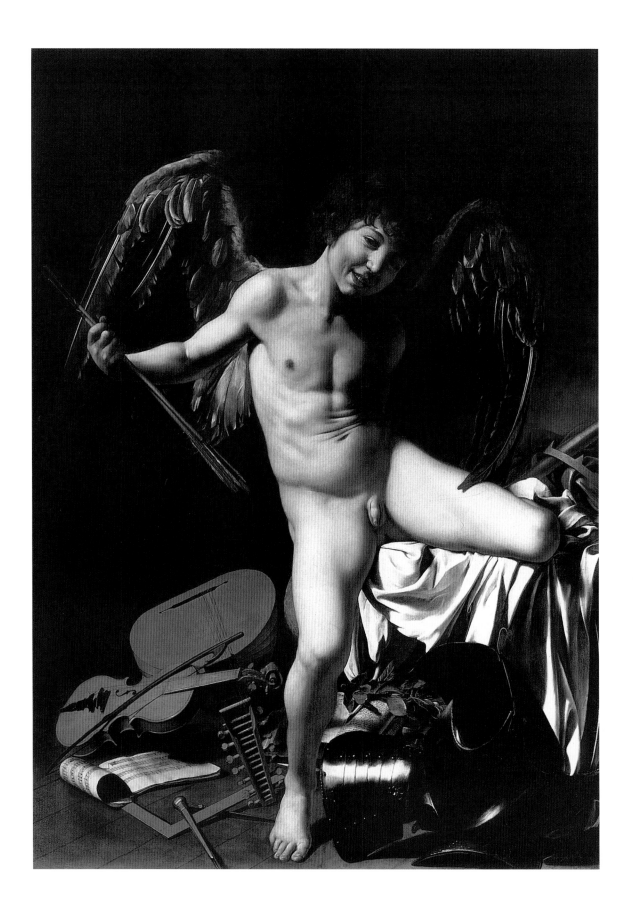

There are other paintings by Caravaggio which relate to classical antiquity. The most beautiful example is the breathtaking Berlin *Cupid Victorious* (ill. 31), which caused such a sensation in its day that Giovanni Baglione (1571–1644) not only brought a libel action against Caravaggio but also attempted to rebuke his competitor in a picture of his own (ill. 32).

The most sensible title for Caravaggio's Cupid is Vergil's phrase "Omnia vincit Amor". In order to show that "love conquers all", the artist proceeded in this picture, painted in 1602/03, to heighten a less than perfect figure into a sublime one. One crucial difference between this and earlier dated paintings with secular subject-matter lies in the picture's size. Caravaggio now depicts full-size figures full-length. No longer draped in any form of clothing, the figure's nakedness strikes many viewers as obscene, since our eyes are directed not only at the young man's genitals, but lower still. It is also odd that Cupid's left hand is concealed behind his body.

The effect of a model posing as a god is again emphasized. The Berlin *Cupid* would be as unwelcome in polite society as he would be in the pantheon of the gods. *Ganymede* by Michelangelo (1475–1564) shows how little guidance on posing this model had at the outset.

The starry globe over which the naked boy is climbing might be a still life object that indicates Cupid's descent from the sky. In the same way, the crown and staff denote worldly power. On top of the armor and the handwritten book which lie scattered on the ground, we can make out a laurel wreath, which is awarded to poets and generals without distinction, and – in the light of Cupid's triumph – equally useless to both. A straightedge and pair of compasses can be seen near the divine model's foot. They stand for proportion in architecture as well as in God's Creation in general. However, they also represent something Caravaggio seems to have totally neglected in his painting: the geometric fundamentals of *disegno*. Caravaggio gives a more prominent place to the art of music, by depicting not only a lute and violin but also a book of music. This provides a mathematical note and leads the eye on to the straightedge and compasses. Paradoxes fascinate the artist. Thus, he depicts intact all the instruments with which people strive after success. Cupid's weapon, on the other hand, is no longer ready for action. The god of love is holding arrows for a bow whose string has broken. In other words, Cupid has either already triumphed or will triumph without any instrument. His body gives him power. The white drapery has fallen – the symbol of Cupid's Victory.

In the Berlin *Cupid*, Caravaggio is not seeking to imagine a myth but to present a model playing a god, whilst elements of still life, placed in front of the characterless studio wall, represent the world at large. Any artist at the turn of the sixteenth century aiming to paint with a brush direct from life without the intermediate step of a drawing, could not work outdoors, because he needed a confined space in which

to mix his colors. Against the dark background of a wall he can more easily achieve what Scannelli calls *rilievo*, a vitality which springs from the three-dimensional energy of painting.

With the Berlin *Cupid*, Caravaggio moved from still life to nude, and therefore to a form of art closely related to still life.

Cupid and nakedness are not a contradiction in terms. Since humanist times, people have believed that the gods of Greece and ancient Rome walked about classically naked. From pagan prototypes the naked figure found its way into the Christian Church. Yet the nude was not uncontested in the sacred sphere. The monumental fresco completed by Michelangelo Buonarotti of the *Last Judgment*, in the Capella Sistina in Rome, of all places, became a canon law-case because of all the nakedness it depicted (ill. 3). As a result, Michelangelo's fresco had to be radically altered by someone painting in loincloths.

This makes it all the more surprising that Caravaggio had so much success with nudes even in religious paintings. It is not only executioners at martyrdoms that he liked to depict almost unclothed – with a pronounced sense of musculature and physical movement. The artist often depicted even saints naked – sometimes without any kind of veil whatever. These figures are meant to be venerated, though not publicly in church. Here, Caravaggio was following an older tradition. In the Galleria Borghese in Rome, for example, next to his picture of *St. John the Baptist* there is an anonymous replica of Raphael's composition (ill. 34), as well as an impressive version by Agnolo Bronzino (ill. 33).

Painting figures full-length, a principle which Raphael (1483–1520) and Bronzino (1503–1572) both respected, was also an essential prerequisite for Caravaggio's paintings on this subject – and four designs are, in fact, full-length (ills. 37, 40, 42, 44). One of the exceptions uses the large format lengthways and finishes just underneath the figure's knees (ill. 39). The effect of four paintings which Caravaggio painted of *St. John the Baptist* in the desert depends on a color combination which was to become almost a trade-mark for the artist and his followers all over the world. Namely: light skin color, strongly brought out of the dark brown background, accompanied by brilliant white and contrasted with a rich red, whose shadows are often almost black in color.

Vegetation remains extremely sparse. All the same, in the earliest *St. John the Baptist* he has painted some marvellous foliage plants (ills. 35, 37). The later the version of this picture – at least in terms of scholarly classification – the more the green disappears. In the latest version, in the Galleria Borghese (ill. 44), vegetation appears only sparsely along the bottom edge.

The finest versions of this subject are astonishing iconographically, because instead of the Easter lamb, which represents Christ suffering the Passion, as an attribute of the Baptist, Caravaggio has painted a powerful ram with strong horns, which John is embracing (ills. 35, 37). The boy's genitals are unmistakably evident.

31 *Cupid Victorious*, 1602/03
Oil on canvas, 156 x 113 cm
Gemäldegalerie, Staatliche Museen zu Berlin –
Preußischer Kulturbesitz, Berlin

Cupid makes his appearance above a still life and some white drapery on a table. He has not descended from above – the picture is too dark in its upper section, and the weight of the body too earth-bound. It looks as if he has just climbed out of bed – yet he is standing by a table. The wing-tip on the boy's upper left thigh is especially impressive. As a silent art, painting produces neither sound nor movement. In depicting this Cupid, as he gingerly stretches one foot out of the disorder of worldly renown and gets his wing in a bit of a tangle in the process, Caravaggio has captured an extraordinary moment of movement. He has also added a tactile note – a gentle rustling of wing against skin.

32 (opposite) Giovanni Baglione (1571–1644)
Heavenly and Earthly Love, 1602/03
Oil on canvas, 179 x 118 cm
Gemäldegalerie, Staatliche Museen zu Berlin –
Preußischer Kulturbesitz, Berlin

How detached contemporary art patrons in Rome were
from pictures' ideological content is indicated by the
juxtaposition of this painting with Caravaggio's Berlin
Cupid (ill. 31). Baglione depicted an angel figure in full
armor, which Orazio Gentileschi (1563–1639) had
already criticized. This angel was shown chastizing a boy
Cupid, painted in Caravaggio's style, with a sword of
light. After Baglione made a gift of the painting to
Cardinal Giustiniani, in 1621 it was acquired by his
brother, the Marchese Vincenzo, and it has remained with
the better-known *Cupid* until the present day.

33 (above right) Agnolo Bronzino (1503–1572)
St. John the Baptist, 1550–1555
Oil on wood, 120 x 92 cm
Museo Galleria Borghese, Rome

Appearing to be full-size, this painting demonstrates the
skill of this Mannerist painter in fitting a brilliant body-
study into a small pictorial space. Artistically, all interest is
on the nude, with the nakedness concealed more by the
way the figure holds his body than the way he plays with
the drapery and the hide mantle. The only symbol in the
picture is the Jacob's staff, in the dark. This is cleverly
foreshortened, and thus not the real message of the
painting.

34 (below right) Raphael (1483–1520), Studio
St. John the Baptist, 1518–1520
Oil on canvas, 165 x 147 cm
Galleria degli Uffizi, Florence (owned by the Accademia)

Raphael depicts the boy Baptist in the wilderness as
a full-size figure. He severely restricts our vision of the
landscape, seeks to build up a strongly three-dimensional
body against the dark background, but allows the viewer a
glimpse into the distance at the rear of the picture on the
right. The lamb is not shown, but the stream indicates St.
John the Baptist, and the banner with inscription, the
lamb of God, even if we can make out only DEI. This
motif was so popular that, for example, an anonymous
version from the late sixteenth century was mentioned in
the Galleria Borghese, where it is still hanging today, as
early as 1613.

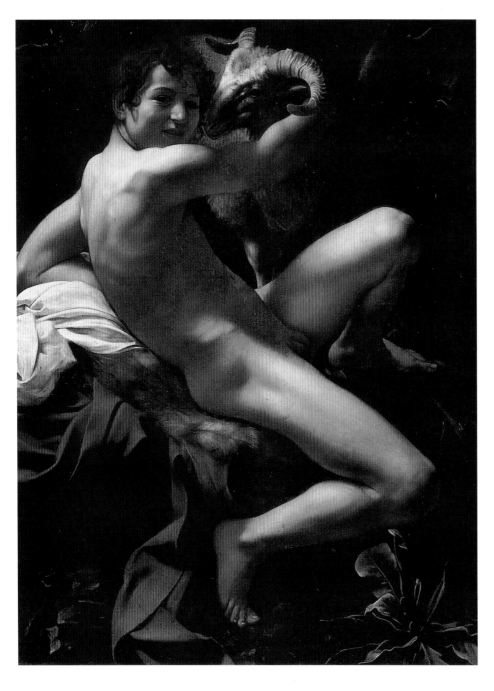

35 *St. John the Baptist*, ca. 1600
Oil on canvas, 129 x 94 cm
Musei Capitolini, Rome

36 Michelangelo (1475–1564)
Youth on the left above the Eritrean Sibyl, 1508–1512
Fresco
Vaticano, Capella Sistina, Ceiling, Rome

Later generations remembered the anonymous boys of the
Sistine Chapel ceiling as *ignudi*. That said, they were
better known through graphic reproductions than in the
original fresco, to which it was not easy to gain access,
since the Sistine was the Pope's private chapel.
Michelangelo used the light solely to reinforce the
sculptural qualities of his strongly drawn bodily forms.

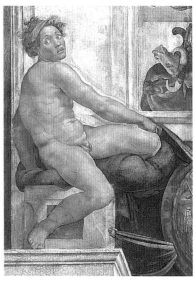

37 *St. John the Baptist*
Oil on canvas, 132 x 95 cm
Galleria Doria Pamphilj, Rome

In this almost identical picture, the totally naked boy sits
leaning far back, like the *ignudi* who adorn
Michelangelo's Sistine Chapel ceiling. Here, he is
propping his left elbow on some white drapery, has
straightened out his left leg behind him, and is supporting
his bent right leg by gripping the toes. A magnificent
piece of red fabric provides pictorial ornament, at the
bottom on the left. The Baptist's body is so firmly
embedded in the yielding hide of his coarse garment that
the energetically black contours from his upper thigh to
his back stand out in a clear flow of lines. With his right
arm, the boy is reaching for a ram which has suddenly
materialized from the depths of the picture. Its nose and
mouth are nearly touching the smiling boy's cheek.

Caravaggio clearly based the figure on Michelangelo's
example, though he painted it according to his own
principles of working direct from a living model. The
figure does not reveal the great Florentine's feeling for
musculature, but the vigorous contouring of his back
shows his influence. Caravaggio is likely to have used a
study here. With great skill and his instinct for dynamic
action, Caravaggio has placed the carefully built-up body
in such a way that the figure's left elbow almost bumps
against the edge of the picture. Otherwise, however, the
figure is completely free. This enables the apparition in
the light to develop dynamically from top left towards the
right.

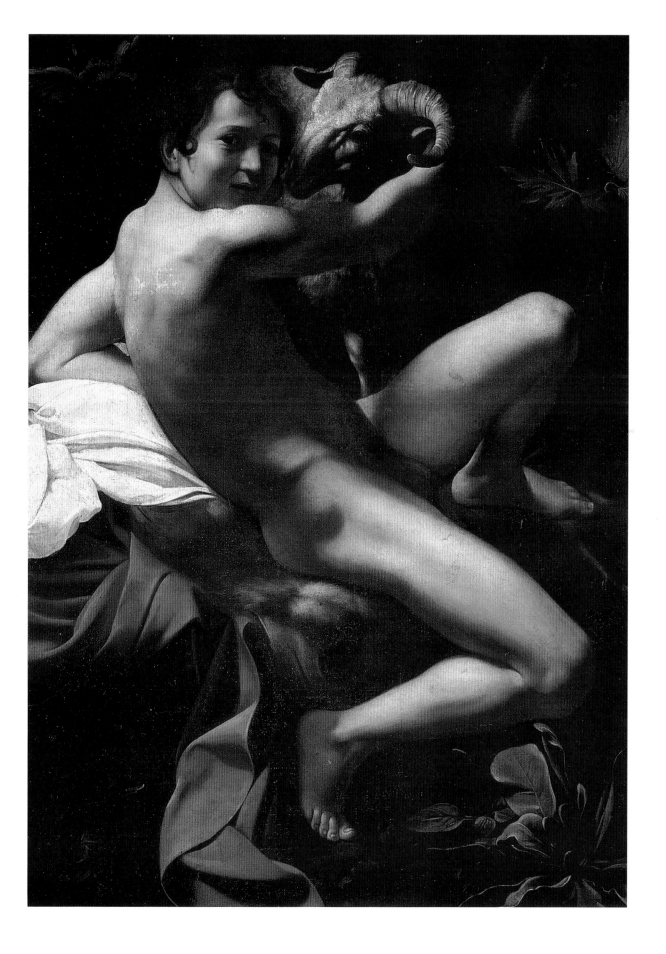

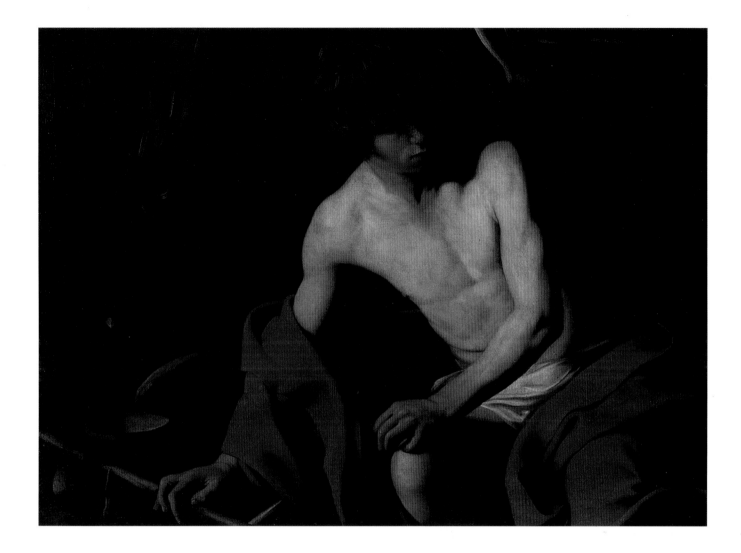

38 *St. John the Baptist*, ca. 1600
Oil on canvas, 94 x 131 cm
Galleria Nazionale d'Arte Antica – Palazzo Barberini,
Rome

In the oblong version in Rome, the Baptist is sitting in
front of some somber tree-stumps, without any sign of
dignity or saintliness. He is reaching towards the left for
his Jacob's staff. In the process, he abruptly swivels to the
right, as if he has suddenly noticed a danger in the
wilderness. His not very attractive body, with its slack
stomach-muscles, defies normal conventions of taste –
not only because of his crude suntan. Caravaggio's work
on the model is the only thing which makes this
unappealing picture an artistic sketch of first-rate quality.

39 *St. John the Baptist* (detail ill. 38)

The expressionless face, which is averted from the viewer,
demonstrates Caravaggio's tendency to avoid ideals of
beauty, which older art theorists regretted as an overhasty
choice.

Even the very earliest picture of the Baptist (ills. 35,
37), in which Caravaggio concerns himself deeply with
Michelangelo's *Youth on the left above the Eritrean Sybil*
(ill. 36), is divided more clearly by light and shade than
by the musculature.

The nude in the Kansas City *St. John the Baptist*
(ill. 40) also takes issue with Michelangelo. The black
shadows which the vigorous *chiaroscuro* projects on to
the model's pale skin introduce structures into the
composition which do not originate from the *disegno*,
but create a color phenomenon out of the light. In
Florence, artists had spent a long time in front of
Michelangelo's works, viewing them with their critical
graphic insight and making an extensive study of the
anatomical construction of the male body. After all this,
Caravaggio's *chiaroscuro* offers a Venetian element which
is often virtually intersected by the structure of the less
fully developed body.

The version in the Galleria Nazionale d'Arte Antica
(ill. 38) reveals itself to be a study of motion in the nude.
This time the model's nakedness strikes the viewer as

almost vulgar. After Caravaggio painted a boy in the
earliest version, for the next two versions the models
who pose for him are young men. Caravaggio clothes
them both in a coarse robe and red cloak, leaving only
the upper body above the navel and one leg uncovered.
There is no sign of a lamb or a ram in either picture.

With its depiction of a situation in the forest which is
left to the viewer's imagination, the oblong picture in
Rome represents a kind of pastoral genre. In a
composition which Caravaggio made on Malta in 1608
or possibly during his second stay in Naples in 1610 (ill.
41), he puts himself even more intensively into the
situation of a hermit.

I would date the painting owned by the
Kunstsammlung, Basle (ill. 42), much later than the two
studies in motion after Michelangelo and the small-scale
genre picture on Malta. I make a point of this because
older art literature is entirely ignorant of it . This picture
does not have the powerful red color of the other
paintings of *St. John the Baptist*. The kind of boy who
modeled for the picture is not typical – and even less

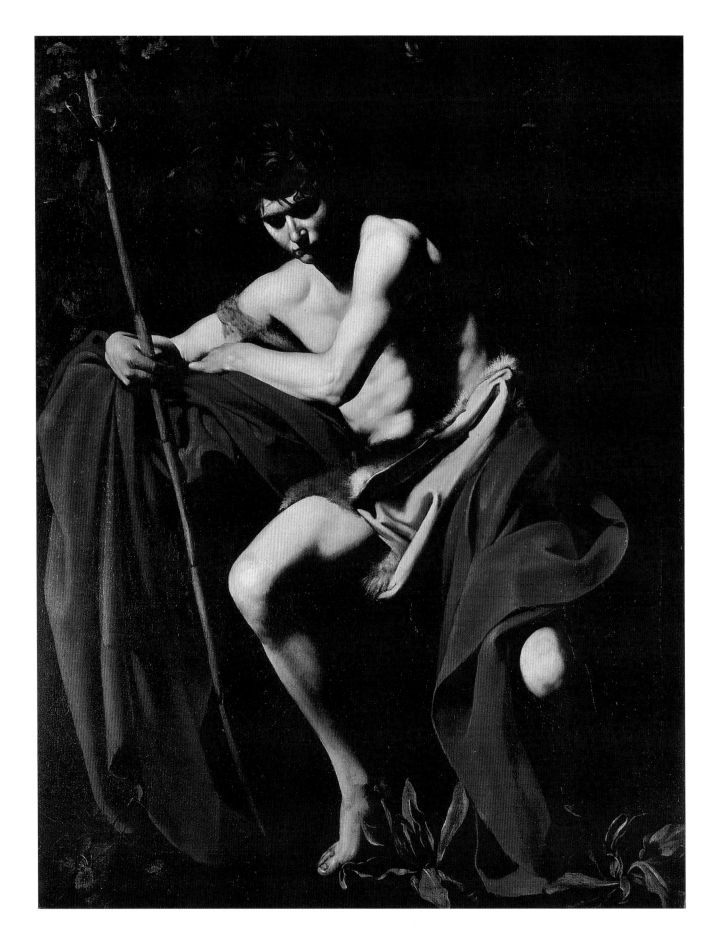

40 *St. John the Baptist*, ca. 1600
Oil on canvas, 173 x 133 cm
The Nelson-Atkins Museum of Art, Kansas City

In a remarkable variant of the arrogant boy on the left
above Isaiah in Michelangelo's Sistine Chapel ceiling, this
Baptist is almost an adult man. The eye-sockets of this
figure, who is meditating with his head lowered, are
darkened by a black just as deep as the background, in
which a few leaves of vegetation are suggested. This black
background, which the figure has not quite filled, and
which was later to take up more space in paintings by
Caravaggio, has been tested out and found to be effective.
Swinging his arm a long way back, St. John is supporting
himself, as if exhausted, on one of the rocks that is
covered with his red cloak. He is holding a large bamboo
cane. The small crossbar, which turns it into a Jacob's
staff, is so much in shadow that only *cognoscenti* will be
aware of its existence.

41 *St. John the Baptist at the Well*, 1607–1608 (?)
Oil on canvas, 73 x 100 cm
Collezione Bonello, Malta

Hardly any expert has ever seen the original of this
painting. It is said to be distorted by heavy repainting.
This composition, so the argument goes, is unique in
Caravaggio's work. Equally, the opening of a vista on to
landscape high up is supposedly just as unusual as the boy
leaning forward towards the viewer. In no other picture
does Caravaggio use water to indicate the Baptist.

42 (following double page, left) *St. John the Baptist*,
1609 (?)
Oil on canvas, 102.5 x 83 cm
Öffentliche Kunstsammlung, Kunstmuseum, Basle

This painting does not fit into the artist's series of other
St. John the Baptist paintings. Only a few experts accept
it as a genuine Caravaggio. Like the Madrid *David and
Goliath* (ill. 43), its colors are muted. A banner with
writing on it, which is wound around the unusually well-
defined Jacob's staff on the ground, has an inscription
which, although the artist twists it skilfully, can easily be
read as: AGNUS DEI, the lamb of God. Together with
the Christmas Picture of San Lorenzo in Palermo
(ill. 114), this painting possibly represents a late phase of
the artist's creative work.

43 (following double page, right) *David and Goliath*,
ca. 1609 (?)
Oil on canvas, 110 x 91 cm
Museo Nacional del Prado, Madrid

Another of the paintings which is difficult to classify in
Caravaggio's total work, is this youthful David, who is
kneeling on Goliath's corpse and is in the process of
gripping the giant's severed head. Observing this kind of
process would normally be the province of a book-
illuminator. Making this observed moment so
monumental is just as irritating as the crude
foreshortening. Caravaggio uses the pictorial space, into
which the youth fits only because he is bending down at a
right angle, in the same way as he does in his *Conversion
of St. Paul*, in the Cerasi Chapel (ill. 89). In terms of
colors, the painting matches the Basle *St. John the Baptist*
(ill. 42) from Caravaggio's time in Palermo (?).

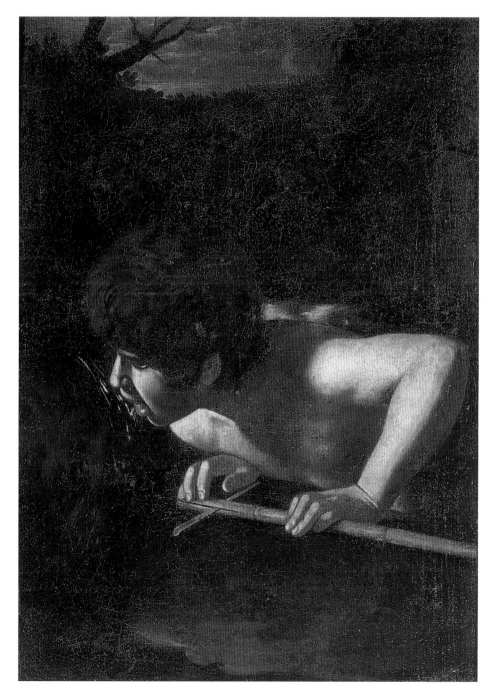

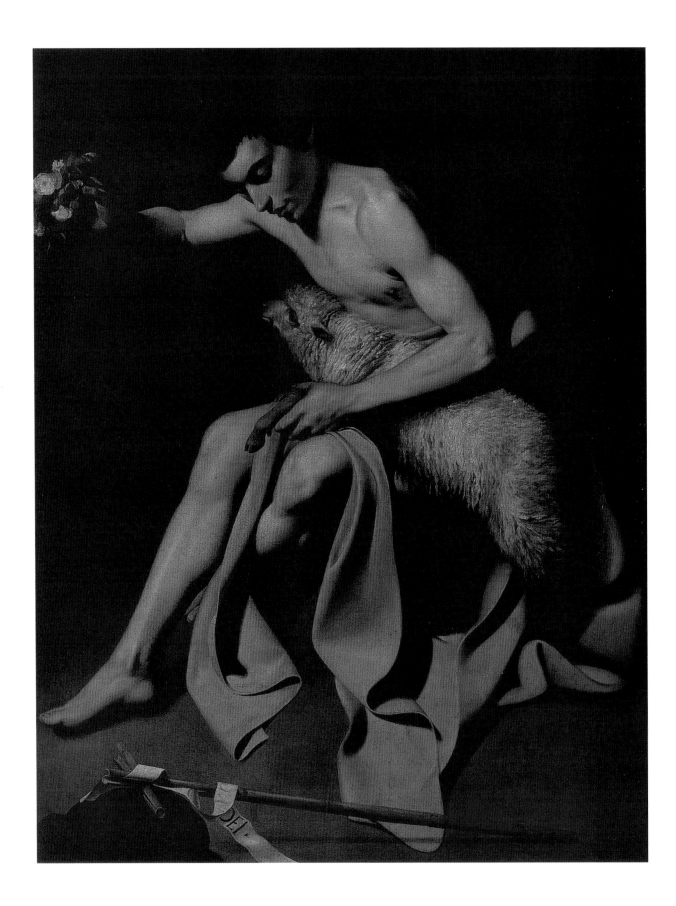

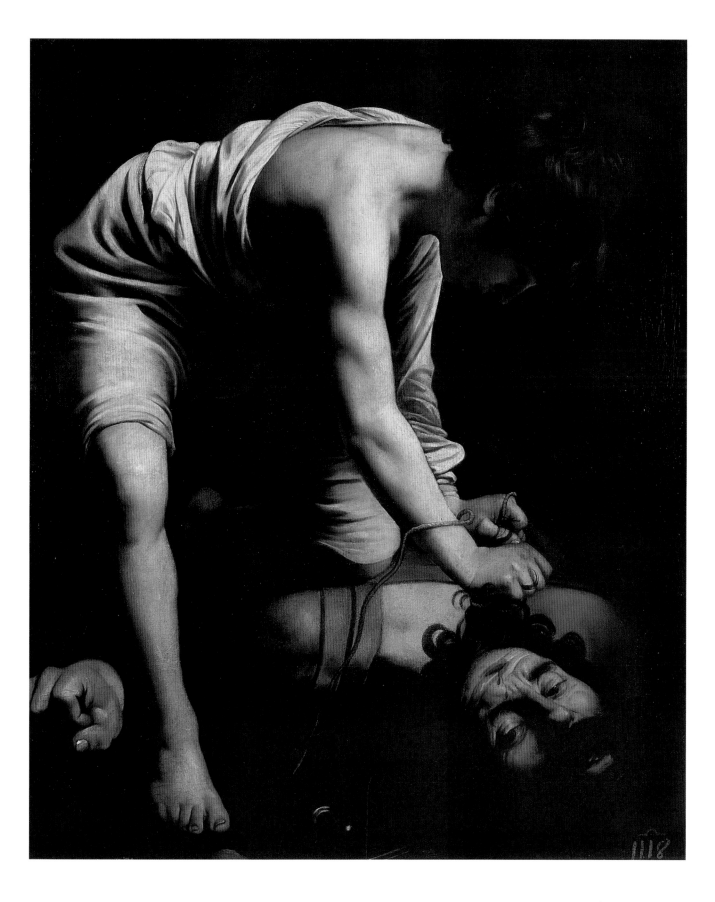

typical is a staff with a strip of writing on it. A device of this kind does not accord with Caravaggio's years in Rome. However, it does link the painting, which can also be compared to the Madrid *David and Goliath* (ill. 43), with the Christmas picture for Palermo (ill. 114). To me there seems to be an obvious connection – not only in the coloration but also in the execution of the leathery, earth-colored drapery, as well as the lamb's skin and pelt.

The pastoral game with the lamb, to which the youthful Baptist is holding out a bunch of flowers as if the animal was meant to snap at them, also expresses a theological thought. The forerunner of Christ holds out white and red roses to the lamb. As symbols of blood and water, they indicate passion and death. As the strip of writing in the foreground explains, the Basle canvas has less to do with the Baptist than the message about the lamb of God.

The *St. John the Baptist*, in the Galleria Borghese, Rome (ill. 44) is generally considered late Caravaggio. With its elegiac tone, its melancholy mood, and its lack

of physicality, this painting seems to fit as well as the David with Goliath's head (ill. 2) at the end of Caravaggio's career.

On the other hand, the artist did not see painting the nude purely in terms of young men's bodies. Even the sufferings of Jesus in the *Flagellation of Christ* inspired him to create an impressive rendition of nude painting (ill. 109). But even more astonishing is a group of pictures devoted to naked old men, depicting the penitent Father of the Church, St. Jerome, in an interior.

For two of these pictures (ills. 45, 48) Caravaggio obviously used the same old man as a model. In the third example, however, he combined findings from portrait work with studies direct from a model (ill. 49). In his portrait in the role of St. Jerome, the artist seems to be paying his compliments to the man who commissioned the painting, Alof de Wignacourt, a powerful figure on the island of Malta (ill. 50). Caravaggio places him in a corner of the room to the left, whilst on the right a narrow strip of brown wood holds the eye in. It is as if a wooden door, bearing the coat-of-arms of Ippolito

46 (left) *St. Jerome* (detail, ill. 45), ca. 1606

The artist has made the event he depicts very gripping. The old man's intense expression, which completely ignores the viewer, is marvellously observed.

48 (opposite) *St. Jerome*
Oil on canvas, 118 x 81 cm
Monastery, Montserrat

The suntan revealed in this smaller upright picture on the old man's face and hands, in contrast to the light color on his arms and upper body, indicates that Caravaggio was again studying from a living model, who has now taken up a different pose. Once again, strong shadows disturb the structural features of the upper body. With only a piece of white drapery around his loins, and his Cardinal-red mantle slung across his legs, the old man has his left hand resting on his mantle, which also covers the table, whilst he is pensively stroking his beard with his right hand. Although his head is lowered, he is not looking at the skull in front of him. That said, the skull's empty eye-sockets appear to be staring at him.

47 (right) *St. Jerome* (detail ill. 45), ca. 1606

A skull lies on top of some heavy tomes. Its naked cranium corresponds with the saint's bald head.

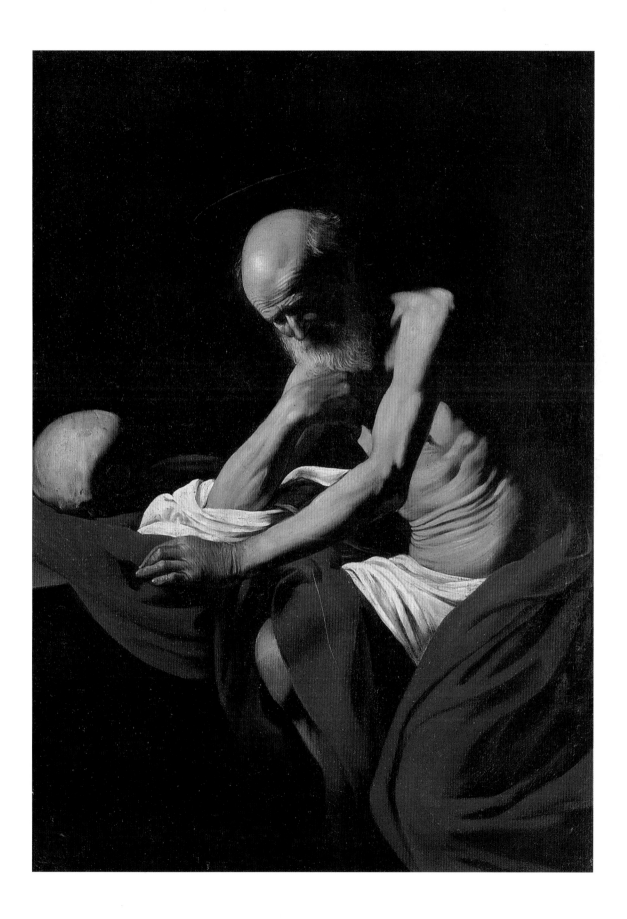

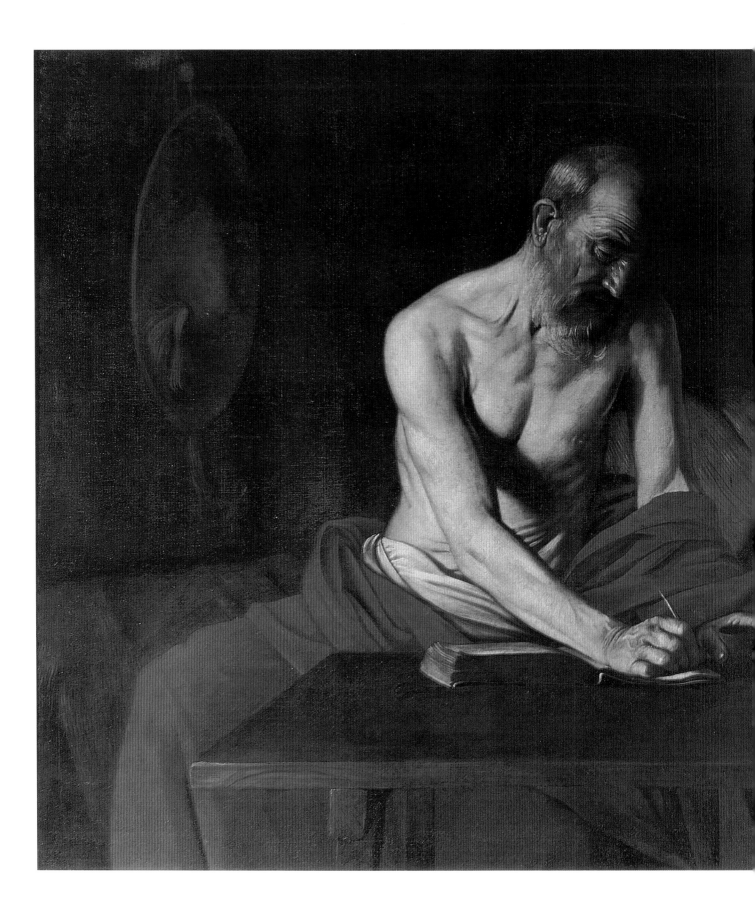

50 *Portrait of Alof de Wignacourt* (detail ill. 11), 1608

For the face of St. Jerome the artist aged the strained features of Alof de Wignacourt, Grand Master of the Knights of Malta, familiar from the portrait in the Palazzo Pitti, Florence, by adding wrinkles and strands of white hair in his beard and hair.

49 *St. Jerome*, 1607–1608
Oil on canvas, 117 x 157 cm
Museum of St. John's, Valletta, Malta

The half-naked old man turns away from the Cardinal's hat on the left. With his left hand around the inkpot, he is making notes in a smallish book, in which there is already some writing. In the process, he turns his head, though not his eyes, towards a skull. Caravaggio skilfully shows the top of this skull leaning against the pebble which the saint uses to break open his breast when he is undergoing penance. An unlit candle stands on the right-hand edge of the table. A small crucifix, an indispensable symbol, reaches from near the skull to a considerable way beyond the table-edge.

Malaspina, the Maltese Prior of Naples who was a friend of Alof de Wignacourt, were about to open.

Two strands of tradition appear to intersect in Caravaggio's pictures of St. Jerome. Northern Europe took the subject up for the sake of its magnificent interiors, which had prototypes in Italy. The subject achieved its supreme expression in Dürer's famous copperplate engraving, *St. Jerome in his Study*. In the North during the Renaissance, the saint continued to be depicted, but half-length rather than full-length.

In Venice, on the other hand, the subject of *A Penitent St. Jerome in the Wilderness* was more popular until well into the sixteenth century. By removing the small-scale half-nude of the penitent from the Venetian landscape and placing it as a full-size three-quarter-length portrait

in a chamber North of the Alps, he transforms this subject into a kind of genre-picture which could be painted indoors direct from a model. Henceforth, it became possible to paint, on both sides of the Alps, not only the Father of the Church, St. Jerome, but also other saints – not in a Flemish or Titianesque style, but in the style of Caravaggio. With scarcely any other subject did Caravaggio achieve such a triumph as he did in these paintings, with his *chiaroscuro* and his breathtaking combination of red next to skin color and black.

Yet it is not merely in the case of boys, youths and old men that nude-painting interested Caravaggio. The naked small child also inspired the artist to make a study (ill. 51). It may also have led to competition with Michelangelo, who painted a similar subject in a work

51 *Sleeping Cupid*, ca. 1605–1610
Oil on canvas, 72 x 105 cm
Galleria Palatina, Palazzo Pitti, Florence

The child has spread his wings out on the ground in order to rest on them, holding his arrow and bow with its broken string in his left hand. A surprisingly broad strip of impenetrable black appears above the figure, enlivened only by the bold touch of the rim of a white wing. The artist may be suggesting nighttime, which would fit in with the picture's subject, sleep, but in that case what is the source of the harsh highlight which floods on to the sleeping child? The figure's plump left arm appears to be separated from the rather stout body. Even more curiously, his right hand appears just above his belly.

52 *The Sacrifice of Isaac*, ca. 1605 (?)
Oil on canvas, 116 x 173 cm
Piasecka-Johnson Collection, Princeton, New Jersey

The landscape has faded out. Against a dark background, the story is pieced together out of figures. As if he had clambered up the mountain behind father and son, the angel brings them the ram, and speaks to Abraham, who is already relaxing his grip on Isaac's hair. Whether this colorful picture, with its rich lighting, was really painted by Caravaggio, is open to doubt.

now lost. In a painting long owned by the Medicis, Caravaggio depicts Cupid as a full-length sleeping putto. Love and death meet in this subject. It was to return over and over again for centuries on tombs.

LANDSCAPE IN CARAVAGGIO'S WORK

Even for a commentator as early as Bellori, Caravaggio's art was rooted in the Venetian painting of Giorgione. In his Dresden Venus, Caravaggio's great predecessor, who was painting shortly after 1500, was tackling a paradox which is similar to that in the Uffizi *Bacchus*.

The Venetian painter does not see the naked woman, who for him depicts Venus, on a meadow fit for gods in a godlike idyll, but near a farm. There she is lying on a cushion and some drapery – articles unfamiliar to gods of nature. She, too, is more a model than a goddess. Even earlier, in his pictures of St. Jerome, however, Caravaggio did not take advantage of Venice's supreme contribution to European art – he avoided landscape. A few plants dotted about like set pieces in front of an impenetrably dark background are not enough. Landscapes need distant views. These Caravaggio offers only in a handful of paintings, including *St. Francis in Ecstasy* and *The Sacrifice of Isaac*.

In the nocturnal *St. Francis in Ecstasy* (ill. 53), the large figures are lit from the front. In the landscape behind,

53 *St. Francis in Ecstasy*, 1595–1600
Oil on canvas, 92.5 x 128 cm
Wadsworth Atheneum, Hartford, Connecticut

With his eyes closed and his body rigid, St. Francis is pointing to
the place where he will receive a wound in the side. Yet he does not
see the angel who will ensure that he is stigmatized. Instead, he
closes his eyes in an expression of ecstasy which has never been
depicted before. An angel shelters him lovingly. They are both
harshly lit.

54 *St. Francis in Ecstasy* (detail ill. 53), 1595–1600

The angel comes from the same repertoire as the early pictures of
boys. As Cupid, he is already familiar to us from the New York
Concert (ill. 4). In the St. Francis scene he forms part of an
arrangement set against an almost black background, which may
well have been painted direct from life and transmutes the spirit of
pictures of boys into the sphere of sacred art.

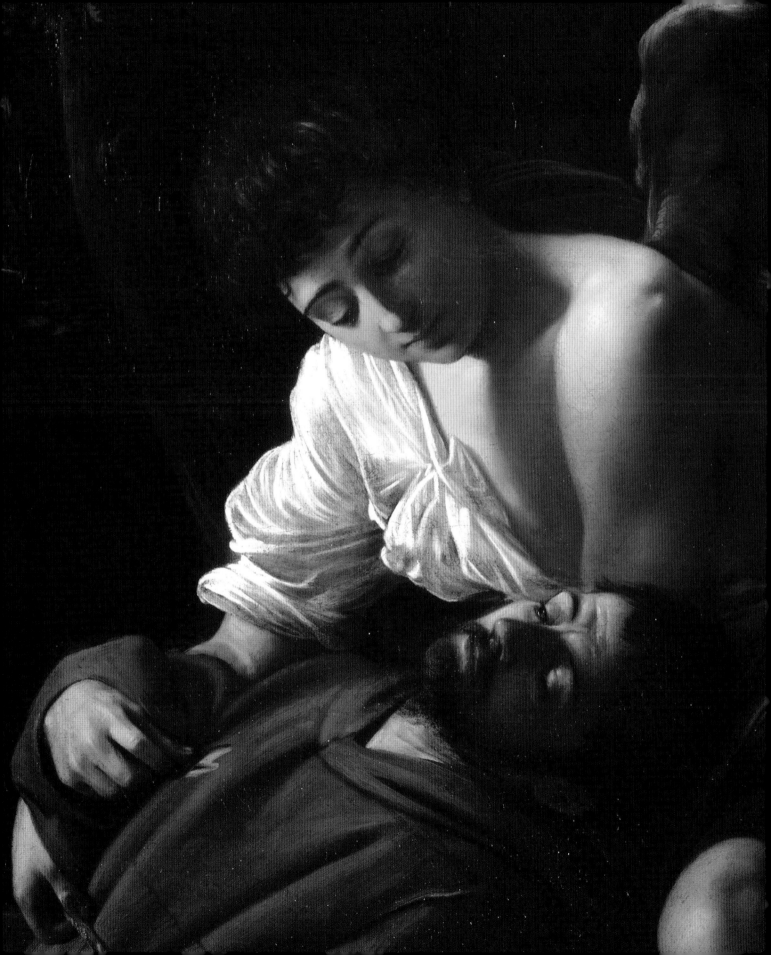

we see a narrow strip of light, but it does not illuminate the impenetrable darkness. We cannot make out the countryside any more clearly than we can the sky and the companion in the distance. For Caravaggio, highlights on angels and saints were more important than the firmament. It is debatable here whether this form of light comes from God's heaven or only from the painter's vision. At all events, landscape does not give the figures something to look at, nor does it provide perspective for their movement. It merely indicates the depth of the night and the unreality of the location.

In the Uffizi *Sacrifice of Isaac* (ills. 55–57), too, the landscape is swallowed up by darkness. This is not night, however, but muted twilight in which the most distant mountains look just as bluish-gray as the clouds. Venetian artists adored views like this. Precisely for their lagoon-city built in the sea, they used to paint the gently climbing slopes of the mainland, complete with trees,

villages and castles. Following this tradition, Caravaggio used the twilight ambience of a heightened view into the distance for narrative purposes. Behind Abraham and Isaac lies the day during which they climbed the mountain.

Nevertheless, a version recently celebrated as an original treatment of the same subject in the Piasecka-Johnson Collection, Princeton, shows that a Caravaggesque picture which exists in several examples, and was probably first painted in Rome about 1605 or in Naples, can depict the action in a very different way (ill. 52). This picture certainly shows us the same sequence of figures – with the angel on the left, and Isaac on the right. Now, however, it is the angel who has brought the ram. In the better known version in the Uffizi (ill. 55), the angel interrupts Abraham. Here, on the other hand, the Patriarch appears ready to respond to the word of God.

55 *The Sacrifice of Isaac*, ca. 1600
Oil on canvas, 104 x 135 cm
Galleria degli Uffizi, Florence

Movement from the left powers this painting. Standing in front of dense, dark tree trunks which obstruct our view, the Angel of the Lord intervenes, to hold Father Abraham's arm, just at the moment he is about to cut his son's throat. According to the Bible story, he wanted to obey God's command and sacrifice Isaac to him – just when an Angel of the Lord offered him a ram instead. The group of figures rises powerfully in the harsh light from the left as far as the patriarch's bald head, only to sink down towards Isaac.

56 *The Sacrifice of Isaac* (detail ill. 55), ca. 1600

The angel, seen in profile at the left-hand edge of the picture, is pointing to a view of the landscape with his powerfully extended index-finger. At first glance he is indicating the ram rather than Isaac, but his finger is pointing beyond this, towards the liberating landscape on the right.

57 *The Sacrifice of Isaac* (detail ill. 55), ca. 1600

Isaac is thrust down roughly on to the sacrificial altar, casts a look of agony at the viewer, and emits a scream of horror.

Caravaggio's Contribution to Genre-painting

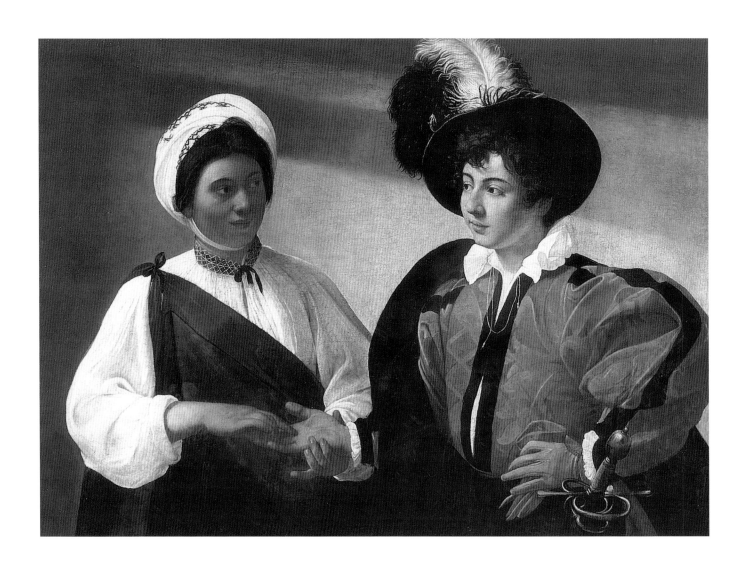

Caravaggio's revolutionary achievement consists – if not in his *chiaroscuro* – then in his genre-painting, which draws its inspiration from the same sources as his pictures of St. Jerome. He mingled Venetian and Dutch stimuli in order to alter the status of this genre. His genre-paintings gave rise to sensation, scorn and recognition all at once. Only when the school of Caravaggio had established itself did this make its triumphant progress through the Netherlands, France and Spain.

That said, Caravaggio himself completed surprisingly few genre-pictures. Without making any attempt at portraiture, a genre-painting depicts anonymous people in clothes appropriate to their social level who are carrying out everyday, typical activities which can be repeated at will.

If we leave aside the individual figures with accessories reminiscent of a still life, because, with only a few exceptions, their poses do not carry any social meaning, then Caravaggio's contribution to genre-painting boils down mainly to two works. The more important of these, *The Fortune-Teller*, exists in two versions with different claims to authenticity. The clothes, which distinguish the exotic fortune-teller from the harmlessly dandified and dolled-up young man, are enough to characterize the two figures.

Bellori begins his Caravaggio *vita* with a fictitous account of how this subject came about. Through this anecdote Bellori wishes to show how the artist distances himself from prototypes in classical antiquity, and approaches genre-painting spontaneously direct from a living model. He writes: "After Caravaggio had been shown the most famous pictorial works by Phidias and Glykon, so that he might learn from them, the painter responded merely by pointing to a crowd of people and remarking that nature had provided plenty of masters. In order to emphasize this, he called a passing gypsy woman in from the street and, after taking her back to her lodgings, painted her portrait, whilst she was predicting the future, as women of the Egyptian race are wont to do. Then he also painted a young man, who has one gloved hand on his sword and has opened his other palm to the woman, who is holding and reading it."

This episode, which has no basis in historical fact, helps explain the picture in two ways. For those who appreciate the picture's merits it confirms the freshness of the artist's eye. For others, it makes the artist's unbridled arbitrariness crystal clear. Bellori follows the line he had already taken in the passage quoted earlier about Mary Magdalene in the Doria Pamphilj Gallery (ill. 14), a section which runs on from this episode in the *vita*, emphasizing the artist's deliberate decision to diverge from classical prototypes and make his own individual choices, irrespective of any hierarchies in art theory.

Bellori did not detect a deeper meaning in the picture. Levity of this kind does not appeal to modern art history, which will not allow artists to follow their impulses and paint worthless material as the fancy takes them. When seduction is in the air, a young dandy is a Prodigal Son on his way to rack and ruin. In linking a picture like this to Christ's parables, we might imagine having a better reason for painting louche pictorial subjects.

Even if we choose not to follow Bellori, pictures could still limit themselves to the kind of human drama which develops anonymously and incidentally into art. Moving further out poetically, we reach Prosper Mérimée's and Bizet's "Carmen", who, although they do not read their Don José's palm in order to steal his ring, do tell his fortune from the cards.

A similar young man who falls victim to a fraudulent game of cards features in a second genre-picture, which has only recently been acknowledged as original. In 1672 Bellori described the card trick exactly. He stated that the *Card-Players* belonged to Cardinal Antonio Barberini, who must have purchased it from the estate of Cardinal del Monte. With card-playing and card-sharping Caravaggio opens up a range of possibilities for genre-pictures, which was to result in an endless series of good paintings.

For Bellori, the *Card-Players* and *The Fortune-Teller* do not necessarily belong together, since he does not have an overriding idea of what genre-painting is. In the battle of the genres one of the genre-paintings attributed to Caravaggio takes up a prominent position. The Musei Capitolini *Fortune-Teller* (ill. 61) was, like the Milan *Basket of Fruit* (ill. 23) and the New York *Lute-Player* painted over an older canvas. In the process of repainting, Caravaggio has in each case failed to respect the hierarchy of different genres, insofar as his still life obliterated a putto and his genre subjects a praying saint, possibly even the Virgin Mary.

By making the figures in his ground-breaking genre scenes full-length Caravaggio is, in effect, saying that he also painted these direct from life. Genre-painting after him kept to the same maxims. Painters in the style of Caravaggio in Utrecht, Holland, liked to place their figures in front of well-lit walls, just as Caravaggio himself did. Painters like Manfredi (1587–1620/21) and Valentin de Boulogne (ca. 1591–1632), on the other hand, used black backgrounds for such pictures, whereas Velasquez (1599–1660) preferred brown backgrounds.

Caravaggio may also have influenced genre-painting through an unusually coarse and ugly picture, which was painted hurriedly, and which deliberately flouts all conventions of beauty. This tavern scene in the style of the Hellenist painter, Peiraïkos, has come to light only recently. As early as 1637, when owned by the Medici, it was recorded as a Caravaggio (ill. 60).

Caravaggio's genre-paintings reach beyond narrow genre distinctions – and not merely because he was convinced that one could only paint well direct from nature. Just as he had moved on from half-length to full-length genre-pictures painted from models, Caravaggio also revolutionized historical paintings.

The way Caravaggio set out his *Martha and Mary Magdalene* makes the two figures look like a Venetian portrait of courtesans. Scholars are almost unanimous in thinking that, in inaugurating this series of paintings (ill. 62), the artist continued to develop the *chiaroscuro* he first put into effect in those pictures. Caravaggio

58 *The Fortune-Teller*, 1595–1600
Oil on canvas, 99 x 131 cm
Musée du Louvre, Paris

Against the fortune-teller's clearly-expressed craftiness, the young fool chooses to rely on his sword-belt. The hilt of his sword is slightly turned towards the viewer, while she unobtrusively – a gesture hardly noticeable nowadays – slips his ring off his finger. At the top of the picture someone has added a strip of canvas which shows even more of the feather and lets the figures breathe a little. Even though Caravaggio had originally concentrated the painting more intensely on the figures, this addition scarcely impairs the picture's subtlety.

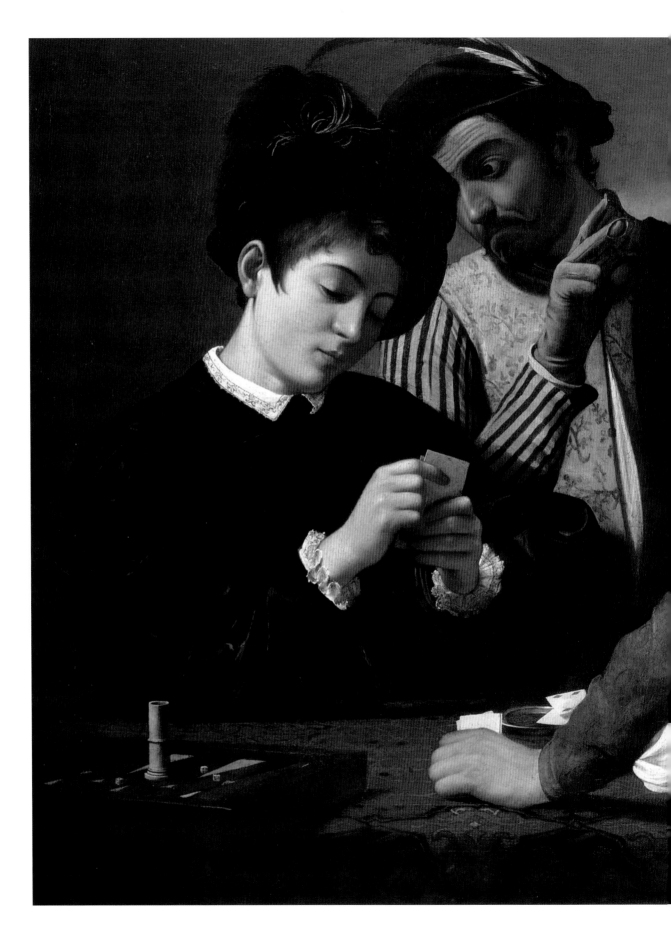

59 *The Cardsharps*, 1595–1600
Oil on canvas, 94 x 131 cm
Kimbell Art Museum, Fort Worth

Whilst a stylishly turned-out youth hesitantly looks at his cards, a man with tattered gloves peers over his shoulder, putting up three fingers to show the youth's opponent which of the cards he has hidden in his waist-band he should play. With dice and backgammon on display, gambling is clearly in the ascendant here, and if the going gets rough, violence, The dagger which the young cardsharp has placed hilt uppermost and facing into the picture shows where a dispute will probably lead. Although the young cardsharp is standing in front of it, the edge of the table, which is in shadow, and which the backgammon set overhangs, forms the real boundary to the viewer. The light also extends the pictorial space dynamically towards the right. It spills over the cardsharps in their blackish-crimson velvet, and appears to promise them success.

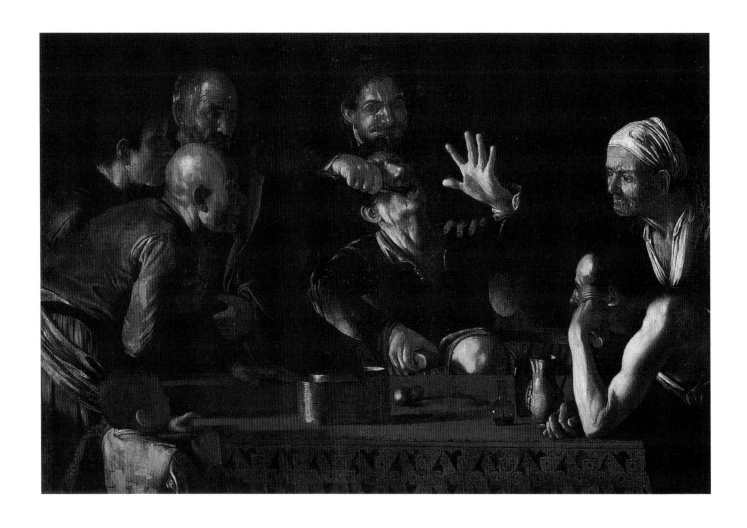

60 (above) *The Tooth-Drawer in a Tavern*, ca. 1610 (?)
Oil on canvas, 139.5 x 194.5 cm
Palazzo del Montecitorio, Rome, on loan from Pitti e Giardino di
Boboli, Florence

A man, whose look should give him away as a charlatan, has applied
a pair of pliers to a victim, who is in pain and already has blood
pouring down his chin, in order to extract a tooth. Not only is the
subject-matter grotesque, the whole picture is painted in a rough
style. Instead of careful work direct from models, such as we see in
paintings from the 1590s, here the artist is aiming at crude effects in
the light.

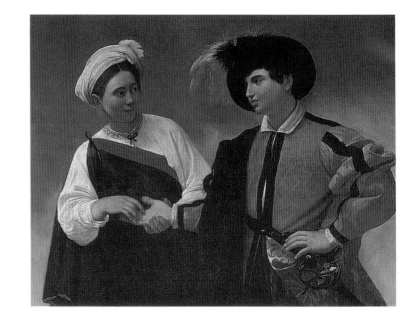

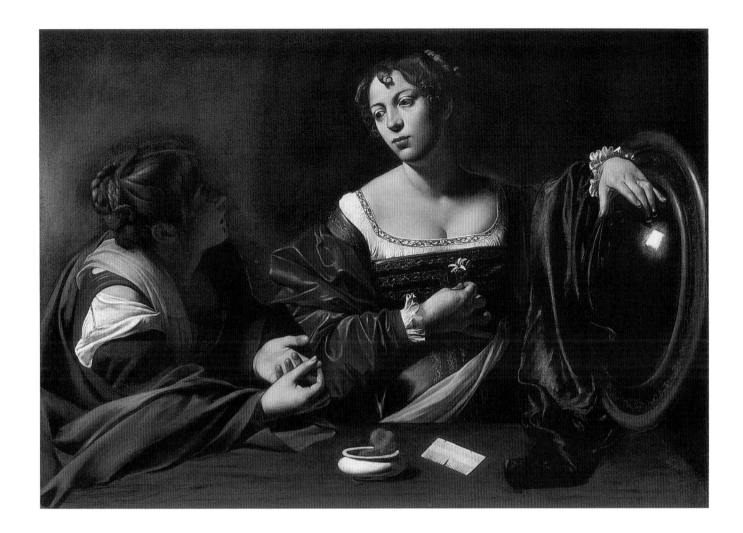

61 (below left) *The Fortune-Teller*, during Caravaggio's Lifetime (?)
Oil on canvas, 115 x 150 cm
Musei Capitolini, Rome

The youth abandons his reserve, leans over towards the gypsy-woman and looks into her smiling face, as if he idolized her, and as if the woman was enticing a very willing man. We cannot be absolutely sure this picture is an original Caravaggio. Its authenticity has recently been based on two arguments. The genre-scene has been painted over a praying female saint, perhaps the Virgin Mary, and the most likely painter is the Cavaliere d'Arpino (1568–1640). The painting also carries the same indication of provenance from Cardinal del Monte's Collection as the *Cardsharps*. The same subject-matter recurs in Narcissus (ill. 25). In the case of this not-undisputed picture, it strikes me that the smooth way in which the paint is applied suggests a Caravaggesque artist of some note.

62 *Martha and Mary Magdalene*, ca. 1595
Oil on canvas, 100 x 134.5 cm
The Detroit Institute of Arts, Detroit

Martha humbly points out to her sister, Mary Magdalene, how transient all worldly things are. Light strikes her only on her shoulder, so that her clothes – in disarray as a result either of work or of emotional upset – stand out clearly. Her face, however, disappears into the darkness, averted from the viewer almost in profile. A piece of soft fabric and a magnificent border form the boundary of Mary Magdalene's hands and generous décolleté. She is propping her left arm, over which she has thrown a piece of expensive green fabric, on a black convex mirror. She was in the process of testing the effect of a small white blossom – orange or perhaps even edelweiß – on her breast. At this point, Martha came in, to reclaim her and make the mirror a symbol of *vanitas*.

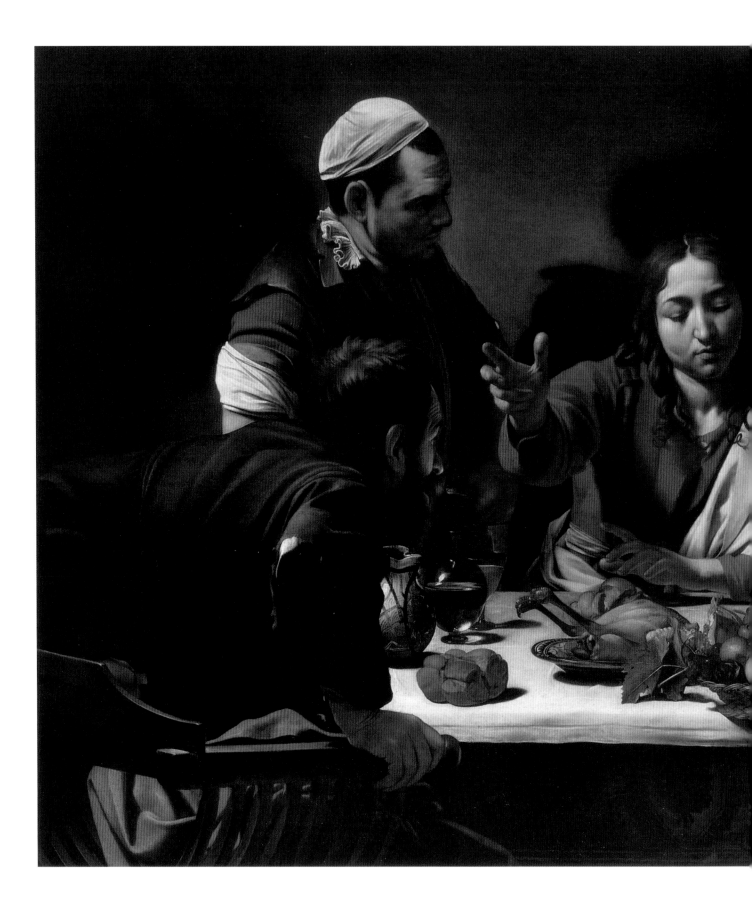

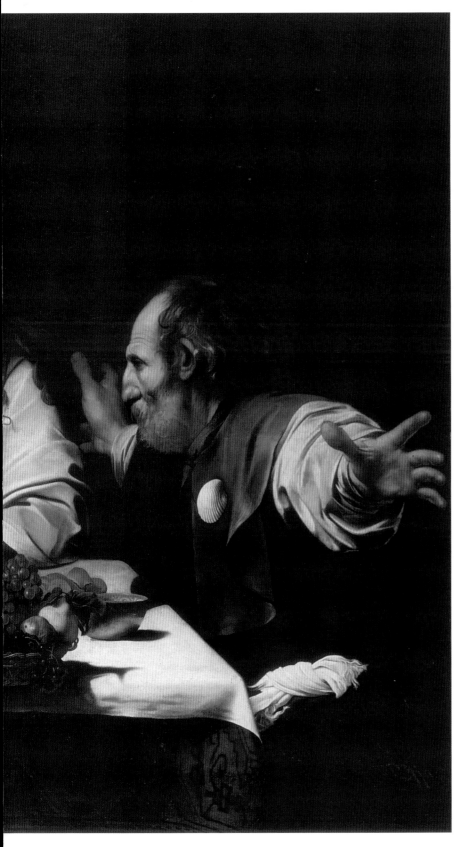

63 *Supper in Emmaus*, 1595–1600
Oil on canvas, 141 x 196.2 cm
The National Gallery, London

Already set out as a genre scene in the Bible, this story concerns two
disciples who, on their way from Jerusalem to Emmaus on Easter
morning, come across a stranger making the journey, with whom
they go into an inn. The moment the stranger breaks the bread the
disciples recognize him as the risen Christ. Caravaggio depicted this
scene twice in life-size half-length figures (ills. 63, 64). These two
pictures, which are virtually the same size, show how differently
Caravaggio saw biblical subjects in the space of a few years.

A basket of fruit impudently intrudes near the front table-edge.
As in the Uffizi *Bacchus* (ill. 18), the still life spreads out under the
main figure, who, supported by the lines of the table-cloth, occupies
the pictorial center in a pyramid shape. If the disciples of Jesus had
walked quite a long way with the resurrected Lord, and only later
recognized him by one gesture, then the figure who appeared at
Emmaus cannot have looked like Christ. For this reason, the artist
does not present the *vera icon*, that is, the usual image of the
Redeemer, but a youthfully plump face without a beard. Whilst
Caravaggio takes this aspect of the Gospel extremely literally, he
does not depict the action accurately. The stranger blesses the whole
meal, and does not need to break the bread, because everyone at
table already has some. The landlord watches the stranger's gesture
of blessing, his shadow on the wall offering the resurrected Christ an
impressive background.

Although the landlord has no idea what is happening, the two
disciples offer the artist the opportunity to express surprise. The
older one, on the right, spreads his arms out wide – in an
exaggerated example of foreshortening, with one much too large
hand near Christ's shoulder. At the same time, the younger disciple
is so astounded he almost jumps up from his chair. He grips the
arm-rests with both hands, and sticks his head a long way forward.
As he does so, light reflected naturally from the table-cloth makes
his face look as if it has been illuminated by divine light.

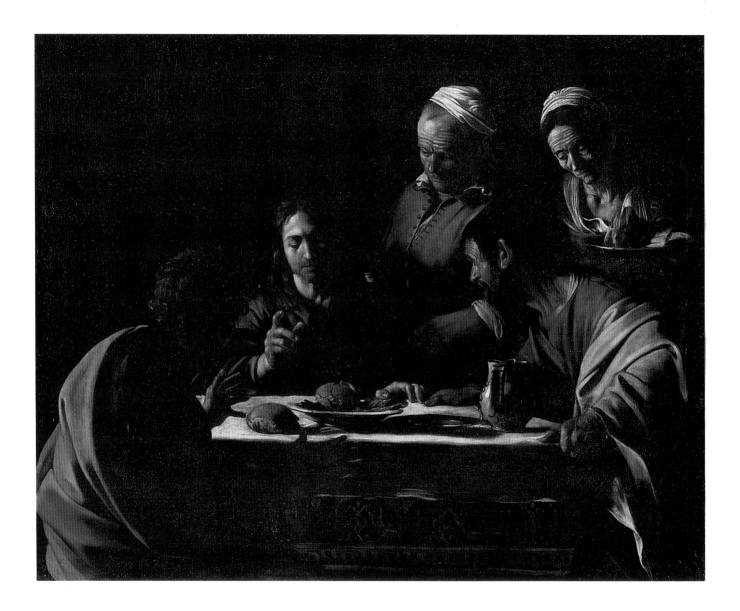

displayed a lot of feeling for the dissimilar sisters. With great surety of touch he pinpoints the rigidity and humility that characterize the sisters, as well as the precise moment when proud Mary Magdalene begins to realize her destiny. To achieve this, he has no recourse to divine intervention, but only depicts what can be externally observed.

The very choice of subject is based on the principle of genre-painting, because the kind of incidents Caravaggio depicts do not exist in Biblical legend. But even in the Four Gospels some scenes originated from a pure genre situation. These revealed the presence of a divine agency only after the people involved thought they were going through an ordinary experience.

Yet there are some Biblical subjects, like *Judith and Holofernes* (ill. 66), which even a Caravaggio could not reconstruct from models. The artist made a ground-

breaking painting of Judith's heroic act in making Holofernes, the general of a besieging army, drunk in his tent, then beheading him in his sleep, so as to save her people. Whilst many artists before him had merely shown Judith and her maid hiding the hacked-off head in a cloth, Caravaggio shows Holofernes's death agony at the moment the sword cuts through his neck.

Caravaggio's gripping depiction owes little to studies of anatomy, the lack of which early art-theorists always noticed in his work, or even to professional curiosity about public executions, which generations of Italian artists were said to have entertained. It is thanks rather to the artist's visual imagination, linked with Caravaggio's meticulous model-studies. Whilst he has obviously painted the young woman from an observed pose, the man is an imaginary figure, and is therefore the weaker part of the painting. In cases where

64 *Supper in Emmaus*, 1606
Oil on canvas, 141 x 175 cm
Pinacoteca di Brera, Milan

Instead of the sumptuous still life, we see only bread, a bowl, a tin plate, and a jug. The gestures of surprise are much the same, though differently distributed.

65 *Supper in Emmaus* (detail ill. 64), 1606

In the Brera version of Emmaus an elderly woman has joined the landlord. This means that the whole movement of the picture, beginning in the bottom left section, swiftly reaches Christ. Christ is also blessing the bread without breaking it. This has seduced several interpreters into seeing the picture as an allusion to the Last Supper, as the painting has sometimes – incorrectly – been called. In that he bases the facial features of Christ firmly on the usual features – unlike in the London example – Caravaggio's later work shows a certain willingness to adapt to traditional norms.

66 *Judith and Holofernes*, ca. 1600
Oil on canvas, 145 x 195 cm
Galleria Nazionale d'Arte Antica – Palazzo Barberini, Rome

A whole book in the Bible is devoted to Judith, because as a woman
she embodies the power of the people of Israel to defeat the enemy,
though superior in numbers, by means of cunning and courage. She
seeks out Holofernes in his tent, makes him drunk, then beheads
him. The sight of their commander's bloodstained head on the
battlements of Bethulia puts the enemy to flight. In the painting,
Judith comes in with her maid – surprisingly and menacingly –
from the right, against the direction of reading the picture. The
general is lying naked on a white sheet. Paradoxically, his bed is
distinguished by a magnificent red curtain, whose color crowns the
act of murder as well as the heroine's triumph.

Judith grips the hair of his head in her left hand, so that she can cut through his main artery with her sword-arm. Blood spurts out of this on to the pillow in three powerful jets. Her drunken victim swivels his eyes towards his executioner.

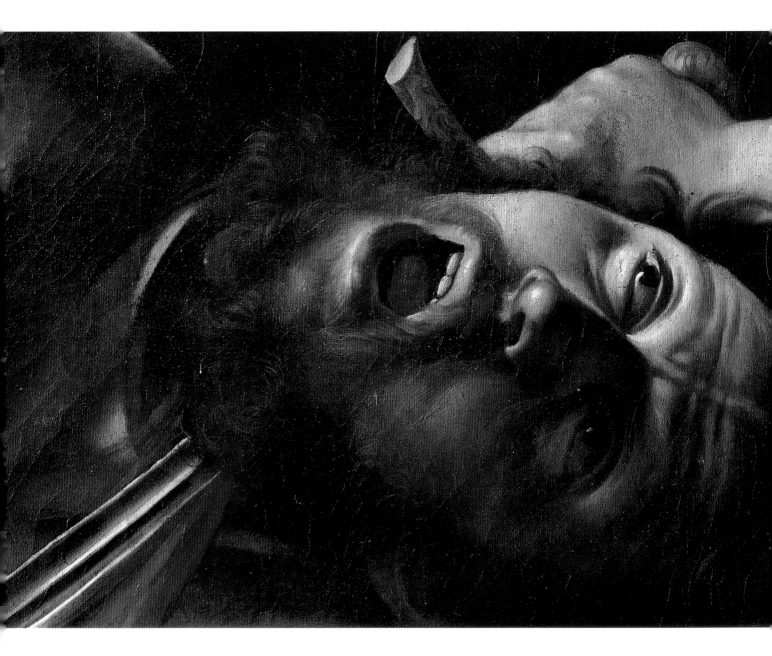

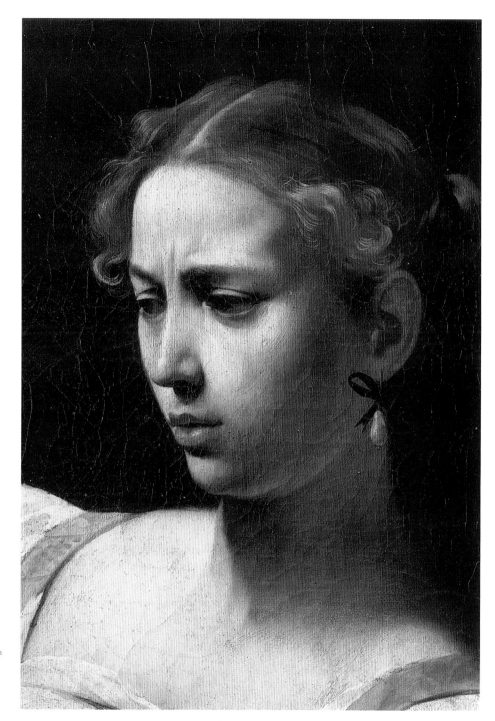

68 *Judith and Holofernes* (detail ill. 66)

Unlike Holofernes, Judith was painted direct from a
model, as the suntan on her hands and face attests. The
well turned-out blond woman with her full breasts, which
remain visible through her white blouse, has rolled her
sleeves up over her elbows. She stretches out her strong
arms, but draws her head back, as if she were repulsed by
blood. The Borghese *David* (ill. 2) behaves in a similar
fashion.

imagination was more straightforward, the gap between *imitatio* and *inventio* – between imitation and invention – is less striking. In the *Doubting of St. Thomas* (ill. 69) Caravaggio often even succeeds in suggesting that he had an incredible Bible story happening before his very eyes.

The Potsdam picture of St. Thomas went to Prussia with the Giustiniani Collection. Baglione, however, mentioned a painting on this subject in the possession of Ciriaco Mattei. Perhaps it is another case of Caravaggio making several examples for competing patrons.

The Mattei Collection contained a *Kiss of Judas*, for which the artist received the not inconsiderable sum of 125 scudi (ill. 70). Even if the dimensions of the painting do not match those of the Potsdam picture, the models make the two pictures form a pair. Caravaggio had the same men pose for the two main figures in both

paintings as well as for Christ. It is true, however, that he painted Judas, the betrayer, as a coarser figure, with a knobbly nose and with thinner hair, which consists only of a wreath – as if he had been tonsured.

Given that Caravaggio depicts half-length figures in the *Kiss of Judas* , it is probably not surprising that Peter, who cuts off one of Malchus' ears and is usually thrown to the ground, does not appear. Though this does not mean that the Prince of the Apostles should also be missing. In this picture Christ is shown gesturing helplessly. Deserted by his favorite disciple, he has to do without the – admittedly unwelcome – support of his Apostle Prince. Christ is kissed by a tonsured Judas, who looks like a monk in his yellowish cowl (in the copy owned by Odessa Museum it is even the color of the Minorite Order). Everyone who sees Caravaggio as a tool of the official Roman Catholic Church ought to bear this picture in mind. With the agreement of his

69 *The Doubting of St. Thomas*, ca. 1600
Oil on canvas, 107 x 146 cm
Schloß Sanssouci, Potsdam

Three disciples crowd in on Christ from the right, so that the head of doubting Thomas and the head of a second apostle form the painting's central axis. A strict color scheme divides the painting into a left- hand section, dominated entirely by flesh tint and muted white, whilst two red tones in the right-hand section shine out of the dark brown background. St. Thomas does not trust his eyes, but only what he can feel. One of the great qualities of good painting lies in conveying the tactile as a sensation that can be seen. The tactile aspect of painting, in the sense of *rilievo*, has to prove its worth against competition from sculpture. Before the highly observant eyes of the three apostles, the action in this picture is enacted only by the two main figures' hands. Christ's brightly lit left hand grips his disciple tightly by the wrist, in order to push his outstretched index-finger deep into the wound in his side. To make this easier, he draws back, with his right hand, the fold of the fabric which turns out to be his death-shroud.

70 *The Kiss of Judas*, before 2 January 1603
Oil on canvas, 133.5 x 169.5 cm
National Gallery of Ireland, Dublin

As in the *Doubting of St. Thomas* (ill. 69), the main figures
are pushed to the left, so that the right-hand half of the
picture is left to the soldiers, whose suits of armor absorb
what little light there is, and whose faces are for the most
part hidden. At the right of the picture, an unhelmeted
head emerges from the surrounding darkness. This is
often regarded as the artist's self-portrait. Caravaggio has
also concerned himself with the act of seeing as one
of a painter's tasks. Once again, the three men on the
right are there mainly to intensify the visual core of the
painting, underscored by the lantern. On the left, the
tactile aspect is not forgotten. Judas vigorously embraces
his master, whilst a heavily mailed arm reaches above him
towards Christ's throat. Christ, however, crosses his
hands, which he holds out well in front of him, whilst St.
John flees shrieking into the deep night. His red cloak is
torn from his shoulder. As it flaps open it binds the faces
of Christ and Judas together – a deliberate touch on the
artist's part.

patrons, who were also closely associated with the papal
Curia, the artist obviously allowed himself to take
liberties with certain aspects of biblical history.

Chiaroscuro has different functions in Caravaggio's
pictures of Christ. In the *Kiss of Judas* deep black
conveys night. As in most of the other equivalent scenes,
the light source is above left, whilst the lamp in the
hand of the man who is sometimes regarded as a
Caravaggio self-portrait, remains ineffectual. If we
follow the increasingly common tendency to regard
Crowning with Thorns, in Vienna, as an authentic
Caravaggio, we must add another picture, which shows
dawn breaking with light typical of the artist (ill. 71).

Any artist who changed his style so radically in so few
years and painted even Christ's face direct from models,
is bound to confuse art connoisseurs. They like to orient
themselves on familiar faces as the personal stamp of the
artist in question. Alongside the debatable picture from

Vienna, we should add *Christ at the Column*, in Rouen
(ill. 72), an episode from the Passion story. This is a
painting in which the face of Christ again seems
inappropriate. Yet the common model for one of the
executioners' assistants lets us specify more exactly what
place the underlying composition has in Caravaggio's
work as a whole. The same assistant who is binding
Christ to the column at which he will be flagellated, also
appears in an artistically superior painting with half-
length figures, in the National Gallery, London (ill. 74),
holding the head of St. John the Baptist. Furthermore,
the Salome in this canvas is modeled on the same
woman who posed as Caritas Romana for Caravaggio's
most important Neapolitan work, the *The Seven Acts of
Mercy* (ill. 106).

Exactly how Caravaggio integrated once-discovered
pictorial formulas with painting direct from the model
is evident in an original free variant, whose deep black

79

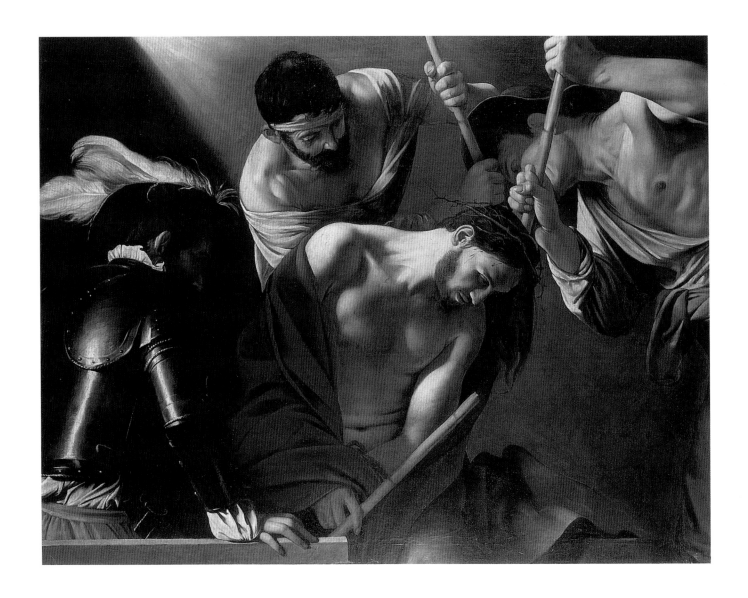

71 *The Crowning with Thorns*
Oil on canvas, 127 x 165.5 cm
Kunsthistorisches Museum, Vienna

The front boundary of the picture is articulated by a wooden
barrier, on which the captain is leaning, in order to observe the
action but take no part in it. He watches the executioner's half-
naked assistants abuse Christ at his behest. The powerful figure of
the suffering victim, sitting almost naked on a bench, seems larger
than he is. Christ's shoulderline continues the shallow diagonal
which began with the white feather of the captain's hat, on the left.

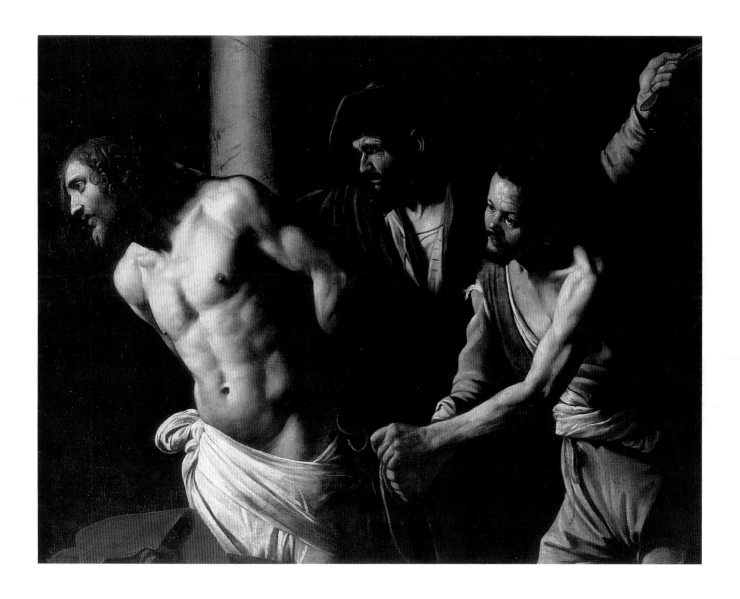

72 *Christ at the Column*, ca. 1606
Oil on canvas, 134.5 x 175.5 cm
Musée des Beaux-Arts et de la Céramique, Rouen

The movement of these figures, who are sharply divided into two
different halves of the picture, is conceived entirely in terms of the
light coming from the left. In the process, the flagellation column,
usually a decisive motif, appears as little more than a symbol of
Christ, without having any effect on the pictorial space, which is
immersed in the blackness of the background. Judging by the
assistants rather than by Christ, this picture dates from the time of
Caravaggio's first stay in Naples.

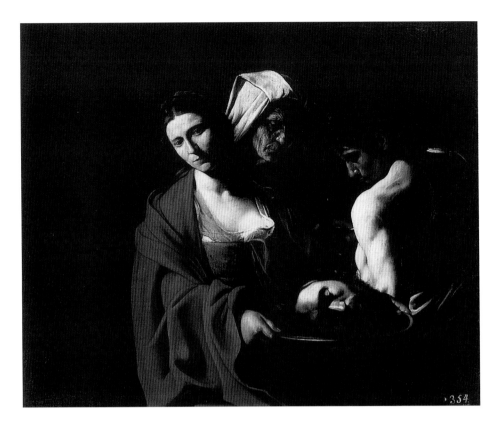

73 *Salome with the Head of St. John the Baptist*,
after 1606 (?)
Oil on canvas, 116 x 140 cm
El Escorial, Madrid

Against a deep black background, the figure-group,
consisting of Salome and her maid, has been moved to
the center of the picture, so that Salome's averted gaze
achieves greater pathos in the empty space. The Baptist's
head is already lying on the metal dish. The executioner
has to cram himself into the picture on the right.
Caravaggio has used a more prepossessing model to paint
him as the figure-study of a half-naked young man.

background presumably dates it later in his career (ill. 74). Caravaggio reproduced the configuration of Salome and the maid with other models. The artist's imagination, his *inventio*, adapts to the layout which Caravaggio repeats exactly at different points, so that in each case he can paint it direct from life. In the later version, the artist has toned down indications of the executioner's bloody office. This fact should not be overlooked by those modern interpreters who look at all the bloodthirsty images in Caravaggio's successors, and conclude that Caravaggio himself, as the founder of this school, had an unhealthy fascination with cruelty and contemporary methods of execution.

As well as oblong pictures of scenes from biblical history, early accounts suggest that Caravaggio also completed vertical pictures of scenes from Christ's Passion. Two vastly different paintings are the subject of fierce debate. In one of them, now in Prato, Christ is sitting in the *Crowning with Thorns* (ill. 76), like the *Belvedere Torso* – in other words, like one of the most famous works of classical antiquity, which Michelangelo made the touchstone of sculptural art. However, in Genoa, where the artist fled in 1605, the painting which exists in that city and may have been completed there – the *Ecce Homo* (ill. 75) – makes use of totally different conventions which Caravaggio ignores elsewhere.

Towards the end of his life Caravaggio recreated more biblical historical pictures with half-length figures into full-length paintings. In 1672 Bellori described a *Denial of St. Peter* in Naples as one of his best works. The authentication of paintings like this still occupies scholars, especially as good versions keep turning up with art dealers or in private collections (ill. 77).

The latest of these paintings which most recent research can consider to be original, a *Martyrdom of St. Ursula* (ill. 78), once again throws open the questions of pictorial arrangement and the use of the model. Sharply divided into two halves, the picture seems to be most like the group around St. Thomas (ill. 69) and the *Kiss of Judas* (ill. 70). Yet its sketchy execution distinguishes it decisively from these richly painted pictures from Caravaggio's Roman years shortly after 1600. The head in profile which again thrusts itself strikingly into the right-hand edge of the picture has sometimes been regarded as a self-portrait of the artist (ill. 70).

Paintings like the picture of St. Ursula show the artist at less than his best. They support the view that towards the end of his life Caravaggio was more or less burnt out. Hurriedly dashed off and furnished with set pieces from older sketches, expressively restrained and almost inept in its spatial layout, a work like this could well give ammunition to those critics of Caravaggio who argue that he was not always able to complete his projects convincingly. In this case, the Borghese *David* (ill. 2) would certainly not be one of Caravaggio's last paintings.

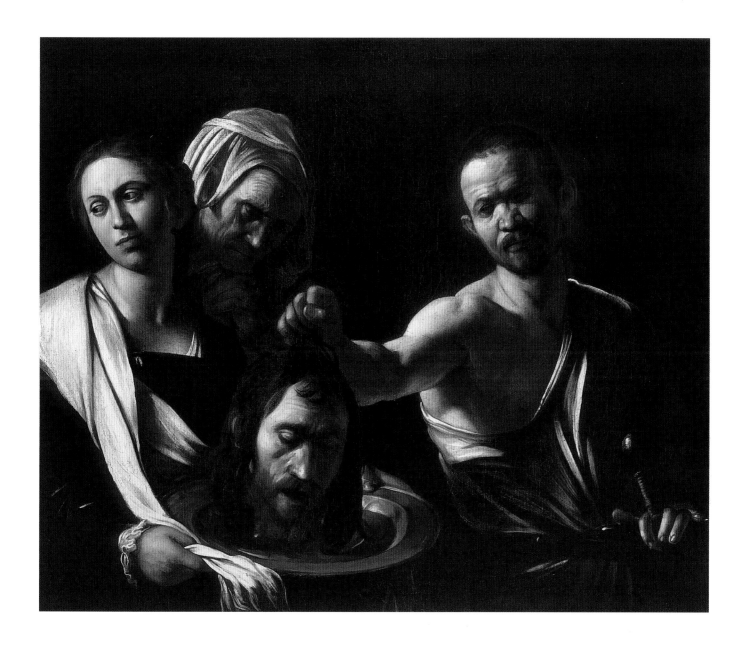

74 *Salome with the Head of St. John the Baptist*, ca. 1606
Oil on canvas, 91.5 x 107 cm
The National Gallery, London

The artist has used a respectable-looking Neapolitan woman model
as the lascivious female dancer, Salome, who has just seductively
persuaded King Herod to grant her wish. At the contrivance of her
mother, she demanded the head of John the Baptist, who had
revealed her mother's incestuous relationship with Herod. The
young woman much resembles Judith, (ill. cf. 66). She does not
look at the chopped-off head, which the rough executioner is
handing her.

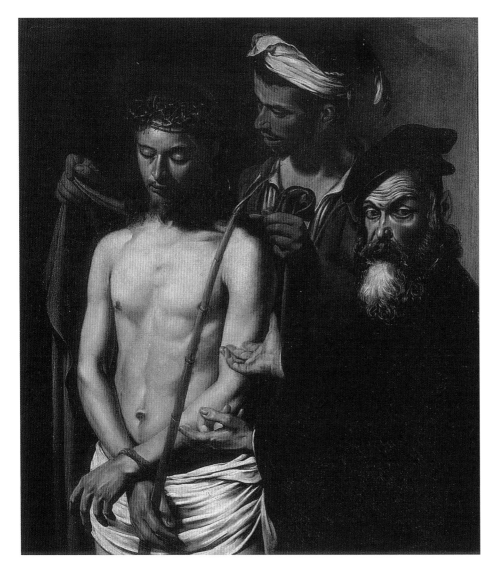

75 (left) *Ecce Homo*, 1605 in Genoa or 1607 in Messina (?)
Oil on canvas, 128 x 103 cm
Galleria di Palazzo Bianco, Genoa

Anyone attributing this picture to Caravaggio will have to accept that the artist always used to change his working method from place to place. Another reason might be that while fleeing to Genoa, or, two years later, while staying in Messina, he was dependent on unfamiliar models. The whole composition – of barrier, the Man of Sorrows, and Pontius Pilate, as well as an executioner's assistant looks conventional. Yet the lowest figure in the social scale towers over the two main figures in order to place a cloak around Christ's shoulders. As if in a devotional picture, the body of Christ is beautifully illuminated for the viewer and exposed to the light. The upper-class gentleman pointing at him looks so contemporary that some critics have even seen a self-portrait of the artist in this Pilate.

76 (opposite) *The Crowning with Thorns*, ca. 1600
Oil on canvas, 178 x 125 cm
Cassa di Risparmio, Prato

This picture creates a different kind of drama than the *Crowning with Thorns* in Vienna (ill. 71), which is also disputed. The vertical format allows us to concentrate on Christ, who occupies the center of the picture, in the pose of the *Belvedere Torso*. The figure of a man, naked from the waist up, sitting on a chair in front of a barrier in the foreground, holding the rope with which Christ's hands are bound, leads the eye towards him. A second man in a brilliant red robe is almost gently gripping the victim by his upper body and upper left arm. A third assistant is pressing the crown down so hard on to Christ's head with his stick that a drop of blood is running down his temple.

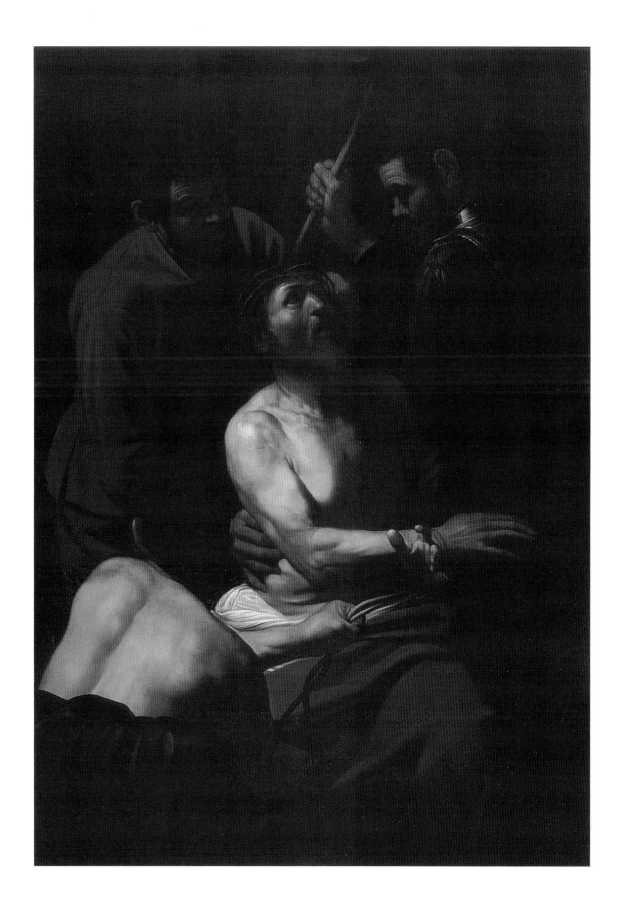

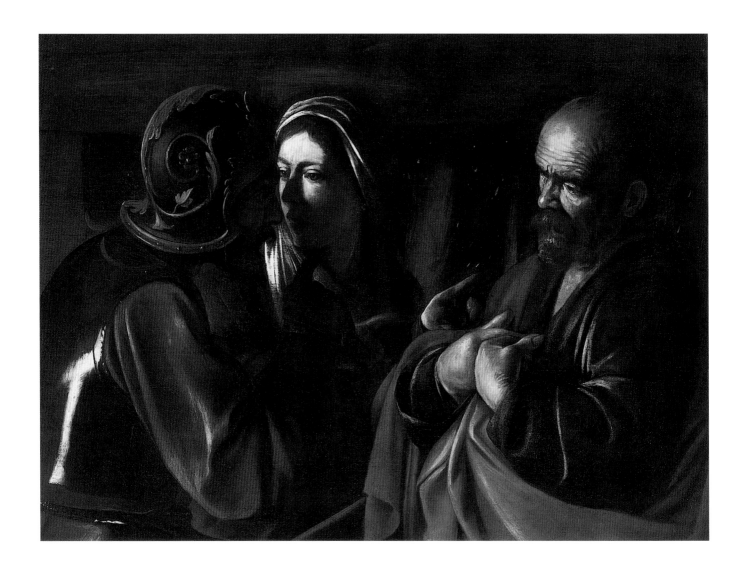

77 *The Denial of St. Peter*, 1606–1610
Oil on canvas, 94 x 125.5 cm
Shickman Gallery, New York

After the artist's many attempts to intensify the dynamics of a scene
from the right, this composition offers a dramatic sequence of
figures from the left. On a very dark night with deep shadows and
without any indication of artificial light, a soldier wearing a helmet
and armor appears from the left. He is turning his face so far round
to the maid that it gets swallowed up by the darkness. The maid
herself, her face obscured by the soldier's shadow, is peering at the
soldier from close quarters. She is pointing her left hand at St. Peter,
who is holding both hands against his chest in a gesture of
confirmation. For the apostle, Caravaggio has chosen a model who
would be ideal for an old satyr or for Socrates. The artist usually
introduced heads like this for executioners.

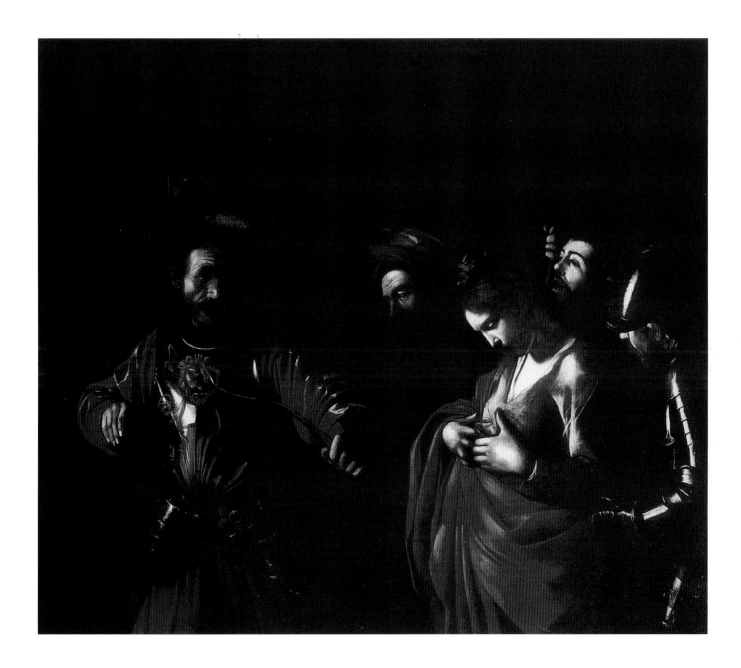

78 *Martyrdom of St. Ursula*, 1609–1610
Oil on canvas, 154 x 178 cm
Banca Commerciale Italiana, Naples

This picture is larger than most of Caravaggio's half-length
historical paintings, and is the only one which depicts a non-
Biblical subject. The painting gives a terse account of the legend of
St. Ursula. Outside the gates of Cologne, she was desired by a leader
of the Huns, then killed by an arrow. In blackest night – of which
the story makes no mention – the magnificently armored Hun takes
up the whole of the left-hand half of the picture. He is standing too
near for Caravaggio to show the flight of the arrow into St. Ursula's
body. On the other hand, he is too far away to be part of a figure-
relief which the artist generally creates so effectively. The saint
dramatically looks down at the arrow shaft which has entered her
heart. She is surrounded by three crudely painted soldiers – one of
them a repetition of the apparent self-portrait from the Dublin *Kiss
of Judas* (ill. 70).

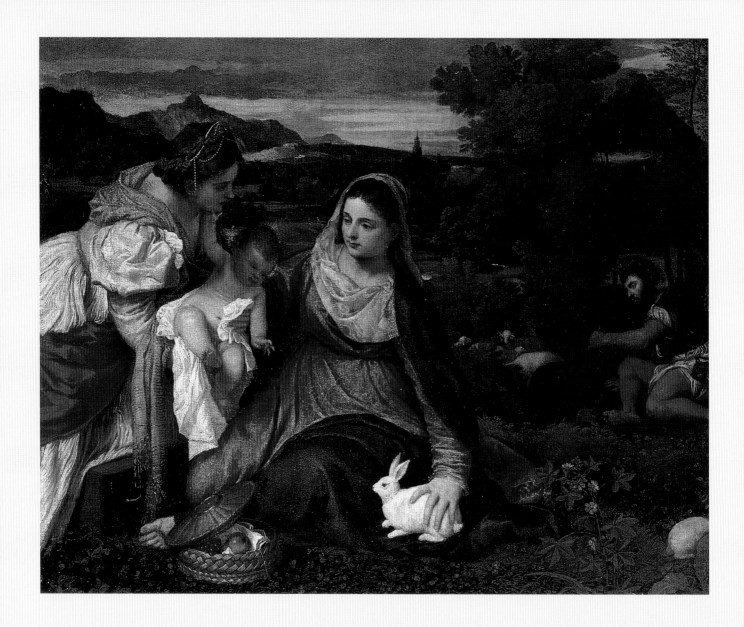

79 Titian (1479–1576)
Madonna with the Hare, ca. 1530
Oil on canvas, 71 x 25 cm
Musée du Louvre, Paris

A kind of poetically charged pastoral art had developed in
Venetian painting, and this influenced all Northern Italy.
Caravaggio developed his *Flight into Egypt* from pictures
like this one which depicts the Holy Family as full-size
figures in an oblong format in which they would be
unable to stand upright.

The writing of history is a catalogue of contradictions – the
more blatantly worlds collide the livelier the debate
becomes. Ever since Walther Friedlaender's ground-
breaking "Caravaggio Studies" of 1955, scholars have been
striving to reconcile the artist's sinful life and irreverent
behavior with the sublime subjects of his religious works.
Accordingly, anyone who opens books about Caravaggio
may sometimes hardly believe what meanings are read into
the pictures. Jutta Held, writing in 1996, is implacably
opposed to the artist, and takes the view that Caravaggio's
pictures are significant only as ammunition in the battle of

the Counter-Reformation against the legitimation of the
Old Church. A slightly more enthusiastic account comes
from Maurizio Calvesi, who focuses solely on Christ.

The published conference papers of a colloquium in
Rome, held in 1996, show what blunders interpretation can
make. Even the secular pictures of Caravaggio's early years
in Rome are given a mystical interpretation, as if not only
vases of flowers but also madrigals about love were really
only the Song of Solomon. Similarly, the goldfinch in the
cage in the New York version of the *Lute-Player* (ill. 30)
becomes Christ in prison.

80 Tintoretto (1518–1594)
The Flight into Egypt, 1583–1587
Oil on canvas, 422 x 580 cm
Scuola di San Rocco, Venice

In painting the *Rest during the Flight into Egypt*, Caravaggio seems to have, as it were, subdued the dramatic impact of Tintoretto's picture of that subject. The Venetian artist depicts the donkey emerging from the political depths. The travel-bundle lies in the center of the picture, near the spot where they are resting by the water, and Joseph is hesitantly fingering the halter.

Even Michael Ondaatje, who calls a character in his novel "The English Patient", 1993, Caravaggio, knows that the Borghese *David* (ill. 2) is a double self-portrait. In this picture some contemporary art historians claim to detect nothing less than a central idea for the conversion of St. Augustine. Thinkers and theologians of Caravaggio's day, such as the Oratorian Cardinal, Baronio, are said to have inspired the artist. Only the long-established – and still unexplained – dislike of intellectuals for Jesuits prevents somebody from seeing St. Ignatius of Loyola's Exercises as the source of the directness of Caravaggio's approach to work.

Whatever form an interpretation geared to the picture as well as to religious tradition might take, we shall explore an example from Caravaggio's years in Rome. The *Rest during the Flight into Egypt* (ill. 81) is an episode in the childhood of Christ which does not feature in the Bible. The music helps us to understand the painting better. As an expert will realize, the music here is a motet from the Marian Vespers. These turn the painting into a Vesper Picture, in which Caravaggio evokes the hours the Virgin Mary spends with her child, the pastoral character of the angelic music and the nearness of sleep and death.

81 *Rest during the Flight into Egypt*, ca. 1595
Oil on canvas, 135.5 x 166.5 cm
Galleria Doria Pamphilj, Rome

The composition fans out from an exquisite angel who is playing music and who has his back to the viewer. He divides the picture centrally with the outline of his right side and his left wing, which projects vertically towards the viewer in the foreground picture area. Nothing grows on the stony ground to the left. Joseph, now an old man, sits there beside a still life consisting of a travelling-bottle and a bundle. He is wearing clothes of earth-color and is holding a book of music, from which the angel is playing a violin solo, whilst the donkey's large eye peeps out from under the brown foliage.

Within the development of Caravaggio as a young man the *Rest during the Flight into Egypt* in the Galleria Doria Pamphilj, Rome, occupies a key position. This subject, which is practically unknown in Italy, demands landscape. In it, the artist gives the figures a slightly less than life-size quality, but makes them as impressively present as he does in his genre-pictures with half-length figures. A strong geometrical layout divides the oblong space into the barren half occupied by Joseph. Almost incidentally, behind the angel's wings, mother and child appear.

Both the pastoral character of the scenery and the angelic music have led some scholars to read the solo score, from which the angel is playing the violin, as a kind of lullaby. Or, to be more specific: whilst old age in the left-hand half of the picture is contrasted with youth as the quintessence of eternal life on the right, the eye is drawn from the stony earth on the left across the world to Paradisical perspectives of eternity. At the same time there are also allusions to the flowers and fruit in the Song of Solomon. The oratorium of the still very young community of secular priests which Filippo Neri had founded, was still searching for the spirit which would give music a totally new value within religious life.

That said, the intimate relationship between the angel and the old man holding the score leads our thoughts in quite different directions. In this figure Caravaggio's nude-painting reaches its supreme expression in a most gentle and beautiful way. That said, he also has his impudent side. A piece of white drapery, fluttering magnificently around his naked body, conceals the unseemly parts of his body from the viewer. If we turn the boy around, however, and imagine what the old man will be looking at, it will be clear how close this angelic figure in a Christian painting is to the Berlin *Cupid* (ill. 31).

The rest during the flight into Egypt is a northern subject. In Italy, landscape took second place to an image of the Madonna, to which Joseph and the donkey were generally loosely connected at some distance. In Venice, whose painting inspired Caravaggio time and again, there is no major example of the rest during the flight into Egypt. Though there probably are a few striking forerunners, by Titian, the *Madonna with the Hare*, for example, in the Louvre, Paris (ill. 79).

To me, however, what seems more important is the artist's harsh confrontation with Tintoretto's famous painting in the lower room of the Scuola di San Rocco in Venice, from about 1583–1587 (ill. 80).

In a critical appropriation of this precursor of his own picture, whose Mannerist inadequacies needed clarification, Caravaggio equated the departure with the rest during the flight. He distinguished the landscape according to the adult figures, with the angel as a hinge between the two. However, in setting out some violin music for this angel to play – and for experts to decipher – Caravaggio was offering a key to the painting's meaning. As in his versions of the *Lute-Player* Caravaggio painted such a meticulous and knowledgeable copy of a music book printed in Rome about 1520 and containing a motet of the time, that, although we can see only the initial Q, we can identify a passage from the Song of Solomon as the text appropriate to the music. As set to music by the Dutchman,

Noël Bauldewijn, it runs: "Quam pulchra es et quam decora carissima in deliciis. Statura tua assimilata est palmae et uba tua botris" (How beautiful, how lovely you are, my beloved, you creature of bliss! As you stand there, you are like the palm-tree and your breasts are like grapes). This quotation from the Bible forms part of the "Vespers of the Virgin Mary". It recurs in famous music pieces, by Monteverdi, for example.

The key word, vesper suggests the office of the Virgin Mary, a form of prayer which played a major role in the day of a pious Christian – especially in the late Middle Ages and the early modern period. Although the pressure of Protestant ridicule had helped to effect the Council of Trent's decision to rethink the whole notion of horary prayer for the laity, the term vesper has survived in the language of German Protestants up to the present day. Whilst the same word – in German – has degenerated into another word for supper, the word vespers actually means the hour of sunset, the end of the day's labors before nightfall. At such a time pious people were expected to meditate upon the flight into Egypt as well as the deposition of the dead Christ from the Cross. Vesper pictures depict Our Lady of Sorrows with her son on her lap.

Caravaggio now merges together both strands of older tradition into a uniquely well thought-through concept. He takes the old relationship of the flight into Egypt to vespers so literally that, instead of depicting the fleeing Holy Family, usual in Italy, he chooses to show them resting, as befits the hour of sunset.

In his painting, the child is replete and the mother exhausted. With his acute appreciation of the everyday, Caravaggio makes the music a lullaby. However, at the same time as he clarifies the liturgical context, he also shows the Virgin Mary experiencing her first suffering during the flight into Egypt – as a prelude to the tears she will shed beneath the Cross.

Ever since the time of classical art, sleep and death have been intimately linked. The everyday subject of a mother and child asleep becomes an indication of things to come, a symbol of death. This transforms the pastoral painting in the Galleria Doria Pamphilj into one of the most beautiful examples of how an artist of genius can make a profound and serious statement through an apparently charming genre-picture.

The text of the music from the Song of Songs, chapter 7, verses 6–7, is as follows: "How fair and how pleasant art thou, O love, for delights! This thy stature is like to a palm tree, and thy breasts to clusters of grapes." Like the secular madrigals of the *Lute-Player*, it describes the beauty of a woman, on this occasion the bride, as recounted by the Song of Solomon in the Old Testament.

If it were only a matter of "How fair and how pleasant art thou!", the angel's music would also evoke the beauty of art. Caravaggio's own contribution to the subject is the naked boy, around whose pure body he drapes an indescribably beautiful piece of white fabric. Accompanied by his violin – in other words, in an art form, music, which is unattainable for the artist, this boy presents a song in praise of beauty. Though directed towards the Virgin Mary, the astonished exclamation "How fair and how pleasant art thou!" might equally be applied to him.

82 Annibale Carracci (1560–1609)
Hercules at the Crossroads, ca. 1595
Oil on canvas, 167 x 237 cm
Museo Nazionale di Capodimonte, Naples

Carracci may have seen the lascivious potential in Caravaggio's exquisite figure, seen from the back, turned the youth into a woman, and then defamed Caravaggio's art by casting her in the role of vice. Or perhaps the younger artist from Lombardy criticized the great painter from Bologna, then felt inspired by the woman figure, with her strong Mannerist overtones, to ask the boy who had modeled the angel for him to pose in a similar way. In that case, Caravaggio's sense of artistic beauty, whose epitome is the youthful nude, would have triumphed over Carracci's moral definition of vice.

Caravaggio's angel (ill. 81) is like a female figure in paintings by Annibale Carracci (1560–1609). In his painting, *Hercules at the Crossroads* (ill. 82) this great competitor depicted – of all things – vice in a very similar way. Yet it is not entirely clear how the two pictures relate as regards the time of their composition, for Carracci completed this painting about 1595, roughly the same time as Caravaggio was painting his *Rest during the Flight from Egypt*.

The angel has come from the world of nude painting, which issues, in turn, from the study of the body and confirms the artist's skill. This art is extended by the still life of the musical instrument, just as a bundle is by a bottle in a basket. The character study of the old man's face is also present as evidence of a form of animal painting which

Caravaggio, as a city-dweller, only rarely attempted. The Virgin Mary and Child may have developed in the same way as the *Penitent Mary Magdalene* (ill. 14). The same young woman seems to have posed for this picture, too, with an infant who is so freshly observed that we suspect he was also painted direct from a model. The synthetic nature of the landscape, with its stony area on the left and, on the right, what would now be called a moist biotope, suggests that the picture has been painted from memory rather than from nature. Just a short while after this picture, Caravaggio was to use the concept of *imitatio* direct from a posed model as the basis for something akin to a new theoretical method of narrative art – or, to put it another way, of historical painting.

CARAVAGGIO AS NARRATOR:
HISTORY PAINTINGS IN ROME

Caravaggio's painting combines a remarkable feature with the Christian religion. The word is made flesh and the supreme being appears incarnate in an ordinary human being, who spontaneously calls other people away from their everyday activities in order to redeem them. In such a case, this God on earth has something to do with the painter who – in Bellori's tendentious description – suddenly recognizes the latent power contained in an everyday subject, a power which can be raised to higher spheres.

Caravaggio's earliest historical painting on a large scale (ills. 83–85) can be interpreted in this way. In the corner on the viewer's right it shows Christ seeing a room where money is changed calling out to one of the men present. The composition functions as a picture within a picture. The genre scene, which is built into the larger painting according to the principles of the golden section, could be cut out of the whole composition if one marked it out from the outline of the figure on the extreme right up to the lower edge of the window which lets in no light. Given the title, "At the Money-changer's", this painting would have been a legitimate subject for a picture from about 1520 onwards, when the Antwerp artist Quentin Massys (1465/66–1530) was active.

When the Son of God intervenes in everyday affairs, he picks out a man who cannot be recognized at first, and whose calling scholars see differently. Some argue that St. Matthew is the young man sitting at the end of the table, engrossed in counting money and not looking up towards Christ. But, like Bellori and others, I believe that the dominating figure behind the table is the disciple. In pointing to his own breast with his left hand, he is repeating Christ's gesture, which Peter, also searching, imitates.

The light in this picture creates a strange effect. There is a window in the rear wall, but it is as dark as if it gave on to a narrow backyard or as if it were night outside. Through the slanting shutters, the left-hand section of the genre scene is immersed in deep black. However, the black shadow falling from an imaginary side wall on the right, which forms a background sloping at the top behind Christ and St. Peter, is even more vigorously black.

Normally we would imagine that just as people come through a door, so light would, too. However, in an irritating but most convincing reversal, hard shadow falls from this direction. This breaks off right underneath the outside contour of the window-shutter, as if the open door had created the shadow. Since, however, both Christ and St. Peter are standing quite close to the wall, they must both be within this shadow area. Without showing any concern for this, Caravaggio lights them from above right. Although himself in shadow, St. Peter even casts a shadow on to the floor into the center of the picture.

Effects which might at first seem to be artificially stage-managed, happening as it were on a theater stage, can be easily explained by the layout of the chapel. The painting hangs to the left of the entrance in a gloomy church, lit only by one window high up in the altar wall to the right. Caravaggio lets the windowless chapel wall project into the picture, without worrying about narrative logic.

Any artist who puts pictures together in such a way that a genre-picture can only be elevated into a biblical historical painting by the device of two figures bursting in with rhetorically demonstrative gestures, is not really a narrative painter. Caravaggio's real subject is the everyday character of the powerfully depicted genre. The event, which picks out a man sitting at the table – first giving him a name among the nameless men surrounding him – breaks into this everyday scene from outside, from the right, as a kind of afterthought. Thus, the unexpected entry of Christ and St. Peter suddenly transforms description into pictorial narrative.

At the same time two principles of Caravaggio's art become evident. Instead of building up his composition out of individual figures in the tradition of the *disegno*, he makes a sophisticated grouping around the money-changers' table, with St. Matthew as the main figure. Free from older pictorial prototypes, he creates continuity in his work out of memories of possible poses and arrangements, which he has tried out in other subjects. In both the St. Matthew picture and *Supper in Emmaus* (ill. 64), the right angle of the table, in foreshortened perspective, serves the artist as the foot of a pyramid above which he constructs a half-length

83 *The Calling of St. Matthew* (detail ill. 84), 1599–1600

On the right, two youths are sitting opposite each other. The younger one, more strongly lit, is leaning back, putting his arm on St. Matthew's shoulder for protection. The youth opposite, with his sword dangling against his left upper thigh, spreads out his legs as he turns right.

84 *The Calling of St. Matthew*, 1599–1600
Oil on canvas, 322 x 340 cm
San Luigi dei Francesi, Rome

In his first public work, Caravaggio was concerned with depicting powerfully
three-dimensional figures by means of *chiaroscuro*. The artist clearly thought very
little of room-corner motifs. This is Caravaggio's only painting to be conclusively
lit from the right. After *Mary Magdalene* (ill. 14) it is the first to depict figures
beneath a sharply defined shadow-boundary against a dark background, and
illuminated by highlights.

85 *The Calling of St. Matthew* (detail ill. 84), 1599–1600

Christ comes in from the right with a majestic gesture, his head in profile and his face in darkness. There have been frequent criticisms of how this handsome head relates to the outstretched right arm. Only as an afterthought, revealed by X-ray photographs, did Caravaggio decide to have St. Peter, who is leaning forward clumsily and imitating Christ's gesture.

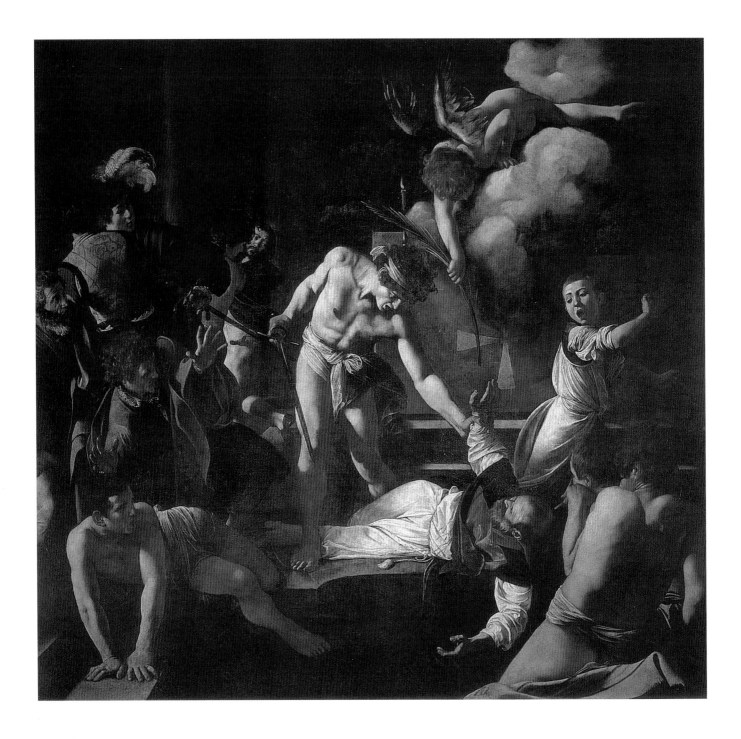

86 *The Martyrdom of St. Matthew*
Oil on canvas, 323 x 343 cm
San Luigi dei Francesi, Rome

The location is the steps up to a Christian altar, with a Greek
cross marked on its frontage, and a candle burning. In the
background on the left, we can just make out the shaft of a
column in the almost impenetrable darkness. Steps ascend
parallel to the picture towards the altar at the back. They also
appear on the left, where churches do not normally have steps.
For this reason, some experts have claimed to detect a baptismal
font in the foreground, especially as men are lying nearby, half-
naked. On the left, a man is leaning against a step. He has no
more concrete a role than two youths crouching in the
foreground on the right, staring at the main action. They form
the right-hand border of the composition, like river-gods on
classical reliefs. The picture's main figure is also half-naked. This
is not the martyr, but his executioner. In terms of stroboscopic
figures, his feet are level with the falling figure to his left. He has
emerged from the depths of the picture to stand near the altar.
This is hard to understand in a pictorial narrative which ought
to be clarifying the passage of time in spatial terms. Insofar as
the murderer has associated himself with the half-naked man in
the foreground, left, the fall of the latter suggests that his power
will also be shortlived.

Yet what Caravaggio is really depicting is the murderer's
moment. He has thrown St. Matthew, a bearded old man, to the
ground. As a priest, he is wearing alb and chasuble. Whilst his
victim helplessly props himself up on the ground, the Herculean
youth seizes his wrist in his right hand, to hold the victim still
for the death-blow. Yet the apostle's attempt to ward off his
murderer, with his furious face, turns into a different gesture as
an angel extends a martyr's palm-leaf to his open hand.

87 *The Martyrdom of St. Matthew* (detail ill. 86)

A boy who acts as altar-boy to the old man, whose service has been interrupted, flees screaming to the right. He is one of those expressive studies of emotion which, like the *Medusa* in Florence (ill. 6), have contributed greatly to Caravaggio's renown.

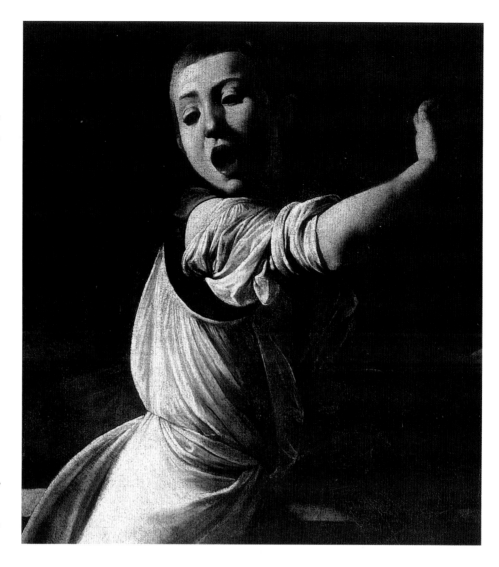

88 (following double page, left)
The Conversion of St. Paul, 1600/1601
Oil on cypress wood panel, 237 x 189 cm
Collezione Odescalchi Balbi, Rome

In the foreground, dressed in Roman leather-armor, which exposes his body as if he were a nude, lies a general, whose crimson cloak is crumpled about him in undignified confusion. At the bottom edge of the picture his helmet has come to rest on its side, so that we can see the skullcap inside. The redbeard is covering his eyes with both hands, to protect himself from the blinding light coming down from the top right-hand corner. It also illuminates an angel, who is holding Christ. Both have emerged from on high so clumsily that a poplar branch has broken under their weight. On earth, Caravaggio confronts them with a white-bearded giant, who is attempting to ward them off with his spear. His un-classical armor, with a golden crescent moon on an oriental round shield, is a reminder that the Middle Ages – though not the Baroque period – equated heathens of ancient times with the Saracens.

89 (following double page, right)
The Conversion of St. Paul, 1601
Oil on canvas, 230 x 175 cm
Santa Maria del Popolo, Rome

This version pays more attention to the development of the action. The helmet lies turned over near Saul's head in such a way that we can imagine it having revolved more than 180°. The sword at his side lies flat on the ground. The rider has, as it were, fallen at a right angle from his horse. His sole companion is an old man, who, moved by the awkwardness of his general having fallen from his horse, tries to lead the animal away, without doing any harm to the rider. The horse also reacts to the miracle. It establishes eye-contact with the viewer, and strides calmly away over Saul, whom, as a result of this event, Christ summons to be the apostle, Paul.

portrait. As the full-size, full-length figures show, legs under the table present a problem, which the artist has avoided in Emmaus and other pictures showing half-length figures.

The smaller group of St. Peter and Christ also reveals an important peculiarity which has nothing to do with the development of its composition, as shown by X-ray photographs. Any artist who, like Caravaggio, creates movement not by physical structure and tectonics but by light and shade, sections of color and areas of profound darkness, will run into problems when painting several figures one behind the other. Caravaggio bunches the figures together, as it were, and depicts only St. Peter. Thus, Christ's head and arm tower behind St. Peter like a set piece. Anyone familiar with the old art of a stroboscopic figure, which can depict several different aspects of a related movement by means of figures standing one behind the other, will understand this brilliant device.

Caravaggio's figure is made up of two bodies developed during the course of a fairly lengthy design process. Interpreters who keep trying to explain Caravaggio's behavior in terms of church politics, see his later addition of St. Peter as a concession to the Papal See. As a profession of commitment, the thrusting figures from the right, the bustling mockery of the Redeemer by the hectic antics of his deputy – will have appeared only to gullible popes.

Caravaggio completed this picture, together with its companion piece on the opposite wall, between 23 July 1599 and 4 July 1600. It was intended for the place where it is still hanging now – the Sepulchral Chapel of Cardinal Matteo Contarelli, who stipulated in his will that the side-walls should be frescoed. After the project had become badly delayed with the Cardinal's death in 1585, Cavaliere d'Arpino (1568 – 1640) made a start on the ceiling frescoes, but did not concern himself with the walls. Probably with Cardinal del Monte's

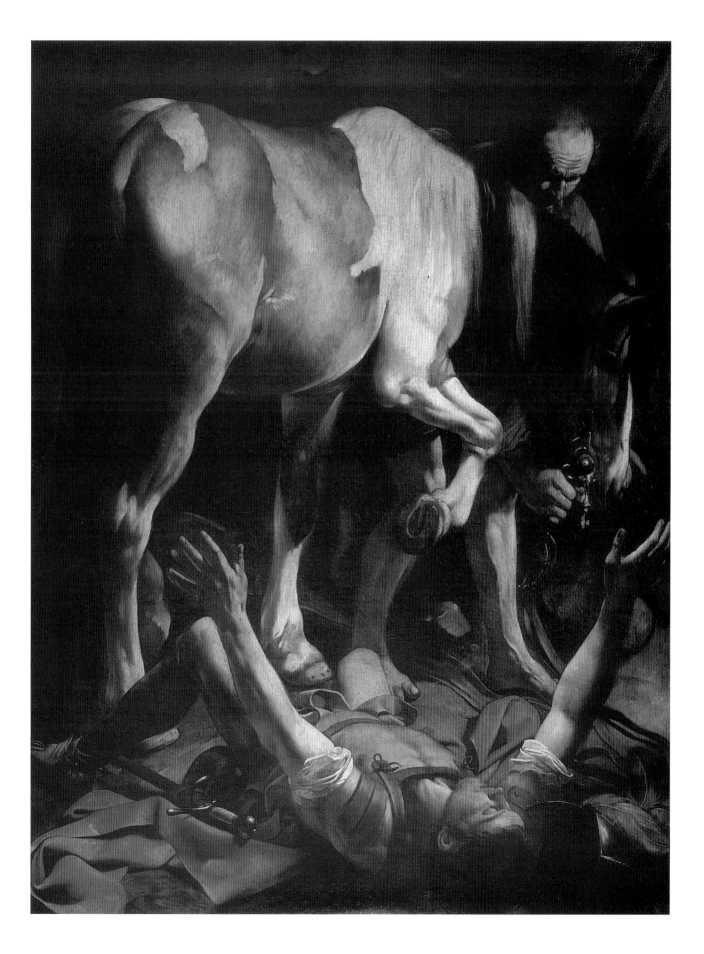

90 *The Conversion of St. Paul* (detail ill. 89), 1601

As compared with the first version, the valid version, painted on
canvas in contravention of the letter of the contract, reduces the
incident to what is visible. Instead of looking like a figure modeled
on a classical river-god, as he does in the first version, Saul now
appears boldly foreshortened. The model Caravaggio has chosen is
markedly younger, though is again wearing Roman leather-armor,
which follows the contours of his body. That said, powerful red
coloring and clearly defined borders, as well as the shadow areas on
Saul's neck, now emphasize the difference between skin and armor.

intercession, Caravaggio received contracts in July and August 1599. These pictures first made Caravaggio an overnight celebrity.

The scene opposite called for a totally different kind of drama (ill. 86). In this picture Caravaggio depicted the *Martyrdom of St. Matthew*. The kind of trouble this picture in a dark chapel caused for artists, too, can be gauged from an account by Joachim von Sandrart. He thought that this was a picture of "The Expulsion of the Money-changers from the Temple", as if he took the central figure of the executioner for Christ.

The figuration is hard to follow here partly because of the tendency Caravaggio also shows in this painting to pack body movements tightly together. The two *ignudi* front right are so close together that it looks as if they have one body with two heads. The half-naked figure lying front left looks a little like a stroboscopic image of the murderer toppling forward. However, he also connects up with the man above him, who is opening his hands in horror towards the man who is being murdered. His movement is echoed by another figure, whilst the two pairs of figures contrast youth and adulthood in men. Even the liturgist stretched out

made the figures look bigger by doing without a large number of figures customary in classical prototypes. By this means he made the expressive character of the painting subtler. He has succeeded very well with the apostle's outstretched hand, whose palm only is illuminated. The artist apparently wished to develop the kind of tension inherent in all Baroque pictures of martyrdom. To achieve this here, he uses the highly unusual motif of a figure being thrown to the ground, then follows the saint's line of vision to open up the main lines of the composition. This also applies to a powerful light-line, which moves across several bodies, is transmitted by the apostle's left leg, and ends in the head of the half-naked man front left. It is equally true of the vertical line leading at a right angle up to the angel. Finally, it also applies to the subsidiary lines, which radiate out from St. Matthew's head and describe parabolic arcs in the direction of both the murderer and the fleeing boy. In other words, the martyr's horror builds into a pictorial dynamic, in which even the magnificently drawn body of the murderer fails to retain its structure. The lighting deprives him of a firm base. At the same time the vision of his dying victim floods

91 *The Crucifixion of St. Peter* (detail ill. 92), 1601

Caravaggio has painted St. Peter's body with his astonishing feeling for anatomy and the skin structure of an elderly male physique. At the same time, he has chosen the very instant when the Prince of the Apostles is raised into the undignified position in which he will be crucified – upside-down.

preparing to die, as well as his ministrant, act as if the figure of the boy draped in white fabric were trying to wriggle free from St. Matthew's movement. Finally, the angel with the small arm of a child, holding out a palm branch, is skilfully related to the terrifying, fully grown arm of the murderer as he seizes the martyr.

This is certainly not a traditional sort of composition. For it, as the X-ray photo shows, Caravaggio suppressed a triumphal arch in the center of the picture. He also

over his body from his knees up as far as his arms and head. Critics often overlook the fact that this picture has nothing to do with the execution practices of established authorities in Caravaggio's day – but instead depicts murder, assassination. The half-naked man with the sword embodies a coarseness which the artist does not usually give his nude figures. In other words, Caravaggio makes a distinction between the nakedness of Bacchus or St. John the Baptist and that of a heathen murderer.

Shortly after his commission to paint the side-walls of the Contarelli Chapel, Caravaggio received a similar commission for the Cerasi Chapel in Santa Maria del Popolo. The smaller vertical format of the pictorial areas allowed the artist to paint the figures life-size only by limiting their number. It is certainly true that both *The Crucifixion of St. Peter* and *The Conversion of St. Paul* take place in the open air. That said, Caravaggio suppressed landscape by obstructing distant views through backgrounds as dark as night, even though night is not mentioned in any of the historical accounts.

However, the viewer hardly notices this breach of narrative fidelity. Literature might well carefully ponder much less significant details, but it passes over this distortion of the facts in silence, for the artist's interpretation triumphs over any expectation that a picture will give a sensible account of an historical event.

At least two versions of virtually the same dimensions exist of *The Conversion of St. Paul*, one in wood and the other on canvas. We do not know whether the first version (ill. 88) was rejected by the artist or the patron. It is one of Caravaggio's few landscapes. The evening sky, in which the domes of Damascus can be glimpsed in the far distance on the right, is in great turmoil. Here, Christ reveals himself to Saul to ask him why he is persecuting him, and he transforms him into the Prince of the Apostles, Paul. A large-leaved plant on the ground and a poplar tree at the picture's left-hand edge, which may allude to the name of Santa Maria del Popolo, are also evident.

After a lot of speculation about whether this painting was by Caravaggio at all and not, for instance, by Orazio Gentileschi, it is now certain that it was intended for the Cerasi Chapel in the church of Santa Maria del Popolo. According to the contract of 24 September 1600, Caravaggio was supposed to paint both pictures on cypress wood. This applies to this example, whereas in the church itself paintings on canvas are hanging.

The incident is narrated in a very round-about way. In the middle-ground, the white horse has swerved round after throwing its rider off, it prances restlessly, and turns its head towards the light which comes from heaven. It looks much too small in relation to the figures, and its anatomy is so badly conceived that only the color of its pelt indicates that head and hindquarters belong to the same animal. Saul rears up, but at the same time leans back against his soldier's spear and knee. The foreshortening of Saul's body is just as unsuccessful as his legs, which are curved like sabers and disappear into the darkness. A mailed hand, a crumhorn and a lance, which all peep out of the dark, suggest non-participants to the left. Normally, Caravaggio refrained from suggesting figures-off in this way.

In his use of lighting effects, Caravaggio overdoes his greatest artistic technique. The landscape and the figures are lit differently. This makes the landscape degenerate into something incidental, whilst the lighting on the figures is debased into a clumsy theatrical effect. Shadows virtually dismember the figures. The overall result is that, despite its magnificent concept, the picture cannot be taken quite seriously. Caravaggio repeatedly

tried to capture momentary events. His tendency to take this task a little too literally shows itself here in the breaking branch with which he dramatically emphasizes how suddenly God intervenes. Yet the gravitational weight of Christ transported off to heaven – together with his angel – contradict our notions of how material heavenly bodies really are.

Even though Caravaggio remains true to himself in this respect even when painting the miraculous scene of *The Conversion of St. Paul*, he is unable to set out the overall composition according to his own principles. Instead, like all painters of historical pictures, he has to combine different studies – direct from a model, as the skin color of Saul's hands and lower arms shows. One drawback – though a modern interpretation might see it as a revealing plus – of this early *Conversion of St. Paul* is that Caravaggio does not try to cover up the fissures and contradictions within his picture, all of which are fundamental to his methods. Taking a term from the early twentieth century, we could speak of a collage of sections studied in advance.

The second version of the same subject, which Caravaggio obviously completed before November 1601, looks like a radical criticism of his first attempt (ills. 88, 89). In this version the artist, who is a master only of what is visible on earth, restricts himself to Saul's reactions. Physical ecstasy, which, as in *St. Theresa* by Bernini (1598–1680), is not unlike erotic ecstasy, overcomes the general, who is still young. In foreshortening the lying body Caravaggio shows his familiarity with similar experiments in perspective, as practised by Italian painters for many years.

That said, he adds the decisive device of *chiaroscuro*. He casts luridly bright light on to Saul, who lies stretched out with his legs open, his arms spread out wide, and shutting his eyes to block out the heavenly light. Diffuse streaks in the upper right-hand corner are enough for him to suggest the direction from which the light is falling into the picture. It illuminates only the ground, rock, boulder, clothes and living creatures.

Caravaggio's blatant contravention of traditional Christian painting, which expressed heavenly light in terms of beams and, in pictures set at night, contrasted objects or figures against a painterly black background, may have something to do with revolutionary discoveries in optics. Even today, one of the most astonishing discoveries about light is the fact that even the strongest light will be visible in a black space only if a colored object is placed in its path. Beams are caused by dust and moisture. However, as soon as these atmospheric disturbances are removed, light will be visible only on the colored surfaces on which it shines. In this picture, the helmet proves that Caravaggio had wrestled with discoveries of this kind – for its blackness allows only reflections, not full illumination.

With impressive artifice, Caravaggio reduces the horse, to a proportion in keeping with the human figures. Caravaggio fills out the verticals on the left with the animal's hindquarters and back, filling the horizontals above in such a way that there is not much space left for the background, which falls away in

92 *The Crucifixion of St. Peter*, 1601
Oil on canvas, 230 x 175 cm
Santa Maria del Popolo, Rome

With horrifying cold-bloodedness and a great instinct for the problems of gravity, Caravaggio shows three executioner's assistants erecting St. Peter's cross. The Prince of the Apostles has had four nails driven through his hands and feet. Now, at his own request, he is to be crucified upside down. Of Heaven, which, in the case of St. Matthew, sent down the angel with a martyr's palm branch, there is no sign here. The harsh light, which makes the figures stand out against the dark cliffs, seems to have no redeeming power. As in *The Conversion of St. Paul* (ill. 89), which forms the companion piece to this painting, the artist has distanced himself from historical fact. He has sound artistic reasons to envelop the event in darkness – as if his painting were competing with sculpture.

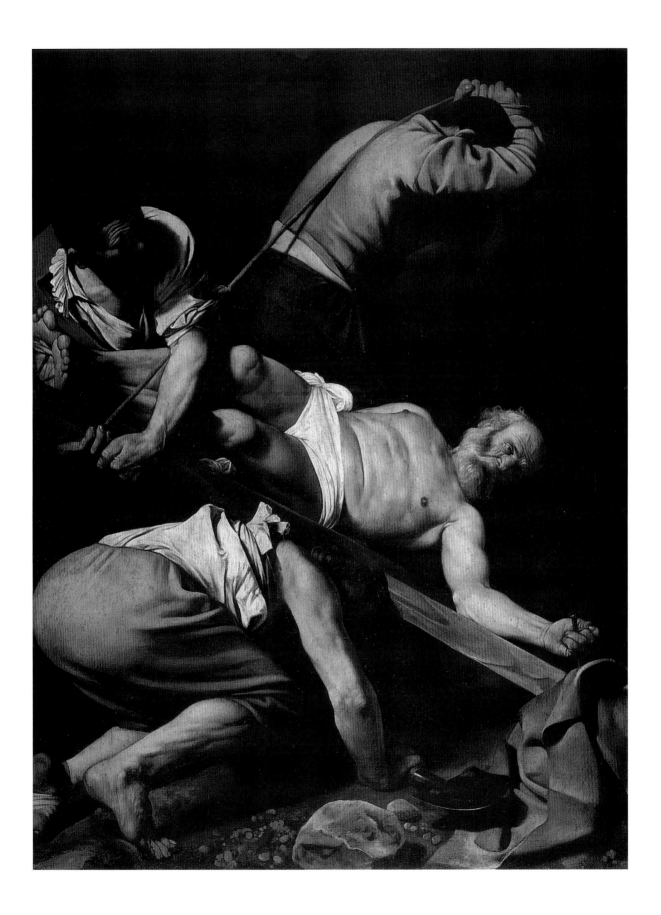

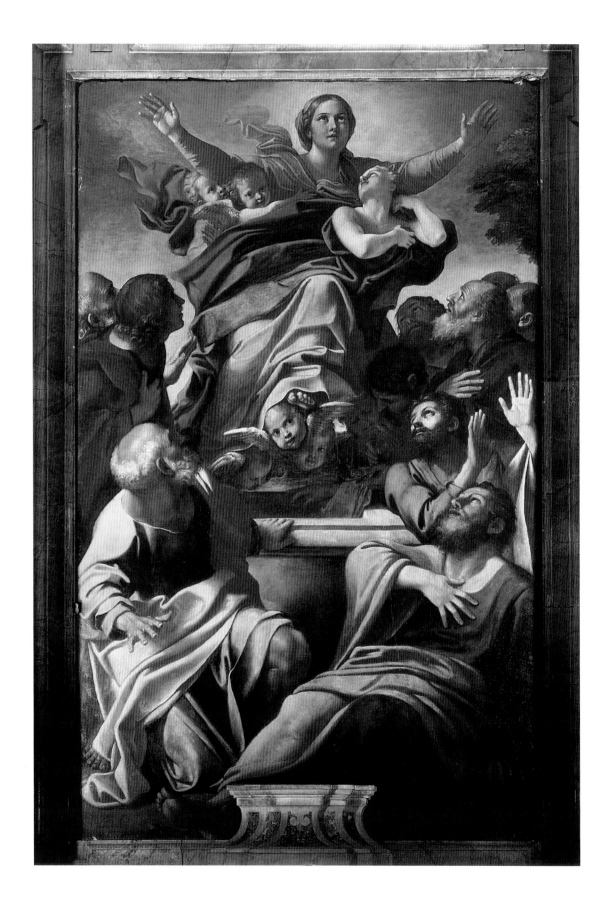

blackish-brown tones. The horse lowers its head to its master, so that the pictorial surface can be used to maximum effect for majestic height.

Instead of a white horse Caravaggio painted a piebald. White shines on its pelt, painted in muted earth-colors, on its feet, over its back, and on a small patch of its hindquarters. Even in the horse's mane, colors vary.

In this version, Caravaggio tried to consolidate the spatial composition, which also failed miserably in the first version. He aligns the foreshortened figure of Saul at a right angle with the horse. Its body acts as the background for the event happening to the main character. Accordingly, the horse adjusts its position to suit the angle in which Saul is lying, but is also gently turning its head. By these means the artist is able to stabilize the pictorial space.

Both the lighting effects and what remains of the narrative blend very well together. Although Caravaggio refrains from beams of light, the human figure and horse, both in the light, reproduce their effect. The apparition has not only thrown the general on to his back. It also fills him with a glow which is expressed by means of light. He tries to grasp it, as if it were a material quality, though the painter can depict it only in Saul's illuminated hands.

The horse responds to its rider's physical shock with supreme caution. The artist utilizes the fact that in a turmoil horses are careful to avoid trampling on people. With an almost uncanny look, which shows no understanding for the fallen rider but at the same time identifies with the viewer, the animal strides off, led by an impassive stable-lad, away from the miracle on the ground. The very gentleness of the horse's movement proves that Caravaggio, far from being the master of the terrifying instant, is at his most effective when surprise switches into careful observation.

As regards a first version of this picture's companion piece, *The Crucifixion of St. Peter*, (ill. 92) opinion is more divided. In many respects the painting on canvas which has found its way into the church seems very well suited to *The Conversion of St. Paul* (ill. 89). The artist is concerned solely with the apostle and the three executioners' assistants. After the not very successful foreshortenings in the *Martyrdom of St. Matthew* (ill. 86), Caravaggio tries out this well-established technique for depicting bodies with a new strength here – and to very much better effect.

An imposing, large figure seen from the back – one who also flouts the conventions of decency, or respectability – opens the picture. This man, with his flowing blond hair, is being assisted by a man with a rough, wrinkled face as well as short hair and a beard, who has put his arms around the cross to lift it. In the process, he looks up towards the right, where a third man, whose face is also hidden, is pulling a rope. Only a spontaneous artist's vision could depict two faceless individuals in such a way – an artist who does not wait until the men engaged in erecting the cross can be seen properly.

Peter, the Prince of the Apostles, is depicted skilfully foreshortened. With only his left lower arm concealed by one of the assistants, St. Peter's body is shown complete from his nailed feet to his head. Critics who accuse Caravaggio of being hostile to bodies should be reduced to silence by this sensitively observed nude. The artist has registered the nails in feet and hands with horrifying precision. St. Peter is forced to look for himself at this terrible method of fastening one thing to another. His deeply furrowed head turns towards the fingers of his left hand, clenched around the nail. Anyone who remembers that St. Peter, who knew he was about to die on the cross, expressed the wish to be crucified upside down, and not, like his master, with his head uppermost, will see the old man's anxiety that the nail might not hold, rather than his contortions of agony.

This invests Caravaggio's perfectly valid depiction of the *Crucifixion of St. Peter* with a profound meaning. To understand it would need a recapitulation of the whole story of St. Peter in Rome. He wanted to flee from the imminent persecution of Christians. However, in the famous legend of "Quo vadis" he was stopped by Christ himself, as he was carrying his Cross, because he wanted to be crucified again in Rome.

The blue fabric draped at the bottom right is not without deeper meaning. It is one of St. Peter's traditional colors, but at the same time interrelates heaven with the dignity of the robe he wears. Turning to Christ, we should not forget that at his Crucifixion the victim's coat at the foot of the Cross also played a significant role.

The Cerasi Chapel receives hardly any light through its own lunette window with the family coat-of-arms, though more from the church's transept – especially in the afternoon. This means that there is no unambiguous light source. In other words, in the picture of St. Peter it is no surprise that the light comes from the left. Illuminated centrally, the picture of St. Paul, however, which adorns the right-hand side-wall, fits the ambience perfectly.

Caravaggio's paintings do not stand alone. The artist's great competitor, Annibale Carracci (1560–1609), of all painters, received the commission for the main picture, an *Assumption of the Virgin Mary* above the altar (ill. 93). This reminds us of the difference between narrative painting and the altarpiece. Caravaggio's paintings do not allow us to address the apostle while praying. St. Peter is too preoccupied with the dignity of his crucifixion, and St. Paul much too enraptured. Our only eye contact is with the horse of the young general, who will only very much later take on the majesty of a Prince of the Apostles. These pictures are narrative only in the sense that they refer the historical event back to the visible. Yet instead of using narrative to intensify what has happened, they concentrate on observing unforgettable genre-painting images. By eliminating the divine element, the artist forces his viewers to focus initially on what happens on earth. The appreciation thus gained can then develop into the kind of astonishment which makes Caravaggio's paintings acceptable even to those people who otherwise reject his art.

93 Annibale Carracci (1560–1609)
Assumption of the Virgin Mary, 1600–1601
Oil on canvas, 245 x 155 cm
Santa Maria del Popolo, Rome

There is a radical difference between the Bolognese artist's beautifully bright colors, the powerful blue and red he applies, as against Caravaggio's earth-tones, which he varies only by blue on St. Peter and red on St. Paul. It is true that he also uses green as a complementary color to red. Furthermore, St. Peter's yellowish flesh tint seems like an indication of the complementary color to blue. All in all, then, we can recognize a conscious use of color on Caravaggio's part over and above his use of *chiaroscuro*. Yet to view his pictures needs a different form of dedication from the jubilation which Annibale Carracci proclaims.

THE ALTARPIECES FOR ROME

94 *Matthew and the Angel*
Oil on canvas, 295 x 195 cm
San Luigi dei Francesi, Rome

The angel above, there to communicate God's word, dominates the picture. Skilfully, Caravaggio shows his explanatory hands occupying the central axis, again demonstrating the artist's precise instinct for geometry. The sudden haste with which St. Matthew follows his inspiration and starts writing, determines the pictorial center. Caravaggio presents the full-length figure as a *trompe l'oeil* effect, as if he were appearing above the altar from a perspective which corresponds to eye-level in the chapel. The viewer gets a good view not only of the stool which is poised shakily over the top of a step, but also of the large table placed in the room at an angle. This continues a long way towards the right behind Matthew. So does the Gospel, as if Caravaggio wanted to make sure it was obvious.

In 1599 Caravaggio's commission for the Contarelli Chapel was limited to historical paintings for the side-walls, as marble sculptures were initially meant to adorn the altar. However, the Evangelist intended for the Contarelli Chapel that was delivered by the Flemish sculptor, Jacob Cobaert, did not meet the requirements. The authorities thus approached Caravaggio again, and made a contract with him on 7 February 1602 for an altarpiece to be completed as early as the Pentecost festival, on 23 May of the same year. But his picture also caused displeasure.

Marchese Vincenzo Giustiniani offered to pay the same sum already paid for the painting installed at Pentecost. For this sum he received the rejected picture, whilst by 22 September 1602 payment could be made for Caravaggio's version which still adorns the chapel (ill. 94).

Even in photographs, the rejected painting can irritate modern viewers. Caravaggio sees the Evangelist as such a ponderous figure that there is almost a wrestling match when the inspirational angel tries to persuade the reluctant instrument of redemption to write down God's word. The version that dates from spring 1602, is, as it were, corrected by the picture that followed that summer and was paid for that autumn (ill. 94). Now the Evangelist can write, he only has to listen to the words of the angel.

One more thing changes. The Berlin canvas (ill. 95) depicted a dark-haired evangelist in the prime of life. His faun-like features, which are reminiscent of Socrates, hardly match the longish face of the well-dressed money-changer whom Christ is calling (ill. 84). In the available version the artist depicts the same bald-headed man he had pose for the Uffizi *Sacrifice of Isaac* (ill. 55). By the way he paints his face, Caravaggio makes it seem probable that the Evangelist looked like this after losing the locks which he had when seated at the table in the Calling.

Whilst Caravaggio composed the Berlin version from in front, he tried now to make the Evangelist above the altar as convincing as in a *trompe l'oeil* painting. Caravaggio draws our view to the upper edge of a stone step, observing the full-length figure and the table's surface from below.

Even if the picture that was finally accepted seems more conventional than the destroyed Berlin example, the organization of space and the spontaneity of movement compare very favorably even with the first-rate *Calling of St. Matthew*, which hangs next to it.

According to the recently discovered contract with Laerzio Cherubini, Caravaggio's largest painting for Rome was completed between the Cerasi Chapel and the two versions of the altarpiece for the Contarelli Chapel. This is the *Death of the Virgin Mary*, now in the Louvre, Paris (ill. 97). On 14 July 1601 the artist committed himself to delivering the painting in June 1602.

The *Death of the Virgin Mary* did not stay in its intended home for long. Today, the Chapel is adorned by a painting on the same subject, which Carlo Saraceni completed for the same patron. Precisely because this painter did not close his eyes to Caravaggio's influence, we can see his picture as a critical corrective to the *Death of the Virgin Mary* in the Louvre. Baglione reported that the Barefooted Carmelites had rejected Caravaggio's work. In 1607 the great Flemish painter, Sir Peter Paul Rubens (1577–1640), saw to it that the Gonzagas of Mantua purchased the painting, now removed from the altar. Before it was transported away, the painting was exhibited in Rome for another week, because the artists in the city wanted this. During this exhibition the picture impressed even the Mantuan Ambassador, who had, on his own admission, at first failed to appreciate its worth.

In this painting, Caravaggio's principle of genre-painting reaches its apex. For him the history of salvation expresses itself purely in terms of what is visible – why the Virgin Mary is really dying. Only the curtain in this picture has no straightforward genre-painting meaning, because it does not serve the purpose of screening the dying woman. Thanks to its rich scarlet color, which wins out over the earth-colors and even Mary's red dress, the magnificent drapery assumes the value of a luminous signal, which surpasses the profound despair of the apostle, who remains in the dark.

The fact that the Barefooted Carmelites rejected one of Caravaggio's pictures should warn us not to assume

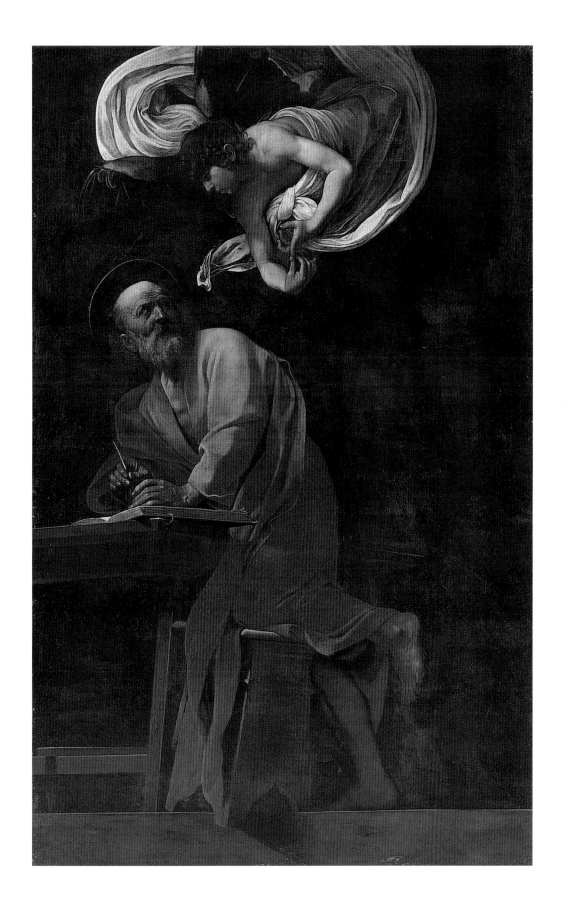

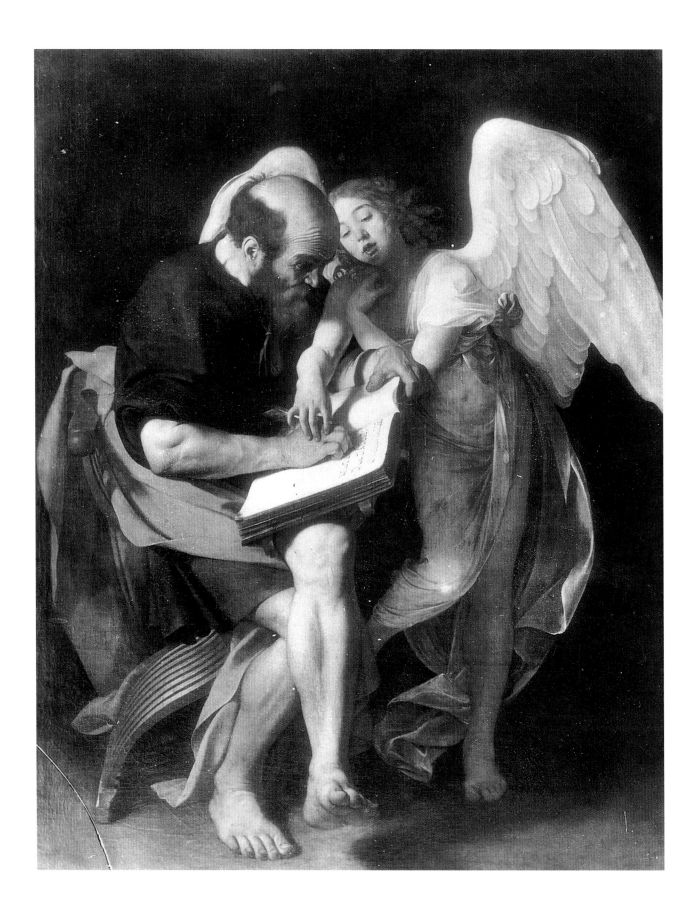

that Catholic ideals about reforming conditions of poverty are the artist's own convictions. Although Santa Maria della Scala is in one of the poorest areas of Trastevere and used to belong to a charitable institution, the Casa Pia, an honest look at earthly desperation was most unwelcome there. It was precisely the poor people and their carers who rejected the picture, whilst artists and art lovers in Rome recognized its extraordinary qualities. A glance at churches in poor areas nowadays will confirm the fact that those people who are really poor are no more able to endure seeing their destitution the subject of a genre-painting than their benevolent carers. Only a certain distance from the suffering allows one to objectify it into art. In his version, completed for the same patron, Laerzio Cherubini, shortly after the removal of Caravaggio's painting, Carlo Saraceni showed what the Barefooted Carmelites and the poor people in Trastevere really wanted (ill. 96).

After the Jesuits, the Oratorians were the most important mouth-piece of the Catholic reform in Rome. Their *chiesa nuova*, Santa Maria in Vallicella, once housed the *Entombment of Christ* – successfully and without any dispute (ill. 99).

In this case we are well informed about the circumstances surrounding the commission. Francesco Vittrice ordered the picture for a side chapel, which his uncle, Pietro (died 26 March 1600), had purchased for the family. The painting was completed between 19 January 1602 and 6 September 1604. Transported to Paris in 1797, it remained in the Vatican after its return to the Pope in 1815. Both the patron and the artist had to adhere to the proscribed decoration of the church with this pcture. The chapel was dedicated to Our Lady of Sorrows. This makes the subject of the painting all the more astonishing. It depicts the darkness of the grave, the heavy tombstone, which juts out frighteningly into the viewer's vision, the dead Christ and the men who lay him to rest, as well as the lamentation of the women present – but only then does it show the Holy Virgin herself, albeit in the impressive position of the picture's geometric center.

Instead of the lament associated with the Marian Vespers, Caravaggio chose to depict the one connected with the compline of the Passion Office, in other words, the Station heralding the onset of night, when Christ was laid to rest in his tomb. Narrative mingles with genre-like observation. This picture, with its profound affinity with the missal sacrifice, in which this dead man is transformed into bread and wine, will offend any sensitive believer. Projecting out of the painting we see the stone slab which forms the basis for the full-length figures. This will seal up the tomb of Christ, who died on the Cross, after he has been lowered into the deep darkness of the tomb, where the priest's altar stands.

Amongst so much dense physicality, which varies from the warm orange of the men's garments to a bright flesh-tint, the only figure conceived in a colorful way almost falls by the wayside. This is St. John, who puts his right hand under Christ's shoulders, and lets his left hand rest on the body, as if meditating. He is wearing a blue tunic and a red cloak, which makes a striking

impact in the center of the painting, set against the white of the death-shroud. The unity of the body dissolves in the contrast of colors and fabrics, which are separated by deep shadow. Furthermore, Christ's favorite disciple is bending his head so far forward that light falls only on his forehead and nose. Thus, his face does not offer a whole entity to be contemplated piously.

Caravaggio's altarpiece for Our Lady of Sorrows in Santa Maria in Vallicella reflects, with frightening clarity, the presence in the Eucharist of the sacrificed Christ suffering his Passion. It also proves that the artist was able to visualize – in the truest sense of the word – a fundamental theological idea by means of bodies and lines of vision. At the same time, for the altarpiece of roughly the same size to St. Anne in St. Peter's, he had to combine a theological speculation with the presence of the saint who plays no part in the proceedings.

The picture (ill. 103) is based on the first Biblical promise of a Savior. After Eve's temptation by the serpent, the Lord of Creation curses the animal with the words: "And I will put enmity between thee and the woman, and between thy seed and her seed; it shall bruise thy head, and thou shalt bruise his heel" (Genesis 3, 15). During the Reformation it was disputed whether Mary or Christ crushed the serpent's head. A papal decree decided that it was the Savior together with his mother, Mary.

Certainly, the boy's eagerness to reinforce the impact of his mother's foot by stamping his own little foot without losing his balance, adds a wonderful note of sympathy. Yet the artist is surely exaggerating when he makes the heavy breasts of the Holy Mother of God push out of her wide décolleté over the child's little head.

The Palafrenieri, or grooms in charge of the papal stables, were displeased, so that this major work by Caravaggio hung in St. Peter's Cathedral in Rome for only a few days. This had nothing to do with papal directives. From there the picture went direct to the gallery of the nepotistical Cardinal Scipione Borghese, who, under Pope Paul V (1605 – 21), also arbitrated on matters of art from 1605 onwards.

In a quite different way Caravaggio also took a literal approach to the *Madonna di Loreto* (ill. 104), which he was supposed to paint for the Church of Sant' Agostino in Rome, and which still to this day occupies its old place adorning the altar in the side chapel to the left. In this picture, only the pilgrims of Loreto, a place of pilgrimage in the Marches, remain. We see nothing at all of the legend which centers on this shrine and its Madonna. Angels had to transport the holy house in which the Annunciation had taken place, from Nazareth to the Adriatic coast, in order to shelter it in Loreto. The painting would also need to show something of the *Madonna di Loreto* as the patroness of the battle against faithless Protestants. But all this, all the things that small-scale votive pictures depict, was not part of Caravaggio's art.

The artist reduces the cult of the *Madonna di Loreto* to her outcome, the pilgrimage to Loreto, and the warm affection felt by the Virgin Mary and her son, who gives his blessing to the pilgrims. A vague indication that the

96 (below) Carlo Saraceni (1579 – 1620)
The Death of the Virgin
Oil on canvas, 459 x 273 cm
Santa Maria della Scala, Rome

Mary is bedded on what looks like a throne. Her death happens in a state of rapture which allows her to hear the music of the angels. Above her in her dark room, clouds gather, from which *putti* with harps and roses flutter down, in order to receive unscathed the body of the Holy Mother of God in heaven.

95 (opposite) *Matthew and the Angel*, before Whitsun, 1602
Oil on canvas, 232 x 183 cm
Kaiser-Friedrich-Museum, Berlin, destroyed in the War

The slow-witted figure of St. Matthew, who is naked below his knees and elbows, and dressed in an ordinary cowl, acquires no real dignity even through the mantle laid over his folding-chair. With his eyes wide open, and with heavy hands, he peers into the thick volumes on his knee. It is not easy to believe he can write. His angel has the greatest difficulty in leading his untrained hand to put the word of God into letters, which are far too big. In doing so, the angel inclines his charming figure, whose shape can clearly be seen beneath his light garment. And so can his androgynous face and long locks of hair, in contrast to the rough bald skull of St. Matthew. Against the almost black background, which has been trimmed on the left and at the top, we see the exquisite white of his enormous wings.

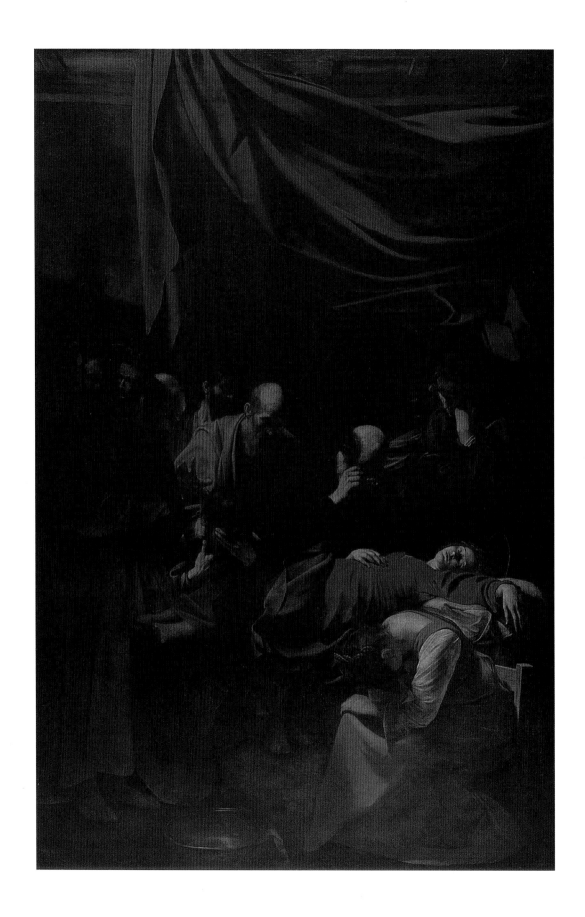

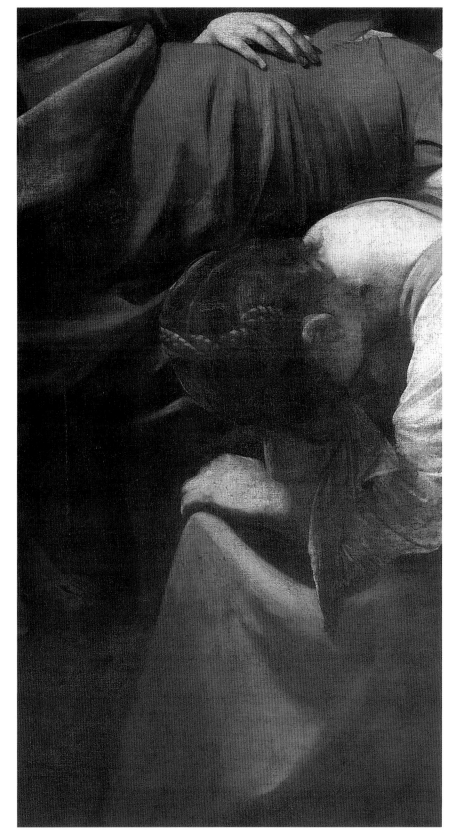

97 *The Death of the Virgin*, 1601–1602
Oil on canvas, 369 x 245 cm
Musée du Louvre, Paris

The fact that the Virgin Mary could die, like any other woman, was something the Church was reluctant to imagine. In Caravaggio's case, however, no light from heaven can make up for the death of the Madonna. All eyes are on a dead woman whose body shows the signs of a death-struggle. As if death had come suddenly, the dying woman was laid on a bed too short for her. A piece of cloth, which is earth-colored and therefore not quite suitable for the Queen of Heaven, is lying forgotten over her lap and upper thigh.

The Virgin's bodice has been opened to help her breathe more easily. Her skin has discolored into a greenish tinge. Her face is swollen, and has sunk to the side, where her left arm is grasping at thin air, whilst her right hand is resting on her body. Her face, with eyes closed, is certainly turning towards the viewer, but anyone expecting help and intercession from the dead Madonna will be praying in vain. The universal horror this depiction aroused can be judged from derogatory reports that Caravaggio's model for this painting was a prostitute dragged from the Tiber.

On the left, one one of the Apostles – open-mouthed – inclines his head, which follows the model of the first St. Matthew picture, towards the dead Madonna. Only a small part of his bald skull is illuminated, with some light reflected around the top of his head. Beside him, however, light floods over the next Apostle, who has sunk to his knees, in strong orange tones. He has buried his mouth and eyes in both hands, so that only his neck, right hand and two fingers of his left hand are in the light. Another Apostle is standing close behind him – Caravaggio used him as the model for his second St. Matthew (ill. 102). He is expressing horror through his open hands, which form a strong shadow against his cloak. Once again, the light illuminates the figure's bald pate more than his face.

The same applies to the figure who is sinking down directly over the Madonna's body, and for whom the first St. Matthew was again the inspiration. Caravaggio brilliantly combines two motifs which he has prepared further left. These are the gesture of this figure's right hand, now reaching for his eyes, and the tension created by the switch from illuminated sections of skin to the black hair. In the same way as Christ's favorite disciple stands beneath the Cross, a young man with thick locks, propping his head on one hand, stands behind the Madonna's head. He is probably meant to be St. John, to whom Christ on the Cross entrusted his mother for all time.

98 *The Death of the Virgin* (detail ill. 98), 1601–1602

In the foreground a woman, probably Mary Magdalene, who was sometimes described as an Apostle, is lamenting – drained of emotion and without any hope of redemption. However temporary the Madonna's makeshift bed may seem, a large brass bowl and towel are lying ready for the washing of her corpse. The woman who has been summoned to do this is incapable of completing her task. Overwhelmed by her pain, she has let her head fall on to her hands. She has already rolled up her sleeves a little way. Yet the deep emotion she is feeling at the death of the Madonna has left her in helpless grief.

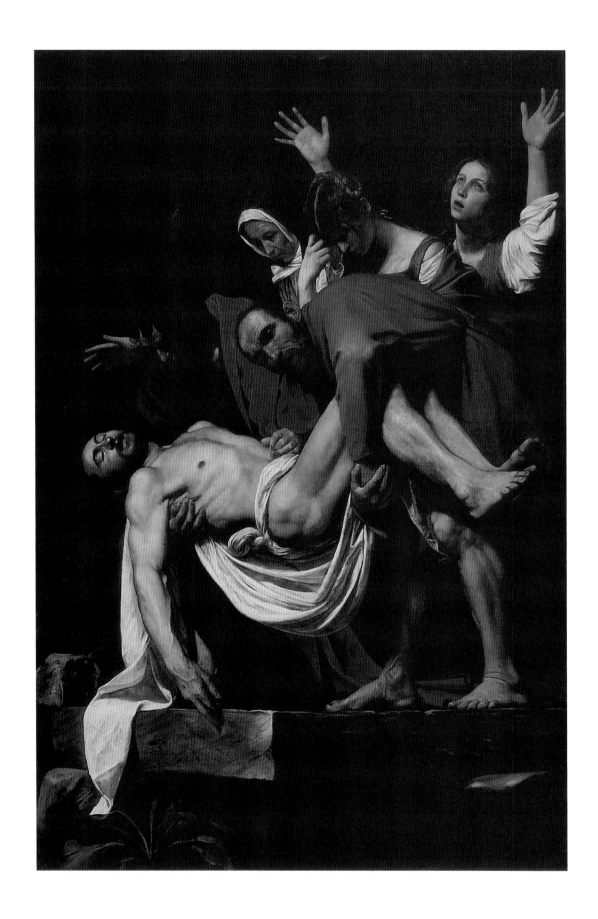

99 *The Entombment of Christ*, 1602–1604
Oil on canvas, 300 x 203 cm
Pinacoteca Vaticana, Rome

In this altarpiece, Caravaggio shows – with alarmingly sharp observation – the dead Christ being laid naked into his tomb. He depicts not only the muscular corpse but also the powerful gestures of the man who is lowering the dead Christ into the grave. This figure might well be one of the two biblical characters, Joseph of Arimathea or Nicodemus. He looks at the viewer on behalf of all the other figures in the pictures, his eyes heavy and dim with tears of pain. As a result, the picture appears to be looking at the viewer through him, rather than the other way about. An expression of such utter bewilderment will repulse any pious worshipper. It will also remind him or her to comprehend the full extent of the agony which is being expressed in three different ways by the three women behind the active figure in the foreground. In church, however, a painting like this would offer quite a spectacle. We need to imagine it during Mass. The priests and their altar-boys in their liturgical robes would play a prominent role. From above their heads there sinks down the dead Redeemer, full-size and showing all the horrifying signs of suffering and death – his flesh and blood returning to the altar in the form of Sacramental bread and wine. Christ's favorite disciple, St. John, totally enveloped in darkness, is holding him.

100 *The Entombment of Christ*, (detail ill. 99), 1602–1604

The stone slab makes its appearance in the picture with terrifying power. According to one's attitude, one will detect in this painting either irreverence or profound religious bewilderment in the face of the death of Christ, because it presents the meaning of the sacred event – the unique occasion – which lies at the heart of Church ritual, in a tangible visual form.

holy house in the Loreto legend is Mary's house in Nazareth, is evoked by the unusual location. The Madonna is leaning against a monumental reveal at her front door (ill. 104).

The picture has an unusual layout. Reading it from left to right, we first see the Holy Virgin and her child lingering in the doorway, illuminated as if by accident, then the two pilgrims nearby. Caravaggio suggests that his *Madonna di Loreto* is a simple woman, waiting for her worshippers. The weight of the large Christ child in Mary's arms makes it clear how humanly this Virgin Mary is experiencing the incarnation of the Savior. By raising her one step higher, the artist creates just enough distance, whilst leaving Mary still in the sphere of ordinary people, so that the fingertips of the man praying almost touch Christ's left foot.

Caravaggio makes the middle of the composition an architectural set piece. However, by showing it very dilapidated, he robs the holy house of Loreto, which the building is meant to suggest, of the magnificence with which pious fantasy has endowed it. Together with the step, the edge of the stone separates the two worlds. On it falls the powerful shadow of the Holy Virgin, before her the face of the pilgrim, glowing with passionate joy.

The artist further characterizes the difference between the pure virgin and the pilgrims by his subtle use of different materials. The pilgrims are wearing coarse cloth, whose color looks dull and dirty after their journey. Only the cape which the man has round his shoulders bears any relation to the fine fabrics Mary is wearing. Does this suggest that pilgrimage is an ennobling activity? The Madonna, on the other hand, is robed in a dark gray silk dress, with red velvet sleeves.

Although the cut of this dress does not reveal the luxuriousness of upper-class society, the very softness of her flesh-tint indicates a social distance which reinforces Mary's beauty, youth and purity.

Only if we take this possible aspect into account will we understand the deeper human meaning which Caravaggio has given his *Madonna di Loreto*. Along with the miracle-bringing house from Nazareth, which was not a palace, the heavenly Virgin Mary, in all her beauty and with the Savior in her arms, has descended, in order to look upon the pilgrims a step below. She has also come down to show them her son, so that he can give them his blessing. Although at first sight this might look like a genre-scene in the doorway of a house in a dark side-street, the contrast between the sublime nobility of Mary and her child and the coarse earthiness of the pilgrims invests the painting with a high degree of solemnity. This relates to the surprise element of a sudden vision of God, which Caravaggio expressed less subtly in his early work, the *Supper in Emmaus* (ill. 63).

Caravaggio's highly developed artist's instinct for what is only apparently a genre-picture, through which the incarnation of God reveals itself in human form, is shown to perfection by the apparently casual manner in which he moves his Madonna figure (ill. 104) out of the picture's center to the left, as if this were a painting with half-length figures, with only the centrally-placed architecture supporting her. By hinting, in the expectantly averted faces of the pilgrims, that they are about to have a vision of God, and by making an important pictorial theme of the way both the Madonna and her child look at them, the artist is showing his concern with the act of seeing.

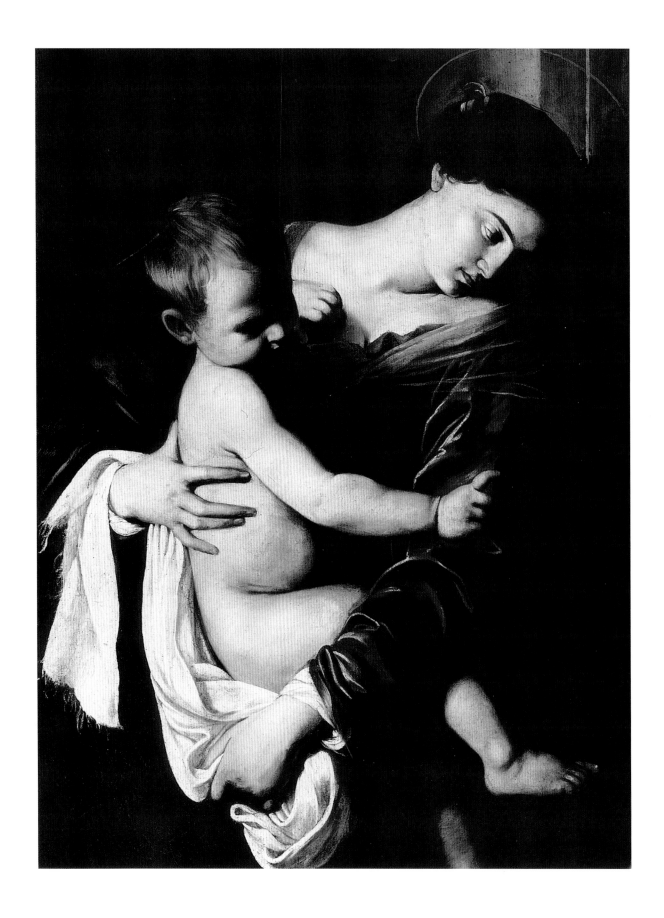

101 (opposite) *Madonna di Loreto* (Madonna dei Pellegrini), (detail ill. 104)

The Madonna of Loreto is conceived as a three-quarter-length portrait. She is holding the extremely heavy Christ-child on a piece of white drapery. She has to hold on to him with both hands.

102 *Madonna*
Oil on canvas, 131 x 91 cm
Galleria Nazionale d'Arte Antica – Palazzo Barberini, Rome

Caravaggio did not paint every beautiful *chiaroscuro* picture in the early seventeenth century. Sometimes attributed to him, this half-length Madonna nevertheless indicates a different artist, possibly Orazio Gentileschi.

103 (opposite) *Madonna dei Palafrenieri*
Oil on canvas, 292 x 211 cm
Museo Galleria Borghese, Rome

The figures seem to be standing in a gloomy side-street, with lurid searchlights trained on them.

Under her left foot, the Madonna is crushing the head of a writhing snake, with the naked Christ-child stamping his little foot in support. Mary's mother, Anna, stands nearby, her hands crossed over her lap, helplessly anxious, but still upright, and a head taller than her daughter. She is following what is happening with her mouth and eyes wide open, though the latter remain dim in the shadow of her old face's deep eye-sockets. Caravaggio avoids any overlap between the group consisting of Mary and the child and the majestic standing figure of the old woman, Anna. The only point of contact is the index-finger of the boy's little left hand, which he is raising as if looking for something.

104 *Madonna di Loreto* (Madonna dei Pellegrini)
Oil on canvas, 260 x 150 cm
Sant'Agostino, Rome

At the bottom left corner a shadow falls into the picture from the pillar of the altar-frame. This area is illuminated by a light-source that lies even lower.

Leaning against a door-reveal is the most beautiful Madonna Caravaggio has ever painted. She stands there with her legs crossed, revealing – most unusually for a Madonna – her dainty, immaculate feet.

The feet of a man who is kneeling alongside an older-looking woman in front of the high front step which leads into the house, are covered with dust from their travels as pilgrims. Both of them lean a long way forward, as they pray fervently. They turn slightly to look at Mary and the child.

THE ALTARPIECES OF CARAVAGGIO'S FIRST STAY IN NAPLES

On the left, freed from the silhouettes of continuous imposts and the austere flattened cupola of a niche cut off asymmetrically from the edge of the picture, stands a fluted column. A red curtain has been wound around it. This picture is more conventional and more banal in color than the *Death of the Virgin* (ill. 97), and for these reasons often thought not to be authentic. The Madonna is enthroned high above four standing Dominicans. Three barefooted men dressed in cloak-like drapery, which makes them look like apostles, press forward from the foreground. As do a woman and a small child with a thick diaper. An upper-class gentleman, in a black robe with a white ruff collar, pushes through in order to grasp the Friar's cowl. Read differently, the painting reveals a strict hierarchy. Mother and child open the picture at the bottom left. Only the woman is allowed to look up towards the Madonna, whilst her child observes the men who come in from the right, classically graduated according to the three stages of life. The two older men are fully dressed, the youth is naked beneath a mantle. All three are holding out their arms, in order to receive rosaries from the hands of the Dominican Order's founder.

The only founder-picture in a painting by Caravaggio must have a key function. With his backward look, the gentleman on the extreme left is assuring himself that a viewer is looking at him. He opens the saint's protective mantle for the ordinary people, and is driven to one side by their intense piety. The hands of the saint on the left form an imaginary horizontal boundary between the saint and the ordinary people with whom the upper-class founder mingles. Only his prominent position in the picture and the legend of the Order of the Rosary, with which the Holy Virgin has entrusted the founder of the Order, make the people on the left recognize him as a Dominican. His face in profile has a counterpoint on the right – a magnificent figure facing front – and the only figure in this section of the picture who looks at the viewer while pointing to Christ and Mary. This figure is probably intended to be Thomas Aquinas, behind whom the heads of St. Peter, the martyr, and Vinzenz Ferrer can be glimpsed. The Christ-child stands on the Madonna's lap as if to prove that he came out of his mother's womb. While Mary is busy urging the Dominican Friar to distribute rosaries to the poor people, Christ puts an arm around her shoulder, touchingly puts a hand on his chubby belly, playfully crosses his little legs, and looks straight at the viewer. Thus, at least this geometrically structured center shows the quality of immediacy which Caravaggio generally gives the whole of his monumental paintings.

Any historian wanting to form an impression of an artist will want to see the character of his hero revealed in his works in a more or less uniform manner – as if the artist's own approach to his visual material were continuous and his exploration of subject-matter, constant. According to this view, feelings about life and religiosity or *Weltanschauung* should scarcely alter.

Unconsciously we might also imagine that the religious pictures, at least, would be an integrated whole. Even the most intelligent of minds will draw a certain distinction between the concepts of mother, lover, and Madonna, even though an artist will tend to merge them.

Since, as an artist, Caravaggio made himself dependent on the model, he cannot, like his contemporaries, make a picture of his idea of the Virgin Mary. If an artist's approach to picture-making is always changing, there are times when something achieved in a major work will no longer be valid for the next project.

In fact, the difference between the Madonna of the Pilgrims (*Madonna di Loreto*) (ill. 104) in Sant' Agostino, Rome, and the *Madonna del Rosario* (ill. 105) is extremely great and abrupt. One similarity – in both paintings simply dressed people, with dusty feet, kneel in worship – makes the difference even more marked. Yet this does not mean that Caravaggio took sides in the ideological battles of his age. For if Caravaggio had wanted to depict his own vision of God without any compromise, he would have painted only one or the other Madonna.

The smooth design of the three kneeling men is very different from the rough, earthy manner in which the pilgrims of the *Madonna di Loreto* are depicted. There is an even harsher distinction between the two versions of Mary. For this painting, the artist could no longer call on his exquisite model for the Madonna in Sant' Agostino. In that picture, the social differences between the Virgin Mary and the ordinary pilgrims had shrunk, as it were, to one dividing step. The Vienna *Madonna del Rosario*, however, illustrates the functions of the Church and prosperous donors in the hierarchy of God and man. Mary is enthroned above the powerful Dominican Order. Its saints force even the distinguished gentleman, who made the picture possible, to his knees.

He is allowed to open the outer cloak of the founder of the Order – but not that of the Holy Virgin.

We might assume that, in the light of such a multi-level hierarchy, the picture was intended to show ordinary people in thrall to the Dominicans, who stand around the enthroned monarch like ministers and advisers. Yet it was not at all usual in paintings for anonymous poor people to push the patron virtually out of the frame. Clearly, the artist, the unknown patron and the unknown Dominican monastery for which the picture was intended, had all agreed that ordinary people should be admitted.

From Naples Ottavio Gentili and the Bruges painter, Frans Pourbus (1545–1581), told the Gonzagas in Mantua that a rosary picture by Caravaggio was to be had for 400 ducats. Then, years later in 1617, we learn from the will of the Antwerp painter, Louis Finson (before 1580–1617), that he had bought the work in Naples. Rubens, "Velvet" Bruegel, van Balen and other painters in the city purchased the painting from Finson's estate, in order to present it to the Dominicans of St. Paul's in Antwerp. In 1781 Joseph II purchased the work, which had been on exhibition since 1619, and in 1786 he took it to Vienna.

Caravaggio painted *The Seven Acts of Mercy* (ill. 106) for the church of the Pio Monte della Misericordia. Pictorial tradition demanded a banal painting, grouping the Seven Acts of Mercy – preferably in separate medallions – around the Holy Virgin. Caravaggio, however, sought to combine eight incompatible objects into one overall event, in his most unusual painting. Mary has no place on the ground. That is why she descends from heaven to see that the works of mercy are carried out properly. No one down below notices the Madonna, because they are all busily engaged in whatever task they consider to be an act of mercy. But even if anyone had time – and no one here does – to look up into the sky, Mary and her child would be very well shielded from gaze. They are hovering above a pair of angels, who embrace one another as they whirl down, with symmetrical wings and opulent fabrics. One of the angels seems to be supporting itself with outstretched hands on an imaginary horizontal boundary of the world of humans.

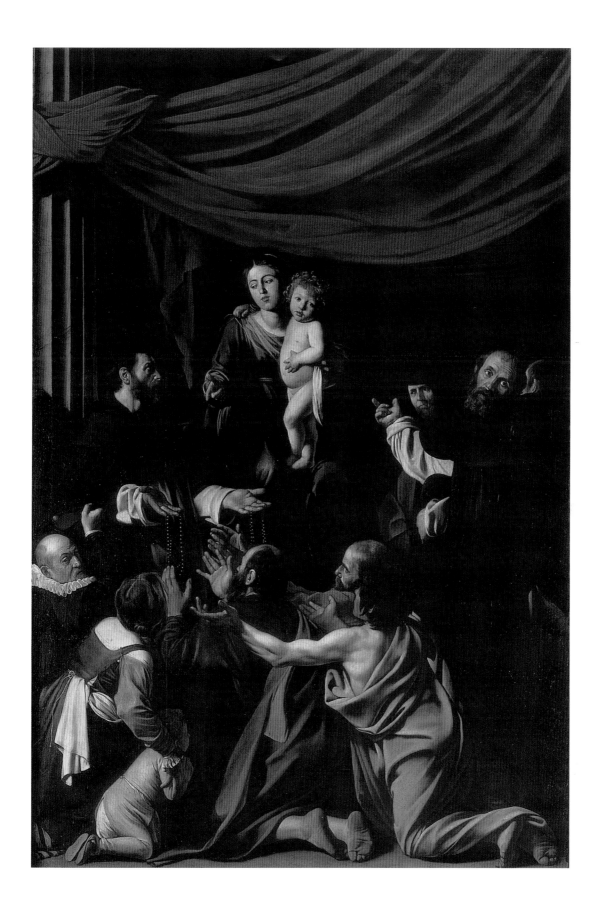

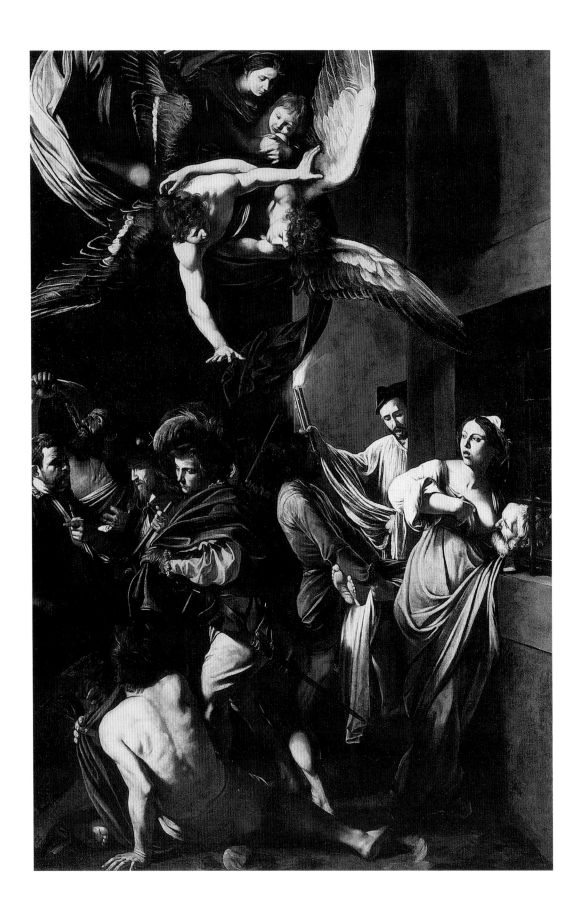

106 (opposite) *The Seven Acts of Mercy*
Oil on canvas, 390 x 260 cm
Pio Monte della Misericordia, Naples

In this monumental painting of the Madonna and the Seven Acts of Mercy, Caravaggio does something unknown in the rest of his work – he brings an exceptionally large number of figures together in such a way that a dynamic quality replaces the usual dramatic element. The subject itself is timeless, as we see from the nine figures below who come from different periods. Night is conveyed by *chiaroscuro*, even though some of the action must have happened in the day-time. Here, however, we see a torch burning, whereas Caravaggio normally never depicted light-sources.

Out of the heterogeneous concept of a Madonna with acts of mercy, the artist has developed a pictorial unity which bursts the bounds of the imagination. On the left, the Old Testament Samson, who quenches his thirst from the jaw of an ass, Christ's apostle Jacob the Elder, and the early medieval saint, Martin of Tours meet three anonymous figures on the left. A landlord shows Jacob, the pilgrim, a room. An anonymous man crouches on the ground in front of him. He is regarded as being ill, even though he is merely lying on the ground, like the half-naked man in front of him, with whom Martin is sharing his cloak. In a compositional sense, the figure of the beggar seen from behind opens the picture in late-Mannerist style.

On the right, a young woman has gone up to a barred window to give an imprisoned old man milk from her breast – a familiar motif, known as "Caritas Romana". Just beyond the wall we see the legs of a corpse, whom a priest, with a torch in his hand, is confirming. In the process, the folds of the dress worn by the "Caritas Romana", as well as those of the death-shroud and the priest's robes, finish so close together that there is no room for Caravaggio to clarify the picture spatially.

It is not immediately obvious what acts of mercy the artist is depicting here. The landlord gives the apostle shelter, Samson owes his drink to a miracle, not a helper, Martin clothes the poor man, a dead man is buried, Caritas visits the prisoner and feeds him. If the man crouching beside the beggar near Martin really is ill, he stays squatting on the ground unattended.

107 (right) *The Seven Acts of Mercy* (detail ill. 106)

Two angels, who are embracing one another, hover down from heaven on powerful wings. They offer the Madonna and her child protection, without carrying them, so that the Christ-child can observe the night's activities on earth along with his mother.

In his strikingly beautiful picture of the *Flagellation of Christ*, (ill. 109), Caravaggio returns to the spirit of the Madonna of the Pilgrims (ill. 104). Scholars have certainly tried – more than once – to find Mannerist echoes in this large altarpiece, of all pictures. However, none of the examples quoted comes anywhere near this Neapolitan work. The emotions of the Madonna of the Pilgrims (ill. 104) are very noticeable in this picture – especially in the inclination of the head. We need to imagine pious people at prayer before the altar, the sort we encountered in the Sant' Agostino painting, and who speak to Christ even though he averts his face in pain.

We associate the *Crucifixion of St. Andrew* in Cleveland (ill. 108) with a commission from the Spanish Viceroy, Benavente, who is reputed to have brought the painting home from Naples with him. In marked contrast to the intricately structured and extremely three-dimensional *Flagellation of Christ* (ill. 109), the martyrdom of the apostle offers only a superficial relief. It is painted in haste and disturbed by garish colors, so that we can understand Caravaggio's wish in better pictures to reduce color almost always to sandy tones in front of black.

We recognize the martyrdom of this apostle from the X-shaped cross of St. Andrew, even though Cardinal Baronio, among others, has disputed the authenticity of this form of crucifix in Caravaggio's day. Only the legs of the apostle, who is hanging from a rope-crucifix, a form usual for Christ, are actually on the cross. Legend has it that the old man stayed alive for several days, in order to preach to the onlookers. The executioner's assistant, who was supposed to take him down, was, it is said, prevented from doing so by a sudden paralysis. This episode is Caravaggio's subject.

Dating this picture is problematic. If attributing it to Caravaggio, along with the *Tooth-Drawer in a Tavern* in Florence (ill. 60), we ought to date it in his last phase, during his brief stay in Naples, from where the artist was to depart on his final journey.

108 *The Crucifixion of St. Andrew*
Oil on canvas, 202.5 x 152.7 cm
The Cleveland Museum of Art, Cleveland

Caravaggio positions the cross at a slight angle to the
pictorial surface. From the left an old woman peers
upwards, whilst a half-naked executioner's assistant, on a
ladder, is untying the apostle's right hand. He was ordered
to do so by a captain in full armor, who is watching the
proceedings with rapt attention. Like him, two other
figures are watching what is happening. Whilst one of
them is obscured by the captain, the other expresses great
astonishment.

109 (opposite) *The Flagellation of Christ*, 1607
Oil on canvas, 286 x 213 cm
Museo Nazionale di Capodimonte, Naples, on loan from
the Dominicans of San Lorenzo

As with *The Crucifixion of St. Peter* (ill. 92), a kneeling
figure on the left, cut off by the edge of the frame, leads
the eye into the picture. Only as he presses forward does
he turn his face towards the main figure, still tying a
bundle of brushwood on the ground. A rough-looking
character is already laying into Christ, punching his neck
at the same time, whilst the man on the right tightens his
bonds.
 Christ, who is shown unusually plump and soft, moves
his body helplessly towards the left, whilst his head is
knocked to the right.

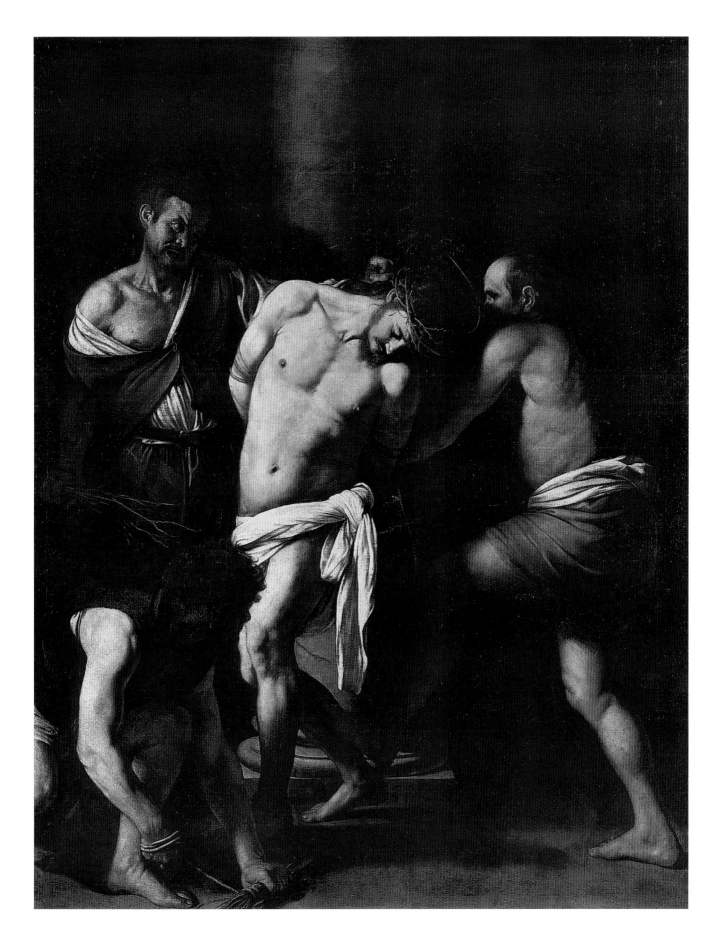

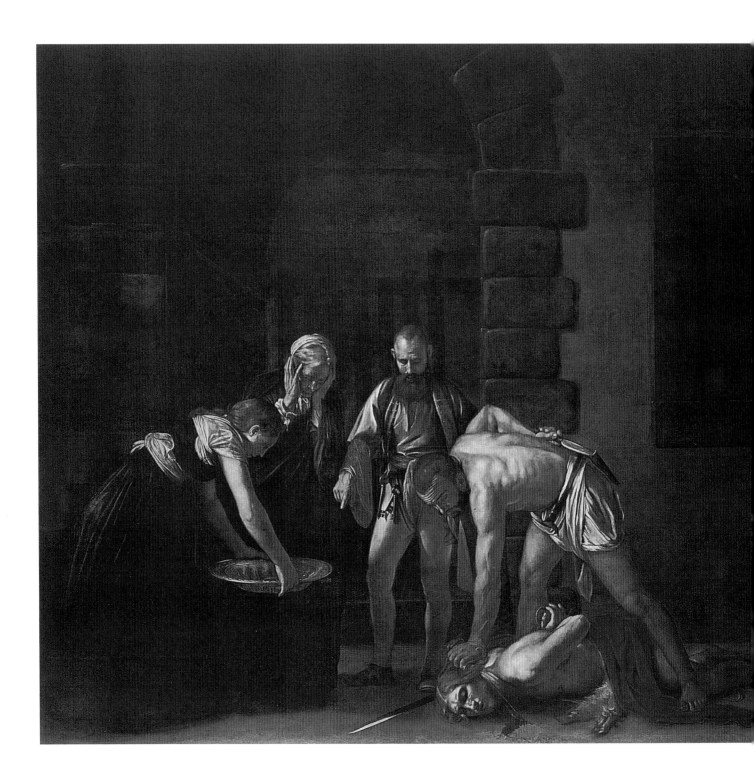

On the Run
in Malta and Sicily

SIGNED WITH THE BLOOD OF THE BAPTIST: THE GREAT WORK FOR MALTA

Caravaggio distinguished himself from most other Baroque painters by not making a sharp distinction between the genres of altarpiece and narrative painting.

An altarpiece for Malta has not survived. But there is a narrative picture which can attract devout attention – it is the artist's largest work (ill. 110).

The picture's laconic layout places both victim and murderers so center-stage that, although the story gets told, pious worshippers, when they see the slain Baptist humiliated and thrown to the ground, are left in no doubt about what they are worshipping. That said, they must lower their eyes just as the people in the picture do. Although the living figures are so preoccupied with the pictorial action that the viewer cannot make any contact with their eyes, the face of St. John, still and relaxed in death, offers itself to meditation, with eyes which, although now blind, are free from pain.

This great work by the artist on the island of Malta was such an attraction that Joachim von Sandrart sailed there simply to see it. It is totally characteristic of Caravaggio's style of painting, which achieved its effects less through individual pictures than through the method the artist employed.

Caravaggio's hasty flight from prison in Malta took the artist to Sicily, where he painted a few more important pictures at great speed. The first one he completed was a shatteringly rough altarpiece, which is one of the most irritating works of European painting, and which is still in the place for which it was intended, the church of Santa Lucia, Syracuse. Two pictures which almost equal Caravaggio's great Roman works in their inventive power, have survived in Messina. Until 1969 Palermo also owned an altarpiece by Caravaggio, which has disappeared after a theft.

Bad colors, over-hasty execution, and possibly also artist's depression characterize the altarpiece in which St. Lucy suffered martyrdom (ill. 111). The poetry which

110 *The Beheading of St. John the Baptist*, 1608
Oil on canvas, 361 x 520 cm
Museum of St. John's, Valletta, Malta

A weakly-lit, sturdy barred gate, with the top of its arch cut off, appears just behind a frieze of life-size figures on the left. On the right, a barred window interrupts the line of the wall. Through it, two prisoners are watching what is happening on the left. With her sleeves rolled up, more like Judith than a lascivious dancer, Salome bends down to receive the head of John the Baptist on a large golden dish. Beside her, her maid is holding her head in silent horror, whilst looking down at the gleaming executioner's sword. It is lying near a man who has ordered the beheading. Sturdy, and seeming much larger than the three other figures, the half-naked executioner is bending over the Baptist's corpse. Whilst gripping his hair in his left hand, with his right hand he reaches for a short dagger in his belt, as if he needed this to help cut the head from the body. The Baptist, already beheaded, lies in a pool of his own blood, which pours out in diagonal spurts towards the right. In this blood, Caravaggio has signed his name on the floor. This is his only noticeable signature anywhere – limited to the letters f michela, which stand for fecit or frater Michelangelus. One interpretation of this would be that Michelangelo had created the picture. The other, however, would denote the artist as a Knight of Malta.

111 (following double page, left) *The Burial of St. Lucy*, 1608
Oil on canvas, 408 x 300 cm
Santa Lucia, Syracuse, stored in the Museum

The saint, who in Sweden is celebrated with a crown of lights before Christmas because she sacrificed her eyes in her martyrdom, is lying in dismal darkness on the bare floor of a bleak vault. She is being confirmed by a bishop and mourned by pious worshippers. Her dark eye-sockets are allusions to her martyrdom. Only after several false starts, revealed by X-ray photographs, did Caravaggio decide on the exact form of her death, on which his contemporaries failed to agree. The artist eventually agreed with Cardinal Baronio's opinion that St. Lucy's throat was cut. Her dress is disordered – torn away from her shoulder to her breast.

112 (following double page, right) *The Raising of Lazarus*
Oil on canvas, 380 x 275 cm
Museo Regionale, Messina

Night, with light penetrating it, become metaphors for death and resurrection through Christ, even though he himself gives off no light. On the right, level with Christ, and graduated like the helpers, the dead man's sisters, Mary Magdalene and Martha, appear. Even if, in this scene, they are normally shown asking Christ to raise their brother from the dead, here they are bending down towards the dead man's head in a gesture of lamentation.

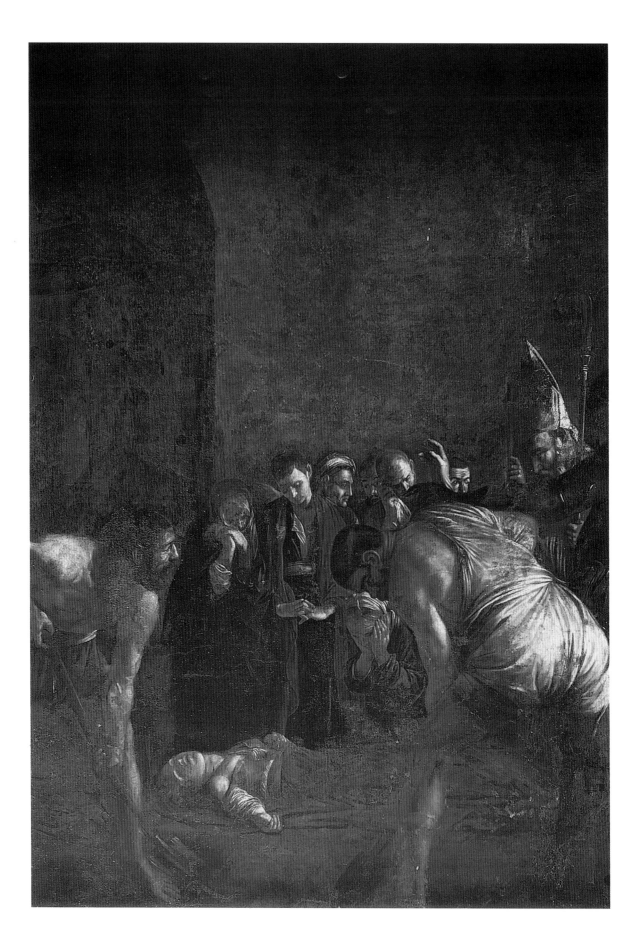

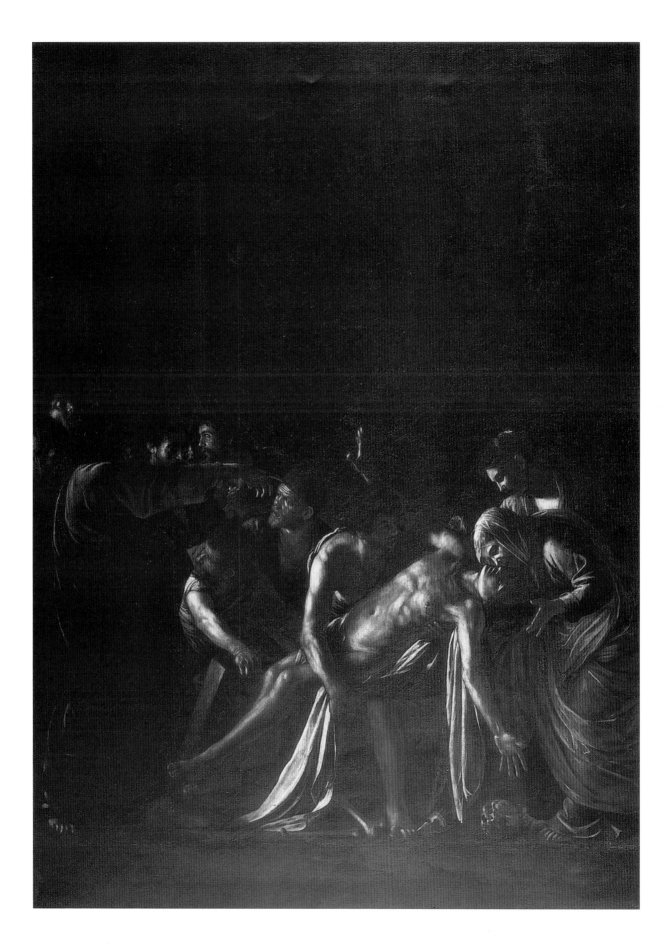

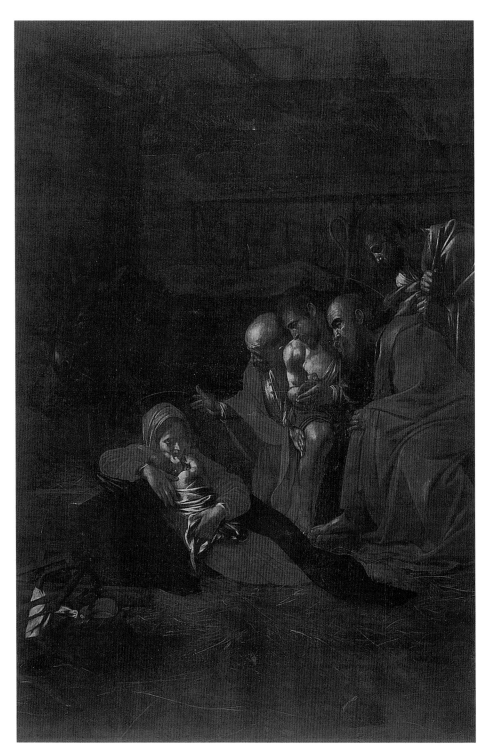

113 (left) *The Adoration of the Shepherds*
Oil on canvas, 314 x 211 cm
Museo Regionale, Messina

At an astonishing distance from the viewer, which is filled
in by a still life of heaped-up implements in the left
foreground, and a stone lying on the ground on the right,
Mary is stretched out on straw, leaning against the wall of
a crib for oxen and asses, holding her child tightly in her
arms, without looking up towards the shepherds. They
are pressing forward on the right behind Joseph, who is
sitting watching mother and child.

114 (opposite) *The Nativity with St. Francis and
St. Lawrence*, 1609
Oil on canvas, 268 x 197 cm
San Lorenzo, Palermo, until 1969

Under the roof of the stable in Bethlehem, whose side
walls are disappearing into brownish darkness, shepherds
and saints have gathered to worship the newborn Christ-
child in such a way that we can make out Archdeacon
Lawrence on the left only after a second look, and viewers
may well mistake St. Francis for a shepherd. One figure,
the patron, represents the church for which the picture
was intended, and the other, the Order to which the
church belongs. We cannot be entirely sure who Joseph,
the foster-father, is. As in *The Adoration of the Shepherds*
in Messina (ill. 113), art literature has claimed to
recognize him as the foreground figure seen from the
back. This is true insofar as this man has sat down, which
is not appropriate for shepherds. But where would Joseph
have acquired a coiffure like that, and, despite his gray
hair, how could he look so young? The center of the
picture is shared out between the figures who have come
to worship. The naked Christ-child lies there on a bed of
straw and some white drapery. In his laterally inverted
foreshortening, this figure is not totally unlike St. Paul in
the Cerasi Chapel picture (ill. 90). Exhausted, the Holy
Virgin is crouching on the ground behind him – wearing
an unusually cut dress, which is falling from her right
shoulder – looking at the child. The ox, which appears
behind St. Lawrence, is also looking in that direction.
Above all this, an angel is flying down from heaven. In his
left hand he is holding a banner on which the words of
the gloria are written. His right hand is pointing upwards,
as if, by also looking at the baby, he wanted to reassure
the Christ-child that he really is the Son of God.

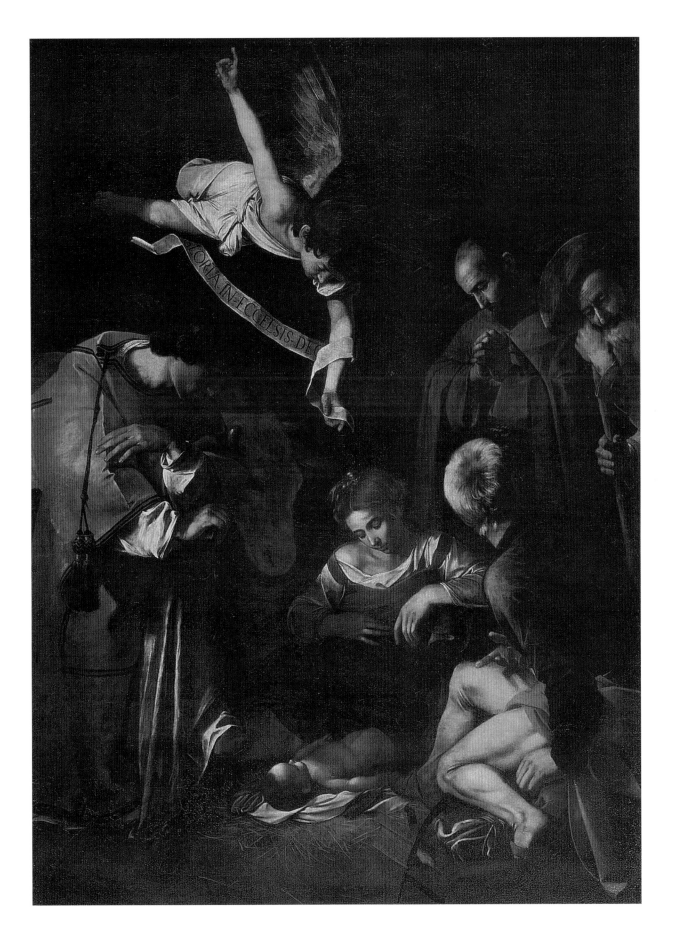

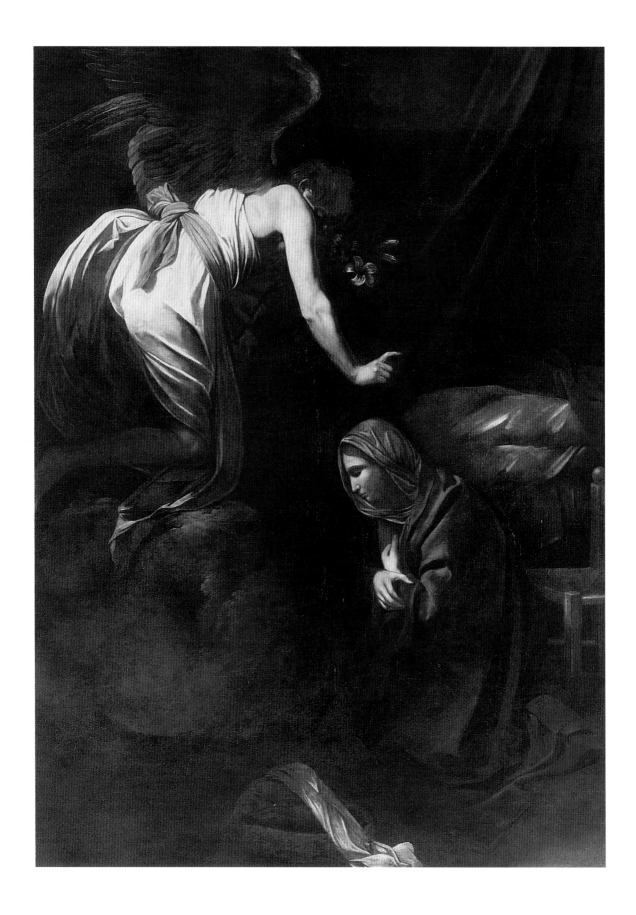

115 *The Annunciation*, 1610 (?)
Oil on canvas, 285 x 205 cm
Musée des Beaux-Arts, Nancy

Caravaggio's figures are so self-absorbed, so much a part of the scene in which they find themselves, that even pious worship must, as it were, take place before the pictures in silence and without being noticed. One high point is that this is the last monumental painting which is now regarded as being the artist's original work. The Madonna is kneeling humbly on the floor. From the left, on a cloud which looks solid enough to bear his weight, the angel descends, his wings still spread out. He has turned away from the viewer towards the future Mother of God. A lily-stalk appears in the center of the picture, as if this symbol of the Holy Virgin's purity were its most important object.

is so markedly absent from the austere picture of the *Burial of St. Lucy* re-established itself in the other works which Caravaggio painted for Sicily. In these, allusions to earlier paintings in Rome merged with echoes of older paintings. The pathos of the *Calling of St. Matthew* (ill. 84) lives on in the *Resurrection of Lazarus* (ill. 112). In this picture, Christ comes in, with the light, from the left, so that the illumination of the gloomy scene and the entry of the divine element are well co-ordinated. The artist's geometric instinct leaves the outstretched hand of Lazarus isolated in the center of the figure-composition. Morning light bathes the hand, a symbol of life returning. In a similar fashion, Caravaggio had filled the hand of the apostle in the *Martyrdom of St. Matthew* (ill. 86) with heavenly promise, and structured St. Paul's fingers in his *Conversion* (ill. 90).

In the breathtakingly beautiful scene of the *Adoration of the Shepherds* in Messina (ill. 113), Caravaggio once again moves his figures dramatically against the usual direction of reading. In contrast to his normal method, he depicts the interior of the stable at Bethlehem in the Venetian manner, as if he wanted to prove his biographers right when they claimed Giorgione as a major influence. That said, he comes closer to later Venetian painters like Jacopo Bassano (1510/18 – 1592), and Correggio (1489 – 1534), the Upper Italian painter no longer connected with the city on the lagoon – especially his *Holy Night* in Dresden.

In the *Adoration of the Shepherds* in Messina, the figures bunch so closely together that an atmosphere of poetic intensity and veneration results, which may spill over on to the viewers, and make them also want to pray. In the *The Nativity with St. Francis and St. Lawrence*, which Caravaggio painted for Palermo (ill. 114), we see again the form of Christian altarpiece which combines Mary and the Christ child with saints of various epochs in the form of a Sacra Conversazione. The way the saints are ranked in order concentrates reverence on the Holy Virgin. The light also helps to make her, rather than her child, the center of the picture.

The paintings from Malta and Sicily are extremely well suited to embellishing an artist's life with Romantic allusions. The large prison panorama makes us think of Caravaggio languishing in a Maltese jail. The Burial in Syracuse strikes us as being the absolute nadir of a brilliant career. That said, the picture of Lazarus shows new hope burgeoning – hope which will lead on to the exquisite Christmas scenes with the Shepherds in Messina and Palermo.

A LAST GREAT ALTARPIECE

There is still very little information about how Caravaggio spent his years after he had fled from Malta and Sicily. His spectacular fame as an artist, which had reached well beyond Rome by about 1600, must have been a heavy burden to him, when we consider that he was being pursued by the papal authorities and the Knights of Malta. Despite his frequent moves, however, Caravaggio was still receiving commissions from all over the world.

An enigmatic painting in Nancy, which scholars have never fully addressed, was supposedly painted in 1609 in Rome by someone called Michelangelo (ill. 115). Even if scholars thought mistakenly that it was painted by Michelangelo Buonarotti (1475 – 1564), the information can be taken as a valuable source. So much speaks for Michelangelo da Caravaggio that, after restoration work in the early 1970s, the painting seems more and more to be his work. A gift to the future Cathedral of Nancy by Henri, Duke of Lorraine (in office 1608 – 24), the painting might have been commissioned through the Gonzagas. Judging by its style, it dates from Caravaggio's last stay in Naples.

What is surprising about the not very well preserved painting at the Museum in Nancy is that Caravaggio suddenly introduced interior set pieces into the picture. Admittedly, they are in the background, but they are painted with great care, and are fully visible. The still life of basket and piece of fabric distances the figure-relief a little. The same effect is achieved in the similarly lit *Adoration of the Shepherds* in Messina (ill. 113).

Perspectives of this kind opening up in Caravaggio's last paintings make us ask a question. How much further would this artist have taken European painting if he had not met an undignified and premature death in Porto Ercole after more brawling? His art may have degenerated into Mannerism. By the time he worked in Syracuse, his brilliant originality had deteriorated into a coarsened form of expressive painting. On the other hand, two completely new directions are suggested by the *Adoration of the Shepherds* and the *Annunciation* in Nancy. In the Nativity for Palermo (ill. 114), Caravaggio had proved how intensely he could paint the slightly unreal presence of different saints during Holy Night. In the other two pictures, he again altered his conception of space and figure very radically, as if he wished to re-organize his figures and their accessories in a completely different way.

RETROSPECTIVE

116 *David with the Head of Goliath*, ca. 1605
Oil on a poplar wood panel, 90.5 x 116.5 cm
Kunsthistorisches Museum, Vienna

This version of David with the head of Goliath stands out from Caravaggio's half-length biblical historical paintings. Instead of an event which the artist depicts, this picture offers a simple presentation of the youthful victor with his enemy's chopped-off head. Unlike in other paintings, the lighting from the left matches the movement towards the right. With shouldered sword, the young man looks out into the darkness. He looks more determined than the Borghese *David* (ill. 2) and expresses more deeply felt emotion. His eyes, however, are suffused by the melancholy which, in Caravaggio's paintings, sometimes affects not only the victors but also the executioners. This picture of David is painted over a Flemish or Roman depiction of Mars and Venus from the Mannerist period.

A monograph on an artist either gives an account of its hero's life in its various stages or orients itself on older predecessors which understand individual works as testimony to an exploration of the tasks which art sets itself.

To the irritation of many readers, this book may have helped bury the chronology of Caravaggio's life and work beneath an overall concept which has watched the artist grow with his projects. The starting-point was Caravaggio's conflicting personality. It expressed itself in a life which often reads more like a police report, and to which Doris Müller-Ziem has contributed in this book. Yet a highly unusual character also spoke from the pictures themselves, and this has provided the impetus to go in search of self-portraits of the artist. There is a striking contrast between Caravaggio's life and work. The quick-tempered character who was always getting involved in fights, and who stylized himself into *Sick Bacchus* (ill. 5) or the hacked-off head of the giant, Goliath (ill. 2), also created paintings of human profundity and tenderness which completely redefined painting.

Basing his art on the fundamental principle of painting direct from nature, to which no special feeling for the genre of portrait corresponded, the artist rebelled against the values of the great art of Rome. If at all, Caravaggio only once attempted the most distinguished monumental work available to an artist then – fresco painting. He rejected the idea of painting historical pictures out of his own imagination.

This is why it seemed appropriate to understand his work in terms of different genres, even if contemporary art theory still has no categories for them.

Anyone who makes painting as an act of reproducing into the guiding principle of his art will regard a still life as equal to the depiction of a human being. Caravaggio constructed his early pictures out of still lifes and models. He quickly grasped that landscape is not a field in which he could prove himself. With his very highly developed tactile sense, he explored the human body and became one of the greatest painters of the nude in the history of art. He attempted genre-painting direct from life and with full-length figures in only a few pictures. Yet, along with his sole authentic still life, he turned these into ground-breaking pioneer works of revolutionary impact. An even more important step was his radical decision to subjugate biblical history-painting to the principles of portrait and genre-painting. Transformed into monumental paintings in a public church context, Caravaggio's redefinition of art met strong resistance. More than once, he was obliged to withdraw a first version, in order to fulfil the wishes of his patron, even though the circle of his patrons included the most progressive minds in Rome. With their support, Caravaggio also opened up new markets for painting. Half-length and full-length biblical history-paintings immediately found a place in royal galleries – as did an advanced altarpiece which the Church authorities rejected. After Caravaggio, whole generations of painters were to earn their living by means of similar projects.

All the works which present-day scholars regard as original Caravaggios would fit into such a concept. Though this does not apply strictly to the Borghese *David* (ill. 2), which was discussed at the start of this book. Nor does it apply to another picture of the Old Testament hero, which now hangs in the Kunsthistorisches Museum, Vienna (ill. 116).

It would surely be artificial to include both paintings, as a kind of ideal portrait, with the early Roman works, which, constructed out of still life and painting direct from a model, stand somewhere between mythology and genre-pictures.

An artist who flouts all the conventions of his age cannot be properly classified into any conceptual system. This makes any exploration of Michelangelo Merisi da Caravaggio as fascinating for scholars as it still is for countless art-lovers, who may keep recognizing traces of their own human nature in his coldly calculated paintings.

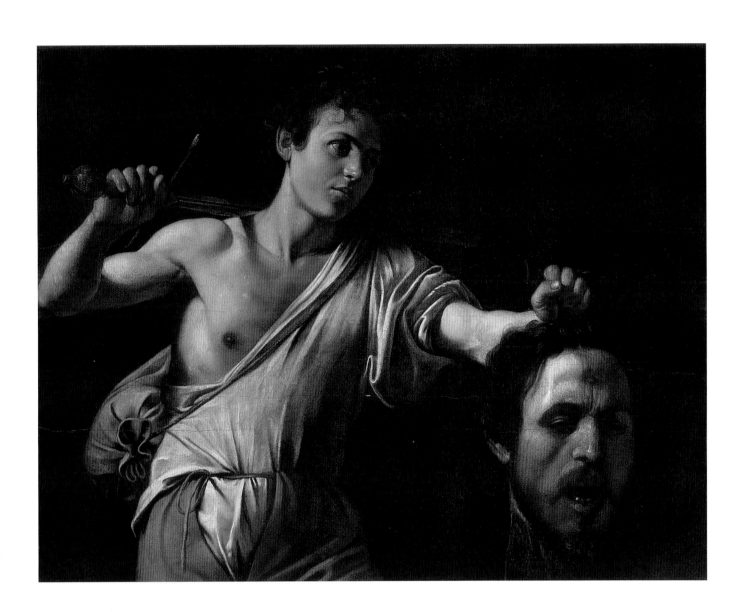

CHRONOLOGY

1571 Most probably towards the end of the year, Michelangelo Merisi da Caravaggio is born, the first child of Fermo Merisi and his wife, Lucia Aratori, probably in Milan.

1576 The family flees from the plague in Milan to Caravaggio.

1577 Death of Caravaggio's father, probably from the plague.

1584 Caravaggio begins a four-year apprenticeship to the painter, Simone Peterzano, in Milan.

1589–1592 The artist lives in Caravaggio.

1590 Death of Caravaggio's mother.

From ca. 1592 Caravaggio lives in Rome and works in various studios.

ca. 1593 The artist joins the studio of the painter, Giuseppe Cesare d'Arpino.

ca. 1595/96 Caravaggio is given accommodation in the Palazzo Madama, owned by Cardinal del Monte.

1599 In July Caravaggio is commissioned to complete two historical paintings for the side walls of the Contarelli Chapel in the Church of San Luigi dei Francesi.

1600 In September Caravaggio receives the commission for two oil paintings for the Tiberio Cerasis family chapel in Santa Maria del Popolo.

ca. 1602/03 Caravaggio is commissioned to paint the altarpiece for the Girolamo Vittrice family chapel in the Chiesa Nuova of the Oratorians, in the Church of Santa Maria in Vallicella.

1603 In August the painter Giovanni Baglione sues the artists Caravaggio, Orazio Gentileschi and Filippo Trisegni, as well as the architect, Onorio Longhi, for disseminating defamatory poems. Caravaggio is arrested on 11 September.

On 25 September he is released after the intervention of the French ambassador.

1604 In October Caravaggio is arrested again for assaulting assistant police officers.

1605 In May Caravaggio is again arrested for carrying a weapon illegally. In July the lawyer, Mariano Pasqualone, charges the artist with having injured him in the face with a sword-blow. Caravaggio flees to Genoa, returning to Rome in August. Here he is commissioned to complete a painting for the Church of Sant' Anna dei Palafrenieri.

1606 On 28 May, during a ball-game, Caravaggio kills an opponent. Caravaggio flees to the country estate owned by Prince Marzio Colonna. From October onwards the artist lives in Naples.

1607 Caravaggio is in Malta by July at the latest.

1608 On 14 July the artist is made a "de gratia" Knight of the Maltese Order of St. John. In December he is expelled from the Order, and flees to Sicily.

1609 In October Caravaggio is attacked in Naples and wounded in the face.

1610 The artist sails to Rome. On 18 July Caravaggio dies in Porto Ercole, or possibly in Civitavecchia.

GLOSSARY

Arcadia (a mountainous area of Greece), in Greek and Roman literature, a place where a contented life of rural simplicity is lived; an earthly paradise peopled by shepherds.

Bacchus, in Greek and Roman mythology, the god of wine and fertility. Bacchic rites were often orgiastic.

Baroque (Port. *barocco*, "an irregular pearl or stone"), the period in art history from about 1600 to about 1750. In this sense the term covers a wide range of styles and artists. In painting and sculpture there were three main forms of Baroque: (1) sumptuous display, a style associated with the Catholic Counter Reformation and the absolutist courts of Europe (Bernini, Rubens); (2) dramatic realism (Caravaggio); and (3) everyday realism, a development seen in particular in Holland (Rembrandt, Vermeer). In architecture, there was an emphasis on expressiveness and grandeur, achieved through scale, the dramatic use of light and shadow, and increasingly elaborate decoration. In a more limited sense the term Baroque often refers to the first of these categories.

The development of the Baroque reflects the period's religious tensions (Catholic versus Protestant); a new and more expansive world view based on science and exploration; and the growth of absolutist monarchies.

Carmelites (Lat. *Ordo Fratrum Beatae Mariae Virginis de Monte Carmelo*, "Brothers of Our Blessed Lady of Mount Carmel"), a Roman Catholic order of contemplative mendicant friars. Founded in Palestine in the 12th century, the Carmelites were originally hermits. In the 13th century the order was refounded as an order resembling the Dominicans and Franciscans. An order of Carmelite sisters was founded in the 15th century; in the 16th century reforms introduced by St. Teresa of Ávila led to the creation of the **Barefoot** (Discalced) **Carmelites**.

Catholic reform, attempts between the 15th and 16th centuries to eliminate deficiencies within the Roman Catholic Church (such as financial abuses, moral laxity in the clergy and so on).

chiaroscuro (It. "light dark"), in painting, the modelling of form (the creation of a sense of three-dimensionality in objects) through the use of light and shade. The introduction of oil paints in the 15th century, replacing tempera, encouraged the development of chiaroscuro, for oil paint allowed a far greater range and control of tone. The term chiaroscuro is used in particular for the dramatic contrasts of light and dark introduced by Caravaggio. When the contrast of light and dark is strong, chiaroscuro becomes an important element of composition.

classical, relating to the culture of ancient Greece and Rome (**classical Antiquity**). The classical world played a profoundly important role in the Renaissance, with Italian scholars, writers, and artists seeing their own period as the rebirth (the "renaissance") of classical values after the Middle Ages. The classical world was considered the golden age for the arts, literature, philosophy, and politics. Concepts of the classical, however, changed greatly from one period to the next. Roman literature provided the starting point in the 14th century, scholars patiently finding, editing and translating a wide range of texts. In the 15th century Greek literature, philosophy and art – together with the close study of the remains of Roman buildings and sculptures – expanded the concept of the classical and ensured it remained a vital source of ideas and inspiration.

cognoscenti, sing. **cognoscente** (It. "those who know"), connoisseurs of art, literature or music; those with refined tastes.

complementary colors, pairs of colors that have the maximum contrast and so, when set side by side, intensify one another. Green and red, blue and orange, and yellow and violet are complementary colors.

Compline (Lat. [*hora*] *completa*, "completed [hour]"), the last prayers of the day; the church service at which these prayers are said.

copperplate engraving, a method of printing using a copper plate into which a design has been cut by a sharp instrument such as a burin; an engraving produced in this way. Invented in south west Germany about 1440, the process is the second oldest graphic art after woodcut.

crumhorn, a wind instrument popular throughout Europe in 16th and 17th centuries. An ancestor of the oboe, the crumhorn was a double-reed instrument that produced a soft, reedy sound.

cupola (Lat. *cupula*, "small vat"), in architecture, a small dome, usually one set on a much larger dome or on a roof; a semi-circular vault.

disegno (It. "drawing, design"), in Renaissance art theory, the design of a painting seen in terms of drawing, which was help to be the basis of all art. The term stresses not the literal drawing, but the concept behind an art work. With the Mannerists the term came to mean an ideal image that a work attempts to embody but can in fact never fully realize. As *disegno* appeals to the intellect, it was considered far more important that *colore* (color), which was seen as appealing to the senses and emotions.

Dominicans (Lat. *Ordo Praedictatorum*, Order of Preachers), a Roman Catholic order of mendicant friars founded by St. Dominic in 1216 to spread the faith through preaching and teaching. The Dominicans were one of the most influential religious orders in the later Middle Ages, their intellectual authority being established by such figures as Albertus Magnus and St. Thomas Aquinas. The Dominicans played the leading role in the Inquisition.

Ecce Homo (Lat. "Behold the Man!"), the words of Pontius Pilate in the Gospel of St. John (19, 5) when he presents Jesus to the crowds. Hence, in art, a depiction of Jesus, bound and flogged, wearing a crown of thorns and a scarlet robe.

genre painting, the depiction of scenes from everyday life. Elements of everyday life had long had a role in religious works; pictures in which such elements were the subject of a painting developed in the 16th century with such artists as Pieter Bruegel. Then Carracci and Caravaggio developed genre painting in Italy, but it was in Holland in the 17th century that it became an independent form with its own major achievements, Vermeer being one of its finest exponents.

golden section (Lat. *sectio aurea*), in painting and architecture, a formula meant to provide the aesthetically most satisfying proportions for a picture or a feature of a building. The golden section is arrived at by dividing a line unevenly so that the shorter length is to the larger as the larger is to the whole. This ratio is approximately 8:13. The golden section (sometimes known as the golden mean), which was thought to express a perfect harmony of proportions, played an important role in Renaissance theories of art.

Greek cross, a cross with four arms of equal length.

history painting, painting concerned with the representation of scenes from the Bible, history (usually classical history), and classical literature. From the Renaissance to the 19th century it was considered the highest form of painting, its subjects considered morally elevating.

iconography (Gk. "description of images"), the systematic study and identification of the subject-matter and symbolism of art works, as opposed to their style; the set of symbolic forms on which a given work is based. Originally, the study and identification of classical portraits. Renaissance art drew heavily on two iconographical traditions: Christianity, and ancient Greek and Roman art, thought and literature.

ignudi, sing. **ignudo** (It.), male nudes. The best-known are the male nudes on Michelangelo's Sistine ceiling.

imitato (It. "imitation"), in Renaissance art theory, the ability to imitate, to depict objects and people accurately and convincingly. Derived from classical literary theory, *imitato* was one of the key concepts of Renaissance art theory.

impost, in architecture, the horizontal moulding or course of stone or brickwork at the top of a pillar or pier.

inventio (It. "invention"), in Renaissance art theory, the ability to create; invention, originality. Derived from classical rhetoric, *inventio* was one of the key concepts of Renaissance art theory; because it was seen as being based on the use of reason, it gave art a far higher status than a craft and helped to establish the intellectual respectability of painting and sculpture.

Jesuits (the **Society of Jesus**), a Roman Catholic teaching order founded by St. Ignatius Loyola in 1534. The express purpose of the Jesuits was to fight heresy within the Church (they played a leading role in the Counter Reformation), and to spread the faith through missionary work in the many parts of the world recently discovered by Western explorers and colonists.

Knights of Malta, a military religious order established in 1113 – as the Friars of the Hospital of St. John of Jerusalem – to aid and protect pilgrims in the Holy Land. As their military role grew, encouraged by the Crusades, they became a powerful military and political force in the Middle East and the Mediterranean. In 1530 Emperor Charles V gave them the island of Malta as a base (hence their name from that date). They remained in power there until the end of the 18th century.

lunette (Fr. "little moon"), in architecture, a semicircular space, such as that over a door or window or in a vaulted roof, that may contain a window, painting or sculptural decoration.

madrigal, a part song, originally sung without accompaniment, originating in Italy in the 14th century. It reached the heights of its popularity in the 16th century, with secular texts replacing sacred ones, and accompaniments, usually for the lute, being written. One of the leading composers of madrigals was Claudio Monteverdi.

Mannerism (It. *maniera*, "manner, style"), a movement in Italian art from about 1520 to 1600. Developing out of the Renaissance, Mannerism rejected Renaissance balance and harmony in favor of emotional intensity and ambiguity. In **Mannerist** painting, this was expressed mainly through severe distortions of perspective and scale; complex and crowded compositions; strong, sometimes harsh or discordant colors; and elongated figures in exaggerated poses. In architecture, there was a playful exaggeration of Renaissance forms (largely in scale and proportion) and the greater use of bizarre decoration. Mannerism gave way to the Baroque. Leading Mannerists include Pontormo, Bronzino, Parmigianino, El Greco and Tintoretto.

Man of Sorrows, a depiction of Christ during his Passion, bound, marked by flagellation, and crowned with thorns.

Minorites (also called **Friars Minor** and **Observants**), in the Roman Catholic Church, a branch of the Franciscan order. The order came into existence in the 14th century as a reform movement wanting to return to the poverty and simple piety of St. Francis himself.

Oratorians (or the **Congregation of the Oratory**), in the Catholic Church, an order of secular priests who live in independent communities, prayer and preaching being central to their mission. The Oratorians was founded by St Philip Neri (1515–1595).

oratory (or **oratorium**), a place were Oratorians pray or preach; a small private chapel.

Our Lady of Sorrows (or **Mater Dolorosa**), a depiction of the Virgin Mary lamenting Christ's torment and crucifixion. There are several forms: she can be shown witnessing his ascent of Calvary; standing at the foot of the Cross; watching as the body of Christ is brought down from the Cross (Deposition); or sitting with His body across her lap (Pietà).

pastoral (Lat. *pastor*, "shepherd"), relating to a romantic or idealized image of rural life; in classical literature, to a world peopled by shepherds, nymphs, and satyrs.

Pietà (Lat. [*Maria Santissima della*] Pietà, Most Holy Mary of Pity), a depiction of the Virgin Mary with the crucified body of Jesus across her lap. Developing in Germany in the 14th century, the Pietà became a familiar part of Renaissance religious imagery. One of the best-known examples is Michelangelo's "Pietà" (1497–1500) in St. Peter's, Rome.

provenance, the origins of an art work; the history of a work's ownership since its creation. The study of a work's provenance is important in establishing authenticity.

putti sing. **putto** (It. "boys"), plump naked little boys, most commonly found in late Renaissance and Baroque works. They can be either sacred (angels) or secular (the attendants of Venus).

rilievo (It. "relief"), in painting, the impression that an object is three-dimensional, that it stands out from its background fully rounded.

Sacra Conversazione (It. "holy conversation"), a representation of the Virgin and Child attended by saints. There is seldom a literal conversation depicted, though as the theme developed the interaction between the participants – expressed through gesture, glance and movement – greatly increased. The saints depicted are usually the saint the church or altar is dedicated to, local saints, or those chosen by the patron who commissioned the work.

Saracens, during the Middle Ages, the Arabs or Muslims, particularly those who fought against the Christian Crusades.

satyr, in Greek mythology, human-like woodland deities with the ears, legs and horns of a goat. Often depicted as the attendant of the Bacchus, the god of wine.

stigmata, sing. **stigma** (Gk. "mark, brand, tattoo"), the five Crucifixion wounds of Christ (pierced feet, hands and side) which appear miraculously on the body of a saint. One of the most familiar examples in Renaissance art is the **stigmatization** of St. Francis of Assisi.

topos, pl. **topoi** (Gk. "a commonplace"), in literature, figure of speech; in art, widely used form, model, theme or motif.

triumphal arch, in the architecture of ancient Rome, a large and usually free-standing ceremonial archway built to celebrate a military victory. Often decorated with architectural features and relief sculptures, they usually consisted of a large archway flanked by two smaller ones. The triumphal archway was revived during the Renaissance, though usually as a feature of a building rather than as an independent structure. In Renaissance painting they appear as allusion to classical antiquity.

tromp l'oeil (Fr. "deceives the eye"), a type of painting which, through various naturalistic devices, creates the illusion that the objects depicted are actually there in front of us. Dating from classical times, tromp l'oeil was revived in the 15th century and became a distinctive feature of 17th-century Dutch painting.

vanitas (Lat. "emptiness"), a painting (or element in painting) that acts as a reminder of the inevitability of death, and the pointlessness of earthly ambitions and achievements. Common vanitas-symbols include skulls, guttering candles, hour-glasses and clocks, overturned vessels, and even flowers (which will soon fade). The vanitas theme became popular during the Baroque, with the vanitas still life flourishing in Dutch art.

Vespers (Lat. *vesper*, "evening"), prayers said in the evening; the church service at which these prayers are said. The Marian Vespers are prayers and meditations relating to the Virgin Mary.

vita, pl. **vite** (Lat. "life"), an account of someone's life and work, a biography. The best-known writer of the vita in the Renaissance was Vasari, whose *Le vite de' più eccellenti pittori, scultori e architetti italiani* ("Lives of the Most Eminent Italian Painters, Sculptors and Architects"), published in 1550 and 1568, provides detailed accounts of the lives of many of the most important artists of the Renaissance.

Weltanschauung (Gr. "world view"), a comprehensive world view, a philosophy of life.

SELECTED BIBLIOGRAPHY

Baglione, Giovanni B.: Le vite de'pittori scultori et architetti, dal Pontificato di Gregorio XIII del 1572, in: V. Mariani (Ed.), Fino a'tempi di Papa Urbano Ottavo nel 1642, Rome 1935

Bellori, Giovanni P.: Le vite de'pittori, scultori e architetti moderni, Rome, ed. E. Borea, Turin 1976

Calvesi, Maurizio: La realtà del Caravaggio, Seconda parte (i dipinti), Storia dell'arte 55, 1985, pp. 227–87

Camiz, Franca T. and A. Ziino: Caravaggio: Aspetti musicali e committenza, Studi musicali 12, 1983, pp. 67–83

Christiansen, Keith: Caravaggio and l'esempio davanti dal naturale, Art Bulletin 68/3, 1986, pp. 421–45

Cinotti, Mia: Michelangelo Merisi detto il Caravaggio, I pittori bergamaschi: il seicento, Vol. 1, Bergamo, 1983, pp. 205–641

Exhibition Catalogue: Michelangelo Merisi da Caravaggio, Come nascono i capolavori, Florence 1991, Rome 1991

Friedlaender, Walter: Caravaggio Studies, Princeton 1955, rev. New York, 1969

Frommel, Christoph L.: Caravaggios Frühwerk und der Kardinal Francesco Maria del Monte, Storia dell'arte 9/10, 1971, pp. 5–52

Frommel, Christoph L.: Caravaggio and his Models, Castrum Peregrini 96, 1971, pp. 21–55

Gregori, Mina: In The Age of Caravaggio, Exhibition Catalogue, The Metropolitan Museum of Art, New York 1985

Gregori, Mina: Come dipingeva il Caravaggio. Atti della giornata di studio, (Florence, 28.01.1991), Milan 1996

Haskell, Francis: Patrons and Painters, New York 1963
Hibbard, Howard: Caravaggio, New York 1985

Longhi, Roberto: Il Caravaggio, Milan 1952, Rome 2/1968, 3/1982, with an introduction by G. Previtali

Macione, Stefania: Michelangelo Mersisi da Caravaggio. La Vita e le Opere attraverso i Documenti. Atti del Convengo Internazionale di Studi 5.–6.10. 1995, Rome 1996

Mancini, Guilio: Considerazioni sulla pittura, 2 Vol., ed. A. Marucchi, Rome 1956–7

Maurizio Marini: Caravaggio: Michelangelo Merisi da Caravaggio 'pictor praestantissimus', Rome, 1987

Rainald Raabe: Images of the Observer. Studies of Caravaggio's Roman Work, Hildesheim, etc., 1996

Joachim von Sandrart: German Academy of the Noble Arts of Architecture, Picture-making and Painting, 1675, ed. A.R. Peltzer, Munich, 1925, English translation in Hibbard (London, 1983)

Federico Scannelli: Il microcosmo della pintura, Cesena 1657, new impression, ed. G. Giubbini, Milan, 1996

Luigi Spezzaferro: La cultura del Cardinal del Monte e il primo tempo di Caravaggio, Storia dell'arte 9/10, 1971, pp. 57–92

PHOTOGRAPHIC CREDITS

The publisher wishes to thank museums, collectors, libraries, and photographers for granting permission to reproduce works and for their kind cooperation in the realization of this book.

Archiv für Kunst und Geschichte, Berlin (9, 39, 60, 61, 66/67, 88, 121); Archivio Boncompagni Ludovisi, Rome (27); Archivio fotografico Soprintendenza per i Beni e Artistici Storici di Rome (111); Artothek Peissenberg (50); Banca Commerciale Italiana, Naples, Foto: Luciano Pedicini/Archivio dell'Arte, Naples (87); Bildarchiv Preussischer Kulturbesitz, Berlin (16); Bridgeman Art Library, London (35, 70/71, 78, 81, 83, 89); El Escorial, Madrid (82); Galleria Doria Pamphilj, Rome (45); Kunsthistorisches Museum, Vienna (80); National Gallery of Ireland, Dublin (79); Nelson Art Gallery, Kansas City (48); Scala, Istituto Fotografico Editoriale, Antella/Florence (6, 10, 11, 13, 15, 18, 19, 20, 21, 22, 23, 25, 28, 29, 30, 31, 33, 34, 37, 38, 43, 44, 46, 47, 49, 51, 52, 53, 54, 55, 56, 57, 58, 59, 62, 63, 66, 68, 72, 73, 74/75, 76, 77, 82, 84, 85, 86, 88, 89, 90/91, 93, 95, 96, 98, 99, 100, 101, 102, 103, 105, 106, 107, 109, 110, 111, 112, 113, 114, 115, 116, 117, 118, 119, 121, 122, 123, 124, 125, 126/127, 128, 129, 130, 131, 132, 135); Scuola di San Rocco, Venice (89); Staatliche Museen zu Berlin – Preussischer Kulturbesitz, Berlin (41, 42); The Barbara Piasecka Johnson Collection Foundation (59); The Cleveland Museum of Art, 1997, Lenna C. Hanna, Jr., Fund 1997.2 (124); The Detroit Institute of Arts, Detroit (69); The Metropolitan Museum of Art, Purchase, Lila Acheson Wallace Gift, New York (86).